and white and

A.

Remembering Whitney

Remembering Whitney

My Story of Love, Loss, and the Night the Music Stopped

CISSY HOUSTON with Lisa Dickey with a foreword by Dionne Warwick

HARPER www.harpercollins.com REMEMBERING WHITNEY. Copyright © 2013 by Cissy Houston. Foreword copyright © 2013 by Dionne Warwick. All rights reserved. Printed in the United States of America. No part of this book may be used or reproduced in any manner whatsoever without written permission except in the case of brief quotations embodied in critical articles and reviews. For information, address HarperCollins Publishers, 10 East 53rd Street, New York, NY 10022.

HarperCollins books may be purchased for educational, business, or sales promotional use. For information, please e-mail the Special Markets Department at SPsales@harpercollins.com.

All photographs are courtesy of the author unless otherwise noted.

Grateful acknowledgment is made for permission for the following: "I Will Always Love You." Words and Music by Dolly Parton \bigcirc 1973 Velvet Apple Music. All rights reserved. Used by permission.

FIRST EDITION

Library of Congress Cataloging-in-Publication Data has been applied for.

ISBN 978-0-06-223839-9

13 14 15 16 17 OV/RRD 10 9 8 7 6 5 4 3 2 1

This book is dedicated to my immediate family, particularly my sons and my grandchildren, and to all the world of wonderful fans who loved my daughter. Hopefully you may get to know Whitney through the love I've shown in these pages.

"I'll lend you for a little time a child of mine," He said. "For you to love while she lives and mourn for when she's dead...."

> —adapted from "I'll Lend You a Child" by Edgar Guest

Contents

Foreword xi

Part One

CHAPTER I	The Night the Music Stopped3
CHAPTER 2	A Child of Newark9
CHAPTER 3	The Gospel Truth
CHAPTER 4	Sweet Inspirations
CHAPTER 5	Life on Dodd Street $\dots \dots \dots$
CHAPTER 6	Training the Voice
CHAPTER 7	Separation

Part Ino

CHAPTER 8	Enter Clive Davis 109
CHAPTER 9	Fame
CHAPTER IO	Welcome Home Heroes
CHAPTER II	The Bodyguard and Bobby Brown 153
CHAPTER 12	"I Never Asked for this Madness" \dots 165
CHAPTER 13	"I Know Him So Well" 181
CHAPTER 14	A Very Bad Year 197

Part Three

CHAPTER 15	Atlanta
CHAPTER 16	The Intervention
CHAPTER 17	The Comeback 239
CHAPTER 18	"I Look to You" 253
CHAPTER 19	Bringing My Daughter Home 265
	Epilogue 273

Acknowledgments 279 Selected Cissy Houston Discography 287 Selected Whitney Houston Discography 291 Index 293

Foreword

by Dionne Warwick

Z've known Cissy Houston my whole life. She's my aunt—her sister Lee is my mother—but because we're only seven years apart, she felt more like an older sister to me.

When I was growing up, Cissy even lived with us for a while in East Orange, so I got to know her pretty well. I can still hear her voice, telling my sister Dee Dee and me, "I am older, and you are going to do as I say." She might have felt like an older sister to us, but she never let us forget she was our *aunt*. She was a strong young woman then, and she is a strong, loving woman now.

From the time we were children, we all sang together at

Foreword

St. Luke's A.M.E. Church in Newark, where my grandfather was the minister. Later, when he moved away, we all joined New Hope Baptist Church. My sister Dee Dee and I sang in the junior choir there, and Cissy rehearsed us and arranged songs for us. Music was always in our family's blood. But there were two things even more important to us than music: family and faith.

When she started having children, Cissy became very mother-oriented. Her kids were primary in her life—she had to be with her babies. There was a great deal of love in their house. And we all loved her children, Gary, Michael, and Nippy.

When Cissy's kids were small, I used to like to bring them out on the road with me. By that time, I had a solo career and was touring all over the world, so during the summers, when they weren't in school, I'd bring them out to join me. They were just regular little kids on summer vacation, but they did learn how to use room service very, very quickly. It was all I could do to keep those children from ordering everything in the world up to the room.

Nippy used to talk with me about her mother, just the usual kids' stuff of "Why won't she let me do this?" and "How come the other kids get to do that?" But later on, she came to realize why her mother did the things she did. We all were brought up in the same way—it was instilled in us to respect our elders, to love God, and to walk the straight and narrow. And that's what Cissy tried to teach her own children, too.

Cissy has always wanted the best for everyone in her family. She's always giving encouragement and support, and

Foreword

she's tried on many occasions to give advice. Whenever she saw something that wasn't sitting too well with her, she'd speak up. As I did. In our family, the apple doesn't fall far from the tree.

But while Cissy was strong and loving, Nippy was always a little girl, even during her womanhood. Yes, she was ambitious, and she had a silent strength. But I'm not sure it was ever really tapped into. We all know of Nippy's beauty and her amazing vocal skills. But in Cissy's book, you will learn about the little girl behind all that.

It's a privilege to have a peek inside someone's life, and that's what Cissy is offering in this book. The truth has always been paramount for Cissy, and I believe she has given the truth within these pages. The fact that she found the strength to write it now, given the grief she has suffered, is a testament to her faith: she is being led to share her true feelings about herself and her beloved daughter.

I hope all of us can take a lesson or two from it, and that with this book, everyone can read about and understand who Whitney Houston truly was.

> Dionne Warwick November 2012

PART ONE

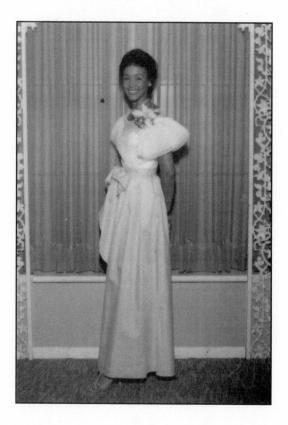

The Night the Music Stopped

CHAPTER I

 T^{t} was the middle of the afternoon on a Saturday when I heard my doorbell ring.

I wasn't expecting anyone, and walking to the door I felt a little irritated about a surprise visit. But when I opened it, no one was there, so I just shut the door and went back to whatever I was doing. Who would be ringing my bell and disappearing in the middle of the day? My apartment building had a doorman, and it wasn't like people were just dropping by all the time.

Not long after, I heard that bell ring again. I got up and went to answer it, really irritated now. But again, no one was there. Now, this just didn't make sense. Why would someone be messing with me like this? I called down to the front desk. "Has anyone come up to see me?" I asked the concierge.

"No, Mrs. Houston," he said. "I haven't seen anyone on the cameras, either." Well then, who was ringing my bell?

Not long after that, around six or six-thirty in the evening, my phone rang. When I picked it up, all I could hear was screaming.

"Oh, Mommy! It's Nippy! It's Nippy!" It was my son Gary on the line, and he was hysterical.

"Gary, what's wrong?"

"It's Nippy," he said again. "They found her!"

"Found her where?"

"They found her upstairs," he cried. "They found her upstairs and I'm not going back up there!"

"Gary, what happened?" I snapped, frightened now. "You've got to tell me what's wrong!"

He never did say what had happened, maybe because he didn't know exactly, or maybe because he was in shock. He just kept mumbling, "Oh, Mommy, Mommy, Mommy," until I finally said, "Gary, is she dead?"

And he said, "Yes, Mommy. She's dead."

And that was the moment my whole world shattered.

I don't know what I did or said after that. I was told later that I screamed so loudly that the whole building must have heard me, but my mind was absolutely blank, except for one thought: My baby was gone.

Somehow, people started showing up at my apartment. My niece Diane came, and other friends and family. The phone rang, the doorbell chimed, people brought food, people tried to hug me. But I just sat in my chair, crying. I was in shock,

and even now, I really don't know how I survived that evening—or the days that followed.

As soon as the news got out, all sorts of people surrounded my apartment building. Reporters lined the lobby trying to get in to ask questions, and strangers snuck up to my floor wanting to pay their condolences. The crowds got so thick outside the building that the police had to be called to keep people away. But I didn't know any of that at the time, because all I could do was weep and moan and wail. All I wanted was to be left alone to grieve for my daughter.

The last time I'd seen Nippy, I had been a little upset with her. It was around the Christmas holidays, just six weeks or so earlier, and she'd suddenly showed up in New York with my granddaughter, Krissi. Nippy wanted me to come into the city and join them, and my sons Gary and Michael, but she hadn't told me they were coming, so I'd made other plans. I was going up to Sparta, New Jersey, to have Christmas dinner with my friend Nell, and I didn't feel right breaking it off, since we'd been planning it for a long time. I wanted to see Nippy, of course, but I just wished she would give me a little more notice when she was coming through.

So I went up to Sparta and spent the night there, and then the next day Nippy called me again, asking me to please come into New York and see them. She was staying at the New York Palace hotel, and Gary and Michael and their wives and children were all there, so it looked to be a nice family reunion. I went into Manhattan, excited to see the whole family together, which was a real rarity these days.

Nippy had just finished working on her new movie, *Sparkle*, and she looked fantastic. The whole day she was in good spirits—laughing and joking with her brothers, and playing with the kids. She'd always had a good relationship with her brothers, and as I watched them laughing together it felt like old times. We had all been through a lot in recent years, but this day it felt like we didn't have a care in the world.

At one point in the day, as I was sitting on the sofa, Nippy leaned over and put her head in my lap. This was something she didn't do all that often, but I always loved it when she did. She and I were very different people, and like any mother and daughter, we'd had our difficult moments over the years. But when Nippy would put her head in my lap, those were the moments that bonded us together, and I cherished them.

I knew Nippy was returning to Atlanta the next day, and I hated that our visit was so short. I was always asking her to come up and visit, as I hadn't gotten to see very much of her in recent years. But now that she seemed to be in a better place, with her new movie and a new lightness about her, I hoped that would change. As I got ready to leave, Nippy and I stood talking at the door.

"I'll come back soon, Mommy," she said. "I've got to go to L.A. for the Grammys in February, but I'll come see you after that."

My daughter had come a long way from being a skinny little girl with a big voice growing up in Newark, New Jersey. She had traveled the world and become a sophisticated, powerful woman—but there was something in our relationship that always brought out the child in her. When I looked at Nippy, I saw the little girl who used to grab a broom and belt out

songs in our basement studio like she was onstage at Carnegie Hall. And I saw the uncertain girl who wanted everyone to like her, who just wanted to sing to make people happy not to sell millions of records or be a global superstar.

But she did become a superstar, and the pressures that brought eventually overwhelmed her. She endured so much, and was criticized so mercilessly by people who didn't understand her—people who didn't know who she was. She always used to say to me, "Mommy, I just want to sing." Yet that would never be enough.

For everything Nippy went through, with drugs, with her relationships, with the pitfalls of fame, she really did seem to be on an upswing in the weeks before she died. During those weeks, whenever we spoke on the phone, she sounded so good, like she was feeling better than she had in years.

When she called me in early February, though, just before she left for Los Angeles and the Grammy Awards, she didn't sound like herself. There was a sadness in her voice. Nippy never liked to share her problems with me, so I didn't know exactly what was wrong. We all have our ups and downs, so I didn't worry too much about it. I knew she'd be busy in Los Angeles, with the awards and all the other events that went on, and I didn't really expect to hear from her again while she was there.

But on the Friday before the awards, she did call me. She sounded a little better, though she still didn't share much of what was going on. I don't remember most of what we talked about, but I do remember the last thing she said to me on the phone. Back in December, she had promised to come see me after the Grammys, and before she hung up on that Friday, she said it again. "I'll be home soon, Mommy," she told me. "I promise."

Those were the last words I would ever hear her speak.

The next day, Nippy died. And the days that followed were a seemingly endless blur of grief and pain. There were times when I didn't think I could live through the despair of losing my baby girl. I just couldn't believe I would never see her, or hear her voice, in this world again. I still can't believe it.

But I did take solace in one thing. On that terrible day, when my doorbell kept ringing in those hours before Gary's call, I believe it was my beautiful Nippy, keeping her promise to me—that somehow, some way, she came to see me, just as she said she would.

CHAPTER 2

A Child of Newark

Z^t was a hot August night in 1963 when Nippy was born. I was doing session work as a background singer, and despite being overdue and big as all get-out, I'd worked a full day. My husband, John, picked me up at the studio in Manhattan and drove me home to our apartment in Newark, New Jersey, but not long after we walked in the front door, my water broke. So it was right back out the door as John put me in the car and hurried to Presbyterian Hospital.

From the moment I found out I was pregnant, I had hoped this baby would be a girl. I already had two boys, my sons Gary and Michael, and I knew this would be my last child. I was tired of having babies, and I surely didn't want to go through what my mother had endured—she had eight children by the time she turned thirty. Three was enough for me, but I desperately wanted this last one to be a girl—although personally, I was convinced that I was about to have another big-headed boy. At that time, of course, you couldn't find out until the baby was born. There were old wives' tales about being able to tell depending on whether you carried the baby high or low, but nobody really knew.

What I did know was that this baby already seemed to love music. All during my pregnancy, I'd been doing session work—singing backup for artists such as Solomon Burke, Wilson Pickett, the Isley Brothers, Aretha Franklin, and my niece Dionne Warwick—and the whole time, that baby never stopped moving inside me. Sometimes, it even seemed to be moving to the music. So, one thing I knew for certain—that child was going to have rhythm!

We got to the hospital and checked in, but I don't remember much after that. This was a big baby, and the delivery wasn't easy. After hours of pain, the doctors gave me an anesthetic to knock me out, and when I finally woke up, John came into the room and told me we had a baby girl. I don't know why, but I didn't believe him. I thought he was just playing a joke on me.

"I'm telling you, Cissy, it's a girl," he said, laughing.

"Stop that mess, John! You're lying." John always liked to tease and joke, but I wasn't having any of that right now.

"No, really," he insisted. "It's a girl."

"And she's gorgeous," chimed in a nurse who was standing there.

Well, there was one way to find out. "Where is she?" I asked.

It turned out the hospital staff were taking her around to show her off. The nurses were just carrying my little baby all

over the hospital floor, showing her to their coworkers and everyone else. It was as if she belonged to the public the very second she was born.

I was so mad—here I was, lying exhausted in a hospital bed, and I couldn't even see my own child because everyone else had to get a look at her first.

"You better go and get my baby!" I told John.

One of the nurses hustled off, and a few minutes later I finally saw my baby girl for the first time. Someone had already tied a little pink bow in her hair, and she was the most beautiful little thing I'd ever seen. I held her in my arms, and I couldn't believe it. She was eight pounds and four ounces, and she had everything—a head full of hair, eyelashes, fingernails, everything.

I was so excited, so happy, that I burst into tears of joy. I named her Whitney Elizabeth—Whitney, the name of a TV character I liked, because I thought it was classy and a little different. And Elizabeth, after John's mother.

I was beyond thrilled that I'd gotten my wish to have a girl, and I wanted Nippy to be a special kind of child. She was my princess, my perfect little jewel, and from the very beginning I wanted to protect her. I didn't want my sweet baby ever to know hardship, if I could help it, because hardship was something I had learned plenty about in my own childhood.

As sweet as my Nippy was, I always had a harder shell, ever since I was a girl. I didn't have much choice, considering all the things that happened to my family as I was growing up in Depression-era Newark.

CISSY HOUSTON

My parents, Nicholas and Delia Mae Drinkard, came north to Newark from Georgia in 1923. The city of Newark had built wooden tenement houses for working-class black folks and immigrants, and that's where they settled—on the top floor of a three-story building with a pull-chain toilet all the way down on the back porch. When they arrived, my parents already had three children—a son, William, and two daughters, Lee and Marie—and over the next ten years, they'd have five more: Hank, Anne, Nicky, and Larry, and finally me, in September 1933.

Our apartment, at 199 Court Street, was in the middle of a racially mixed working-class neighborhood. It had its rough edges, but there were also churches on just about every corner. Both of my parents were devout Christians, with deep roots in the African Methodist Episcopal Church, so my siblings and I grew up in the faith.

My mother was a homebody, a soft-spoken woman who rarely left the house except to go to church, where she served as a steward. Only three things mattered to her: God, her husband, and her children. And I never heard her complain, even though it was a constant struggle to keep eight kids neat, clean, and well fed on my father's Depression-era salary of eighteen dollars a week.

My father did backbreaking work, first doing road repair in Newark, and then pouring iron in the blazing-hot foundry of the Singer sewing machine factory in Elizabeth. His was a hard life, but like my mother he had a strong faith, and he was never afraid to let it show. Daddy wasn't a singer, but in church he would hum along during the testimonials a tradition in the black church in those days. My father

praised God and prayed all the time, openly, without any hesitation. He once even got right down on his knees on the factory floor, to pray for another worker's mother.

Tall and light-skinned, with penetrating blue-gray eyes, Daddy was an imposing man with strong beliefs—one look at him and you knew he didn't take no mess. That was true not only within the church, where he was a trustee and a vocal member of the congregation, but also at home, where he taught us everything we needed to know about Jesus and faith.

And oh, he could be strict. He was determined to protect his children from corruption and temptations, so he kept a close eye on us, requiring us to be home before dark and say our prayers before every meal. Daddy usually led us in prayer, but every so often he'd direct one of us to do it. As my sisters and I came of age, he also demanded that we teach Sunday school—it was his way of making us learn through teaching. He wanted all his children to have strong Christian faith and walk the straight-and-narrow path, just as he had.

But as hard as my father tried to protect us from the world outside the church, he couldn't fully insulate us from the temptations of the streets. My oldest brother, William, who was fifteen when I was born, fell prey in his teenage years to the allure of Newark's darker side. He began hanging out in the streets, gambling, drinking, fighting, and doing who knows what else. William had a hot temper and a mean streak, and when Daddy confronted him about straying, he fought back. I was too young to know what was happening, but they clashed hard, and William left home to make his own way. Our family was close-knit, and it was devastating for my mother to see her eldest son walk out the door. At that time, I had no idea how hard it must be for a mother to watch her child stray into danger and temptation. Many years later, I would learn that feeling all too well.

My mother was already under tremendous stress, trying to feed and care for so many children. The pain of William's departure only added to it, and after he left, her health got worse. She had other burdens to bear, too—in the years after I was born, she lost two sets of twins at birth. Losing four babies in such a short time, and losing her eldest son to the streets, proved too much for her. At age thirty-four, my mother had a stroke.

My mother's life—and ours—would never be the same after that. The stroke damaged the right side of her brain, she lost the use of her left arm, and her left leg was also impaired. I was just a child, but watching my mother struggle to recover from her stroke taught me what suffering looked like. My sisters and I spent long hours massaging her leg to try to increase circulation and comfort her. Because it was hard for her to move around, she only left the apartment for emergencies and church. Every single Sunday, my father would lift her up, carry her down the three flights of stairs, then push her in her wheelchair to church. And when they came back, he'd carry her back up those three flights. Seeing my parents' example, I grew up believing that no matter the hardship, you can overcome it with determination.

But there remained many more lessons to be learned, because our family's troubles had only just begun.

Not long after my mother's stroke, a flash fire broke out

in the paint store on the first floor of our tenement building. The fire spread with a fury, and although we were all able to get out of the house safely, we had no time to save our possessions. We all ran across the street and huddled there, frightened, as the flames rose higher amid the shrieking of sirens and people's screams.

My father held me in his arms, and as I clutched his neck in terror I watched the flames climb higher, engulfing our home and then consuming the entire block of tenement houses. I looked at my father and saw tears roll from his eyes as he watched years of our family's memories burn. The fire destroyed not only our home, but just about everything we owned—our clothes, our books, family photographs, and what few playthings we had. And because our extended family—Daddy's parents, Mommy's sister and mother, and several aunts and uncles—had lived in that same block of tenements, their places burned, too. We'd all have to move.

The fire scattered the Drinkards all over Newark, but strangely, in other ways, it was a godsend. If it hadn't been for that fire, it would have taken us years to save enough money to move out of the tenement. But afterward, with the help of city services, we were able to move into an apartment in a much better neighborhood. From the ashes of something terrible, something good was able to emerge—another lesson that imprinted itself on my young mind.

Once we settled into our new neighborhood, our family started attending St. Luke's A.M.E. Church. At age five, I was too young to understand much of what was going on, but I was drawn to the joy and enthusiasm that seemed to swell up in that place. You could feel the force of the Spirit and the music the minute you stepped inside those doors.

St. Luke's was more than just the place our family went to Sunday school. It was the place where my brothers and sisters and I learned to sing.

At first, I wasn't all that interested in singing. But the music at St. Luke's was different. At St. Luke's A.M.E., they not only had a piano, they also had cymbals, tambourines, and even a washboard. This was where we learned to clap our hands in time, and where we learned syncopation, the offbeat rhythm that's a cornerstone of so many musical styles. It's where we learned to play the tambourine, and to harmonize. And it's where I first began to experience music as something spiritual.

Inspired by the music in that church, my brothers and sisters and I started singing together. I don't remember when we first started, but the minute we did, something just clicked—we could hardly believe what was coming out of our own mouths. We were blessed with some truly great singers in my family (all except poor Hank, who couldn't carry a tune in a bucket), and when my father heard us sing together, that was it—our carefree childhood days were over.

Daddy made us practice together every single day. I didn't want to, of course—I just wanted to keep playing like all the other five-year-old kids. Sometimes I'd hide in my room, or I'd run outside and duck behind the car, and my father would threaten me with a beating to get me to come join the others. He never did actually spank me, because, as the youngest, I was his "baby." But he surely did spank my

brothers and sisters—Daddy was not one to fool around if he wanted something done.

My sister Marie, who we called Reebie, taught us songs and rehearsed us, and she was just as strict as my father. We'd learn the melody of a song from the hymnbook, then add in the harmonies, and then finally improvise. "Strike me up a tune!" my father would say, and we'd stand in a group, hold up a broom like a microphone, and start singing.

I could see the pride in my father's eyes when we sang, but you know, he wasn't training us to make himself proud. As we started performing in churches, and later in concert halls, he really saw us as junior missionaries—young ambassadors of God's Word. He wanted us to be a positive influence on other young people, and to carry God's Word and the family name with our own group: the Drinkard Quartet.

For a time, things were good. We might not have had much money, but we had enough—and more important, we had each other, our faith, and our music. But just as life seemed to be getting better, my mother had another stroke.

From that point on, my mother's hospital visits became part of our family's daily life. Every so often, sometimes in the middle of the night, she'd go to the hospital and stay there for a few days. After a while, we kids would hear from a relative or neighbor that she was coming home, and we'd crowd into the front window of our apartment to watch for her and my father coming up the street, him pushing her in her wheelchair.

We were always so happy to have Mommy home, but after those hospital visits she usually needed relief from taking care of the three youngest children—Larry, Nicky, and me. So, during these times, Larry and Nicky were sent to stay with relatives who still lived near Court Street, and I got shipped off to Newark's Ironbound section to stay with my aunt Juanita. I hated staying with Aunt Juanita, not only because I missed my brothers, but also because she was a mean, nasty woman. She wasn't like my other relatives she dipped snuff and was always trying to get a rise out of everybody. Every day I spent at Aunt Juanita's, I prayed for my mother's quick recovery.

When Mommy was feeling better, and we could all be at home again—those were the happiest times of my young life. But they lasted only until one terrible night in May 1941, when I was eight years old. That night, my mother began having seizures, and blood started pouring from her mouth and nose. Daddy and my older sisters tried desperately to stem her bleeding and comfort her, but the blood was still gushing out when the ambulance arrived. Mommy was rushed to the hospital as my brothers and I slept through it all, unaware that anything was happening.

The next morning, we were told only that our mother had gone to the hospital. And later that day, when a neighbor boy yelled up to us that he saw Daddy coming up the street, Larry, Nicky, and I gathered in the window of our apartment, just like we always did, to watch for Daddy rolling Mommy up the street in her wheelchair.

That's when mean Aunt Juanita yelled up to us, "Get out of that window, children! Don't you know your momma's dead?"

I didn't even have time to take in her words before I saw

my father walking up the street. His head hung down, and he was leaning heavily on Oscar, my mother's brother. He was crying, and my mother and her wheelchair were nowhere to be seen. As it turned out, she'd suffered a severe cerebral hemorrhage and hadn't even made it to the hospital.

My beloved mother, Delia Mae Drinkard, had passed. She was only thirty-nine years old.

I didn't know how to cope with the terrible feeling of emptiness that settled over me after my mother died. I didn't think I'd recover from it, and I'm not sure I ever did.

I was only eight, and the very idea of death was hard to put my head around. To make matters worse, no one had the time or inclination to talk to me about it. I think my father, sisters, cousins, aunts, and uncles all assumed I was too young, so I was left to deal with it on my own. In fact, for years afterward, my sisters avoided talking about Mommy's death, as the mere mention of her name brought tears to their eyes. And so I learned very early on to tamp down my feelings of sadness and just get on with life—because there really wasn't any other choice in the matter.

My mother's quiet stability, her faith and love, had sustained all of us during those harsh Depression years. With that stability gone, we were adrift. And so we turned to the one thing that could ground us: singing the gospel.

Singing and rehearsing kept our family together after my mother's death. We looked to Daddy for support, and he looked to us, burying his grief in his involvement with his children and the music. Daddy always urged us to practice more; sometimes, when he came home after we were in bed, he'd wake us and say, "Come on, now, get up and sing me a song!" Nobody wanted to disappoint him, so we always did it. And with all that practice, we started getting booked to sing in churches and gospel programs from New Jersey to New York and beyond.

I loved singing with my brothers and sisters, but, unlike my older sister Reebie, who had found the Lord and been converted at the storefront church, I didn't know *what* I was singing about. Something definitely touched me when I sang, but I didn't really understand it. For Reebie, who believed that true gospel singers had to have the spirit of God within them, I was just "half-steppin'." And when you're half-steppin', if you're not careful, that's when you start down roads you shouldn't be on.

Reebie and my father would sing and listen only to gospel, but I liked other kinds of music, too—and I loved to dance. On Saturday mornings, when Reebie and Daddy were out of the house, my sister Annie and I would play records on our old Victrola. She loved Billie Holiday and I loved Dinah Washington—who, I later discovered, had started out singing with a female gospel quartet we'd once shared a stage with. But on those Saturday mornings, Annie and I weren't thinking about gospel music. We allowed ourselves to get lost in the romantic dreams and worldly desires described in those popular songs.

By the time I reached my teens, I was straying further into worldly temptations. I had my own little crowd of school friends, including my best friend, Jolly, who lived down the block from us. Jolly and I were pals, and sometimes we'd

20

hang out in the after-school activity room, where kids could play ball or do arts and crafts. But Jolly also liked to go out to the neighborhood places where kids could dance.

I knew my father and Reebie wouldn't approve, but I was tempted by the music and the fun everyone seemed to have dancing. Yet I was also frightened by some things that went on there. I'd lived a pretty sheltered life, and some of those places had hustlers and junkies lurking around. This was the world my brother William had gotten drawn into, and I'd seen what it did to him—and to my family. So, I knew I should stay away, but in the end I couldn't resist the temptation.

Jolly and I started sneaking into one of the tamer teen spots—a place called the Green Lantern—and for a while, I had a good time drinking sodas and eating chips, dancing and playing the jukebox. That is, until one evening when Reebie caught me. She was furious, and she beat me hard for breaking the rules. I knew that it was my father who'd set those rules, and Reebie was only enforcing them, but she was just as upset as he was.

No one likes to get a beating, but in some ways I was relieved that Reebie had caught me. I had been straying from my family's tight little circle, and although going out to those neighborhood joints felt exciting and new, I knew it could lead to a darker place. Deep down, I understood that my father had set strict rules for a good reason—to keep us safe. He did it out of love.

That's why, even into my teenage years, my father still kept us all to a rigid daily routine. After school let out, we were expected to come straight home and take care of our chores. We were allowed to go out for a little while after that,

but we had to be back home before dusk and ready to have dinner by the time Daddy got home from work. After dinner, one of us would do dishes, and then we'd rehearse while Reebie and my father supervised. And on weekends, we were usually booked to sing at some church or another, so we'd be traveling under the watchful eyes of Reebie and my father.

Music kept us busy, and being busy meant we had no time to get into trouble. And that's exactly the way my father liked it.

Around this same time, my father told us he was getting married again. His announcement came as a shock for all of us, but particularly for the girls—Lee, Annie, Reebie, and me. I guess it was partly because we didn't want to share our father with anyone. But it was also because Viola, the woman Daddy planned to marry, was so different from our mother. My sisters tried to talk him out of it, but he'd made up his mind. Viola knew we didn't like her, and she was jealous of the closeness between Daddy and his children, so she aimed to do something about it.

Soon after she moved into our house, Viola convinced my father to send Nicky and Larry to live in Boston with their uncle. Then Reebie, who was twenty-five, announced that she was going to marry the man she'd been seeing for years, and just like that, she was gone, too. Nicky and Larry didn't stay in Boston for long, but soon after they moved back, my father informed us that he and Viola were going to move. Viola was just determined to break up our family unit, the center of all our lives.

I didn't want Daddy to move away, but I felt secure know-

ing that at least I'd still be with my brothers and my sister Annie. But then Daddy dropped the bombshell. He told me that I'd be moving with him and Viola, since I was too young to live in a home without adult supervision. Live with Viola? Without my brothers? This was the last straw.

I ran out of the house without even knowing where I was going. Somehow, I ended up on Charlton Street, and as I wandered past St. Luke's, something made me turn around and go back. It was a weekday, and I could see through the door that the evening service had started. I went in and sat down in a back pew, and though I could see Reverend Odum preaching up in the pulpit, I didn't hear a word he was saying as my mind drifted to all my problems. As I sat there feeling sorry for myself, the tears just welled up in my eyes.

I began sobbing—crying for the mother I'd lost and still missed, for being separated from Larry and Nicky, and for having to leave our home to go live with a woman that I disliked. Why did life have to be filled with so much hardship? How were we supposed to deal with all the cruelties life bestowed on us? It just seemed so hard, so unfair.

But once again, out of the ashes of something terrible, something wonderful emerged. As I sat weeping in the pew, I finally heard Reverend Odum's voice. He was addressing the congregation, but it was as if he were talking directly to me.

"Count your blessings," his voice rang out. I looked up, wiping my eyes.

"Yes sir! Count your blessings, young man, young woman, mother, dad. Where would you be right now if not for God? Did you wake up this morning?" the reverend shouted. "Yes!" the congregation answered.

"Did He put the breath of life into your lungs this morning?"

"Amen," someone yelled.

"Then give Him praise!" the reverend shouted. "Is He worthy to be praised? Then give Him praise!"

Then, over his voice, the piano rang out and the choir began singing:

Count your blessings, Name them one by one. Count your many blessings, See what God has done.

I had heard the song before, but I'd never really paid attention to the words. Suddenly, they took on new meaning. I was only fourteen, but my life flashed before me as I sat in that pew. I looked back and instead of seeing misfortune, I saw how lucky, how blessed I was. I saw how things could have gone horribly wrong, and how fortunate I was to have had a mother who loved me, and brothers and sisters, and a father who protected and sheltered me.

And I suddenly saw Him in all of them—how He loved me through each of them. Silently, I began to praise Him and give Him glory. I raised my arms, and deep inside, I felt a warmth, a glow, building, swelling . . . it was as if I was being transported, lifted to another level, another world. I opened my mouth and felt myself speaking, then singing and laughing for joy. It was the most joyous feeling—I could

feel the Spirit coursing through my body, and I surrendered to it. I gave myself to Him.

The Spirit hit me like lightning, and it was something I had never felt before; I cried out in the name of Jesus and the Holy Ghost, and they heard me. That night, they used me like never before. It was the most glorious feeling I had ever experienced.

Walking home after the service, I knew my life had changed forever. I saw the hand of the Creator in everything around me, and it was like seeing the world for the first time. God was real, I knew it, and I wanted to serve Him. I wanted to sing for Him. That evening, I realized that I'd been serving God all along; I just didn't know what I was doing. But now, it all seemed clear. I no longer questioned His Word, His deeds—I just believed.

I began to see and share my father's vision of the purpose of singing. Singing gospel was a ministry, an end in itself; you didn't have to get famous or make a lot of money. I came to see that, in singing, you convince others of the reality of God and inspire the Word in others. And every song you sing also strengthens your own faith.

I also came to understand that our family's singing together is what ultimately helped us survive. It helped keep us together, even through the hardest times. We sang together and stayed together—we held each other up. I'd always had family, but from that night at St. Luke's onward, I had faith, too—a faith that would carry me through some of my darkest days to come.

CHAPTER 3

The Gospel Truth

Thad been singing in the church since age five, but after that night at St. Luke's, music and faith became the absolute center of my life. I was committed to singing and spreading the Word, and at the same time, the Drinkard Quartet—which we renamed the Drinkard Singers—kept on performing, getting bigger and more popular.

Ronnie Williams, one of the area's biggest gospel promoters, was booking us in shows all over New York and New Jersey, and all down the eastern seaboard. We mostly sang at small churches, but we were also booked into concerts with some of the biggest quartets of the day—acts like the Davis Sisters, with their featured singer Jackie Verdell; the Swan Silvertones; and the Dixie Hummingbirds, with their fabulous lead singer Claude Jeter.

And during the early 1950s, while traveling on the circuit

with the Soul Stirrers, I met their lead singer, Sam Cooke. Sam was not only a great singer but also a very good-looking man. We dated for a quick minute back then, and I almost wound up married to him. But Sam lived in too fast a world for me. I knew that neither my Daddy nor my sisters would approve of our relationship, or of Sam's forays away from gospel and into the world of pop music. Many people—like my sisters—didn't like seeing their gospel stars move into the world of secular music, as they considered it a form of backsliding from the church. And I was young enough then that I still worried what other people thought about stuff like that.

My sister Lee was managing us now, and like my father, she was determined to keep the Drinkards on the straight and narrow, far from the temptations of popular entertainment. So when New York City DJ Joe Bostic, known as the "Dean of Gospel Disc Jockeys," approached her about recording deals, management contracts, expanded road tours, radio, and TV shoots, she shot him down quick.

At the time, gospel music was becoming more commercial, and at certain gospel extravaganzas, or during engagements at places like the Apollo Theater in Harlem, we'd seen how some groups succumbed to the temptations that came with fame and money. Backstage, some so-called church folk and gospel artists were every bit as sinful as the world they were supposed to be saving. Lee didn't want us anywhere near that.

But a little later on, Bostic made an offer Lee couldn't refuse. He had plans to feature Mahalia Jackson in a show at Carnegie Hall—and he wanted us on the program, too. Lee

quickly agreed, so in October 1951, the Drinkards appeared on that famed Fifty-Seventh Street stage with Mahalia and other gospels greats such as Rosetta Tharpe and Clara Ward. This was the biggest venue we'd ever performed in, and that show nearly tore the house down—literally. At one point, Mahalia had to warn the crowd that if they didn't cool it, the police were going to empty the hall and put us all out in the street.

This was a magical evening, but even a Carnegie Hall appearance wasn't allowed to affect our regular routine. There was a big party afterward, but do you think Daddy let us go? No, all of us Drinkards dutifully piled into a cab, went to the Port Authority, and took a bus back to New Jersey—right back to focusing on church, our day jobs, and rehearsals.

My father didn't come to see us perform that night, and some people wondered why. But you know, I didn't really expect him to get all excited about Carnegie Hall. To Daddy, gospel was never about fortune or fame or the greatest venue in New York City. It was about ministry and teaching the Word—these were the only things that mattered to him.

And that's why Daddy soon began urging me to take over directing the St. Luke's choir. He believed that teaching, and helping others to express their gift, was a crucial part of gospel music. That's what he'd done for his children, and I guess he wanted to pass along that vision to me. I was reluctant directing a choir was a lot of work, and I just wanted to sing. But once I started, I soon found teaching others almost as rewarding as singing.

I taught the choir just as Reebie and my father had taught us—with a firm hand and a focus on what really mattered.

And like them, I didn't take no mess. This was the same way I would teach Nippy years later, when she told me she wanted to be a singer—no messing around, no shirking. It might have seemed hard-edged or strict, as I wasn't one to sugarcoat anything. But that was the way I had learned, so it was the only way I knew how to do it.

Our family had already been through so much together the fire, losing my brother William to the streets, my mother's strokes and her death, and my father's remarriage. But through it all, we had stayed close and looked out for each other. We were all adults now, living our own lives and working day jobs while singing with the Drinkards. Once again, life was good—but if I knew anything by now, it was that you never know what's around the corner.

In the spring of 1952, when I was eighteen, my father went into the hospital because of stomach pains. Exploratory surgery revealed that he had stomach cancer, and it was already so advanced that even though he'd only just been diagnosed, it was too late to do anything. Within a week, Daddy was dead.

Perhaps because I was older and closer to him, and was able to understand more clearly what had happened, I was even more devastated by my father's death than my mother's. I walked around in a daze. I just couldn't believe that my father, the man who had always been there for us, who had served as a model and a protector through good times and bad, was gone. Just like that, I had no parents—and I was barely out of high school.

Life after Daddy's death was a blur. I was lonely and rest-

less, and I didn't have any kind of ambition left in me. What was the point, when everything could just be taken away from you in the blink of an eye? Without my father's steadying hand, and mired in sadness at his death, I started to slide from the safe and disciplined path he'd always kept us on.

I started drinking, and for a few years, I partied pretty heavily with my brothers and my sister Annie. I did still make it to church every Sunday morning, and I never missed a choir rehearsal, but things were changing at St. Luke's, too, which only added to my feelings of being unmoored.

We had always loved St. Luke's, especially its regular pastor, the Reverend Warrick, who had started coming to our house for dinner back when my mother was still alive. My parents loved Reverend Warrick and his wife, and we were all thrilled when the reverend's son, Mancel, got together with my sister Lee. (They married and had three children—my nieces Dee Dee and Dionne Warwick, who both later became recording artists, and my nephew Mancel Jr.) Our families were very close, and Reverend Warrick was a big part of the reason we loved St. Luke's. So, when he left the church not long after my father died, we all began drawing away from it, too. We just didn't feel as comfortable there anymore.

Losing St. Luke's on top of everything could have been the final straw, plunging me even further into drinking and despair. But just when we needed it, our family found another church. The Drinkards had sung a few times at New Hope Baptist Church, and we all liked it. So we decided to switch to New Hope, and soon I took over directing their choir there. New Hope would become my spiritual home, the place where I would worship for the rest of my life—and the

church where Nippy would first learn to sing. Years later, it would also be the place where we brought her home, to lay her to rest.

But all that was far in the future. For the moment, New Hope was the place that drew me back from partying and straying, the place where I once again found strength in my faith and managed to put myself right. My parents were gone, and it was time for me to grow up, time to move on to the next part of my life—even though, as I'd find soon enough, I was still so naïve I didn't know my rear end from my elbow.

I started the next phase of my life with a big misstep, by marrying a man named Freddy Garland. A good-looking construction worker, Freddy had proposed after a couple of months of dating, and I said yes. I suppose I agreed because I was lonely—my sisters and brothers were all starting families by then, and I was the only one who wasn't married. Freddy and I married at New Hope in 1955, but within a few months I knew I'd made a mistake. He was a good man, but I didn't love him, so I left him after two years of marriage even though I was pregnant.

I moved in with my sister Lee to save money, and kept working at a job I'd had for several years, making electronics at the RCA plant in Elizabeth. And a few months after leaving Freddy, I gave birth to my first child—a five-pound, sixounce baby boy, Gary Garland. I was a twenty-five-year-old single mother, and I had no idea what would happen next.

That summer, the Drinkards got the call that would end up changing my life. Ronnie Williams called with our biggest

32

offer yet—to sing with Mahalia Jackson and Clara Ward at the Newport Jazz Festival.

The Drinkards had cut back on performing since Daddy had died, so Ronnie's call came out of the blue. We were a little out of practice, and I was pregnant and showing, but somehow the Spirit was moving us that day. The crowd was huge, and they felt it, too—people rushed toward the stage, nearly mobbing us as we sang. It was a performance I'll never forget, and later I thought how much I wished Daddy could have seen it—all those people being moved by music, by the Spirit, just as he always hoped.

Our performance that day at Newport led to a resurgence for the Drinkard Singers. Representatives from the RCA-Victor label offered us a contract, and we became the first gospel group to ever sign with that label. We released our first album, *Make a Joyful Noise*, in 1958, and after Joe Bostic began playing one of the cuts on his radio show, people started taking notice. Elvis Presley heard it and must have liked it, because he tried to convince us to record or tour with him—but of course Lee wouldn't hear of it. With all of his famous hip-shaking and provocations, she wasn't letting us anywhere near "Elvis the Pelvis." Though we missed that chance to meet Elvis, another, much more important meeting was about to take place.

The success of *Make a Joyful Noise* led to an invitation for the Drinkards to perform on a gospel show broadcast every week from Newark's Symphony Hall. And that's what we were doing one Sunday morning when a tall, good-looking man was sitting in front of his TV at home, watching the show. The camera happened to zoom in on me for a closeup, and the man apparently liked what he saw. He knew a few musicians around town, so he asked one of them to introduce us.

And that was how I met John Houston.

When John showed up on the set of our Symphony Hall gospel show one morning in the spring of 1958, I didn't know who he was or why he was there. I just knew that he was gorgeous—and that he was staring at me.

Later, it dawned on me that I'd first seen John about a decade earlier. He was an army MP then, and he'd come to the apartment building next to ours looking for someone who'd gone AWOL. I didn't speak to him, and he didn't notice me. But my friends and I all thought he was one of the most handsome men we'd ever seen. I was only fourteen, of course, and it may have been partially because of the uniform, but John made an impression the moment I saw him.

Ten years later, at Symphony Hall, I was even more impressed. John had light skin and fine features (his dad was part Native American), but what really struck me was how he carried himself—tall and well built, the man just exuded charisma. I was nervous as a schoolgirl when he walked over, but as we talked, he turned out to be not only smart and sophisticated but drop-dead funny, too. Even though he'd gone to the Seton Hall prep school in Orange, New Jersey, John was down-to-earth and real.

I loved the way he'd laugh and joke with me—and oh, how that man could talk! I could have listened to him all day. I'm not sure I believe in love at first sight, but if there is such a thing, it happened that day for me.

I was twenty-four when we met, and John was thirteen

years older. The age difference didn't matter to me, but my sisters Lee and Reebie didn't like it. They thought he was robbing the cradle. And they were disgusted with me when they found out that, although separated, John was still married. By now, though, I had developed one very useful trait that has stayed with me my whole life: I never worried about what other people thought—even my own sisters. I liked John, and he liked me, so that was that.

John and I started going out, and pretty soon—well, we did wrong. We began living together, moving into an apartment on Eighth Street in Newark. I knew what we were doing was wrong as long as John was still married, but we were just so much in love. He loved kids, and was so good with my son, Gary. And when I met his family, we hit it off, too. It may have been wrong, but it sure did feel right.

I was still working at RCA, singing with the Drinkards, and picking up a few dollars directing the choirs at New Hope and another small church. John was driving a taxi at night, and he sometimes drove those big rigs that hauled food and goods cross-country. We struggled to make ends meet while John looked for better work, but in those early years we were really happy. We'd laugh and cut up together like a couple of teenagers. And we were truly in love. Later on, I used to like to sing a song called "I Miss the Hungry Years," and you know, sometimes I still do. They really were good ones.

Right from the start, John and Gary and I were a family, and soon we met a neighbor who would also become like family—the woman who would become my best friend. El-

len White was a single mother with four children when she moved in across the hall from us. John invited her over for coffee one day, and we started spending all kinds of time together. Though her given name was Ellen, I took to calling her Bae—short for "Baby." I wasn't close to too many people, but Bae and I got to be like sisters, and Nippy and my sons would come to know her as "Aunt Bae." From those humble beginnings a lifelong friendship was born, and Bae would eventually see us through the highest and lowest points of our lives.

John was still working on getting his divorce, and while he always enjoyed driving the taxi and those big rigs, he also had greater ambitions. About the time we moved in together, he started talking about some big ideas he had for the Drinkards. He believed we were good enough to make it big on the gospel circuit, if we'd just branch out and travel more. If we gave up our day jobs, he said, we could compete with popular gospel singers like Mahalia Jackson, the flamboyant Alex Bradford, and Clara Ward.

My sister Lee, who was managing our group, wasn't buying into John's big dreams. Like my father, she saw gospel singing as ministry, not as a road to fame and fortune—so although she liked John and knew he loved the Drinkards, she was wary of his ambition. She was also put off by his occasional irreverence, as John wasn't above laughing at the fake "healings" of holy rollers. Once, Lee even threw him out of a Pentecostal church when he couldn't stop laughing and making comments in the back pew.

But John felt that with his managerial skills, gift of gab, and knowledge of the gospel circuit, he could successfully

36

manage a singing group. Lee wasn't about to let him get his hands on the Drinkards, so he had to look elsewhere. As it turned out, my nieces Dionne and Dee Dee—who sang in the New Hope choir and occasionally with the Drinkards—had gotten together with two other girls to form a group called the Gospelaires. John saw his opening, and he began taking the Gospelaires around to churches and gospel shows.

One evening, while he was sitting backstage at the Apollo Theater with the Gospelaires and a few other performers, another musician came in and asked if anyone knew some backup singers he could hire for a recording session. John said, "Sure, I do!"—and just like that, he got the Gospelaires the gig. That was the beginning of Dionne and Dee Dee's career as backup artists. And that was also how John officially became their manager.

Finally, John was right where he always wanted to be, in the middle of the action. He just loved sitting around joking with the moneymen, producers, and musicians, and his easy manner with executives and artists allowed him to get Dionne and the group some fantastic session work. By the early 1960s, they were working with the legendary producers Jerry Leiber and Mike Stoller, Henry Glover, and artists such as the Drifters, Dinah Washington, Ben E. King, the Coasters, and Solomon Burke. They made good money, but the real money was in being a solo artist. And that's what John wanted me to pursue.

"Cissy," John would tell me, "I can help you do that!" He was always pressing me, reminding me how much money I could be making. He had big ideas about my future in the business, but to his frustration, I just wasn't interested. I had a good job at RCA, and by then I'd been there for more than ten years, so I had some seniority—something that meant a lot to Depression babies like myself. Also, there was a part of me that was just plain stubborn: I wasn't going to do something just because *John* wanted me to do it.

I also remembered how my father had felt about popular music—how he never allowed us to play it in the house. And I'd seen how artists like Dinah Washington, the Staple Singers, and Sam Cooke were booed and called backsliders after they began singing pop music. So, I decided to resist that particular temptation.

Besides, by January 1961, I was pregnant again. Our son, Michael, was born in August at Beth Israel Hospital in Newark—strangely enough, in the same room as Gary. I took a few weeks off from my job at RCA, then put baby Michael with Gary into day care so I could go back to work. With two small boys, a full-time job, and singing with the Drinkards, I just didn't have time for any other commitments.

But right around that time, John got himself into a jam. He'd promised producer Henry Glover that he'd bring Dionne in to do a session, but she had gotten a call from Scepter Records to do another session for them at the same time. John was stuck, and he begged me to step in. I didn't want to, but I knew it was important for John to show that he was reliable—so for his sake, I agreed to take Dionne's place and sing the backup soprano part.

When we arrived at the studios, I could tell Henry Glover wasn't too happy to see me walking in the door instead of Dionne. John calmed him down long enough to let him hear me sing—and when Henry heard me, he changed his mind

fast. That's how my journey into background work began—a journey that would change not only my life, but the record-ing industry, too.

That session, we were backing up Ronnie Hawkins, a rockabilly star from Arkansas who was being groomed as the new Elvis. The first day lasted until six in the morning, and we had to come back in for the next three days to finish. By the time we wrapped everything up, I was exhausted, though I had to admit the money was good. Still, I had bad feelings about the job, as I knew my sisters would disapprove.

As members of a younger generation, Dionne and Dee Dee got a pass from our family on singing popular music. But I was a few years older than they were, so my sisters expected me to stick to the old ways—to uphold the tradition of separating sacred and pop music. I was torn, as I wanted to keep singing backup, but I didn't want to let down the family. And I'd been struggling with this my whole life, ever since my sister Annie and I used to listen to those old Victrola records in secret at home.

After a lot of thought and prayer, I finally took the attitude that I could be *in* the world of secular music, but not *of* it. I consoled myself with the thought that I wasn't trying to be a pop star, or bring attention to myself, or make anyone stray—no, I was just doing a job. And that job didn't make me any less faithful than anyone else. So I decided to keep on doing background singing, never imagining where it would soon lead me.

As soon as I decided to continue doing background singing, the work came fast and furious. During the first few months

after Michael was born, Dionne, Dee Dee, and I worked with Jerry Leiber and Mike Stoller on an album by the Drifters. From the start, Jerry and Mike were impressed with our rapport, going on about how we "felt each other" and "breathed together." But you know, it really wasn't magic—it was just that we'd all been in the New Hope choir, and so we had a lot of experience singing together.

Jerry and Mike knew how to use everything available to them to create a finished recording—how to pull together the lyrics, the arrangement, the instruments, and the voices to create something special. I admired how they used our voices; they raised pop music to another level. So I watched and studied, and tried to learn as much as I could from them. I loved to sing, but on a deeper level, I wanted to understand how songs really worked, and how they could be made better.

We worked on Drifters songs like "On Broadway," "Some Kind of Wonderful," and "Please Stay," rehearsing at Jerry and Mike's offices in the Brill Building in Manhattan. We were so busy that I had to quit my job at RCA—but the truth was, I earned as much doing two sessions in New York as I did working a whole week at RCA. And I added to those earnings when I joined the union and became the contractor—the person who selects and hires the background singers—for our sessions. Music was now not only my passion, but my profession as well.

One day while we were recording for the Drifters, the great songwriter Burt Bacharach stopped by to listen. His ears perked right up when he heard Dionne, and before leaving he asked if she could sing on some of his projects. She

40

started out just doing demos of his songs for other artists, but she was determined to do more—and her voice was not to be denied. Burt soon agreed to record her as a solo artist.

Dionne signed with Scepter Records in 1962, and her solo recording "Don't Make Me Over" was released in November of that year. Dee Dee, Sylvia Shemwell, and I sang background on the song, and by December it had climbed into the Top Ten. At age twenty-two, Dionne had her first hit record. And that same month, I discovered I was pregnant once again—with the baby that I so desperately hoped would be a girl.

"Don't Make Me Over" opened up a steady stream of work for me from Scepter Records. As my pregnancy progressed, the girls and I worked with such artists as Chuck Jackson, Maxine Brown, and the Shirelles. We also worked with great producers like Leiber and Stoller, Burt Bacharach, Bert Berns, and Jerry Wexler at Atlantic Records, which had become the home of soul music. We were busier than ever, and I probably spent at least as much time in the studios as I did at home. John would drive me into Manhattan in the mornings and come back to pick me up when the sessions ended. When we worked for Atlantic, Tom Dowd, who was their genius chief engineer, looked after me during the day—but I think Tom started to get a little nervous during that summer of 1963, when I was overdue and big as a house.

When I first started doing sessions in New York, I had mixed feelings about working with people I didn't know particularly white people. Maybe it stemmed from hearing stories about my family's experiences back in Georgia, or maybe it was because my life had been centered in Newark's black working-class neighborhoods, and on St. Luke's with its black congregation. I just didn't know many white people growing up, so I didn't really know what to expect.

But doing studio work, I got to know and like a little group of brilliant but kooky soul brothers, Jews, Irishmen, Hispanics, and Italians—and they all became my buddies. We were making music that brought together all of our talents and combined all of our cultural backgrounds. It really was a rich tapestry, and learning to appreciate that was the first step in broadening my somewhat narrow worldview.

Although I was well past my due date, I just kept on singing. And that's what I was doing right up until that day in August 1963 when Nippy was born.

CHAPTER 4

Sweet Inspirations

Thad hoped and prayed to have a baby girl, and now that I finally had her, I wanted to give her the best life we could. And that meant moving out of the apartment where we lived on Eighth Street and into a real house.

I was laid up for two months after Nippy was born, but John got busy looking for a house in a better neighborhood. He found a place on Wainwright Street in Newark, and we were able to get a loan from a friend and close on it within a few weeks. We also made some improvements, putting in a new kitchen and living room, and soon we had the home I'd always dreamed of. We even got a dog for the kids.

The best thing about the house, though, was the neighborhood. Our old apartment on Eighth Street had been a thirdfloor walkup in a busy, working-class urban neighborhood. But the Wainwright House was in an area that was more like

a village, with brick row houses occupied by young families like ours, and backyards where children could play safely. It was still a working-class area, but it was quieter and less crowded.

I was so proud that my children would have physical comforts that I never had growing up. For a lot of black people who left the South and settled in the North during that time, this was something our families always preached to us: We wanted to see our kids do better than we had, to have the chance to really make something of themselves. My parents had given me a strong belief in God and all the love and support I needed. I wanted to give my kids all that, plus the opportunities and material things that my folks couldn't afford.

What I never anticipated was that, in trying to give my children a better life and shield them from hardships, they might end up less prepared to face the kind of trauma that life inevitably throws your way. My childhood toughened me up. But my children—especially Nippy—never developed that same toughness. And that would cause even bigger problems later.

A few months after Nippy was born, I began going back into New York for session jobs. I was making good money, but John had been having problems finding steady work, so much of the time he stayed at home with the kids. Most days, he'd fix Gary's lunch and send him off to school, then drive me into the city for work. He'd spend the rest of the day taking care of Michael and Nippy, and then come back to pick me up when my session was finished.

John was good with the children and loved them all, but

Nippy was his princess. Even before she could walk, she was a cutup, always knocking things down or getting into some kind of mischief. When he took her out to the porch for some air, he'd cover her with a blanket to keep warm, but she'd rustle around and throw it right off and he'd have to keep running out to put it back on. It was around this time that John started calling her "Nippy," after a comic strip character who was always getting into trouble. Pretty soon, we all were calling her Nippy.

She was such a beautiful child—and smart, too. She started walking when she was just six months old. John and I couldn't believe it. And of course, once she began walking she just got into more trouble. She was always teasing and messing with Thor, the German shepherd we'd gotten for the kids. John used to watch her grab that big old dog with her tiny hands and just laugh. He'd tell me stories when I got home from work, and I was jealous that he got to spend so much time with the kids. But of course, I had to work to support the family.

In the spring of 1964, almost a year after Nippy's birth, John's divorce was at last finalized, and he and I were able to get married. John and I had known since the beginning of our relationship that we wanted to be together, but it was a relief to make it official. Now I had a husband, a family, and a home—and soon, I'd have myself a new singing group, too.

At the recording studios in New York, our backup group's reputation kept growing—even as the faces began changing. My niece, Dionne Warwick, went on to her solo career, and soon afterward her sister Dee Dee started to dabble in solo performances, too. Dee Dee sang with us up to 1965, when

she signed a deal with Mercury Records, but then we had to replace her. I tried out a lot of different singers, and finally I was able to put together the group and sound I'd been looking for. That group would become known as the Sweet Inspirations, also known as the Sweets.

Sylvia Shemwell, Myrna Smith, Estelle Brown, and I made up the original Sweet Inspirations, a name Atlantic gave us in January 1967. I had just cut a single with Kapp Records, and I guess Jerry Wexler wanted to make sure that I didn't follow Dionne and Dee Dee and leave for another label, so Atlantic offered our group a contract. At first, the executives wanted to name us the Inspirations, because of our gospel background. But when they discovered another group had already taken that name, they changed it to the Sweet Inspirations.

Our beginnings were humble, but the Sweet Inspirations would end up changing the world of background singing. It all began in 1967, when we were chosen to work with Aretha Franklin on her newest record.

In some ways, I felt I knew Aretha before we even met. As a child I had listened to her father, Reverend C. L. Franklin, on the radio, and years later the Drinkard Singers had performed on programs where Aretha was featured. Her records may not have had the sophistication of Hal David and Burt Bacharach songs, but they had something else, a gospel fire that was missing in most popular music. Like me, Aretha—who I called "Ree"—had grown up in the church, so we shared that sensibility. We just understood each other, musically and otherwise.

I loved that gospel fire in her songs, and we loved singing

with each other, as something magical always seemed to happen. Jerry Wexler at Atlantic Records called it "a communal thing": I'd spend a lot of time working out the background parts on Aretha's tunes, and she'd give me the freedom to put my two cents in. All that time I'd spent learning from producers Jerry Leiber and Mike Stoller paid off when I started improvising our backup parts—something background singers just didn't do at that point.

When I first started doing background, session singers would come in, sing whatever the producers told them to sing, and go home. But the Sweets began shaking things up. For one thing, although most groups had three members, I added one more, a fourth voice that would double the part that I sang on top, but an octave lower. That low fourth voice made for a much fuller sound than other backup groups had—and nobody at the time figured out what we were doing to make that sound.

We also started changing the parts that we were given to sing. I wasn't pushy about it—we'd sing whatever parts they gave us. But if something didn't work as well as it could have, I'd ask if we could try something a little different. And most of the time they'd say, "Okay, Cissy, do what you do."

So I'd ask them to play a track, and I'd listen until I got a feeling for where the song was going. I'd try different things in my head, and keep on listening until I felt I had something good. Then the girls would gather around and we'd go to work. I'd say, "Let's try this," and when we started singing together, that's when things would really start to flow.

Usually, we'd have to change things around a few times until we got it right. I'd use the lyrics of the song, the story

the songwriter was telling, to trigger things in my mind—it was kind of call-and-response. I'd listen to the melody and words, and then come up with a corresponding line that would bring out what the artist was singing about. It could be very simple—if the line was "Do you love me," we might follow it with "Yes I do." The goal in backup is to find a way to make a good song sound great. And the girls in the Sweets were right on it.

I always believed that you have to feel what you do—that you can't just go in and sing words without really *feeling* the song. That was something I learned singing in church, so when I became a contractor and started putting together the singers for sessions, I chose people who came from backgrounds like my own—from the church. Producers liked what I was doing, and, after a while, they figured out that if they'd just let me handle it, the backgrounds were going to be outstanding. And that's how background singing became a real industry, where people did more than just show up and go through the motions. It became a respected profession, and the Sweet Inspirations became the industry's firstcall background singers.

Of course, there were the occasional young producers who didn't know us, who would say, "No, I'll tell you what to sing." I'd just nod my head and we'd do it the way we were asked. A lot of times, the artists would be laughing and whispering to themselves because they knew that the material and the approach weren't even close to what we could have come up with. And even when those young producers tried to keep us in line, most of the time I'd find a way to get my own ideas into the songs.

So, that's how it all began, with Aretha. Singing background for her felt special, because we had a real rapport together; I could feel what she was trying to do, and I riffed off that. All the songs we recorded during those early sessions, including "Chain of Fools," "I Never Loved a Man," and "Since You Been Gone," ended up being big sellers.

But my favorites were "Natural Woman" and "Ain't No Way," which had one of the best background lines I ever sang. At first, we were stumped for ideas on "Ain't No Way," and then John suggested that I thread in a high solo part behind Ree's lead. I thought he was crazy, but we tried it, and those lilting high notes provided the perfect contrast to the melancholy in her voice. Later, during a performance at Lincoln Center in New York City, the audience gave Ree and me a long standing ovation after we sang that song. It became one of my signature performances with her.

Great things started happening for the Sweets. We released our first single, the Pops Staples tune "Why Am I Treated So Bad," and we also recorded with Van Morrison, doing the backup for one of my favorite songs, "Brown-Eyed Girl." And although I didn't want to go away and leave my children, the Sweets and I agreed to go on tour with Aretha, both opening for her and backing her. As an incentive, Atlantic promised to let us cut our own gospel album after the tour. So we went into the studio later that year to record our first gospel set, *Songs of Faith & Inspiration*.

But one of the best things that happened in 1967 came after an appearance we made at the Apollo Theater.

We were singing background for Tommy Hunt, whose song "Human" had been a big hit, and sitting up in the bal-

cony was a sixteen-year-old boy playing hooky from school. A legendary place in the music world, the Apollo used to have five or six shows a day, particularly on Wednesdays when the amateur show would take place. Each of their shows had about five or six acts or artists, who would play three or four songs apiece until the headliner would do a whole forty-minute set. This teenage boy playing hooky happened to arrive at the Apollo just in time to see the Sweets come out onstage in our flowing yellow chiffon gowns. When he heard us sing, he decided he had to somehow get backstage to talk with us.

And that's how we met Luther Vandross. He walked right up to me backstage and said, "You all are the best singers I've ever heard!" I was sucking on a piece of candy to soothe my throat, so I took it out and said, "Thank you, baby." That moment marked the beginning of a beautiful, close friendship. Luther was just a high school kid then, but he would end up working with Nippy and me as a backup singer when Nippy was a teenager. Later, after he became a star himself, Luther always insisted that the Sweet Inspirations sing background for him whenever we were available.

That was the thing about the Sweet Inspirations—we were known throughout the industry for great work. Everybody was trying to make a hit record, and a lot of times, the background was what put a record over the top and made it a hit. We always tried to make the background memorable, to make it something that people would sing along to when they heard the song. And we were professionals: We always got to a session on time, and we finished in the allotted time.

We were the baddest four girls in town, out of town, all over town!

So, 1967 was a great year in many ways—but it brought some frightening times, too.

One night, while I was in Las Vegas on tour with Aretha, I couldn't sleep. I didn't know what it was, but I could just feel that something was wrong back home. It was very late in Newark, but I called anyway. John answered the phone, and right away I said, "What's wrong with my baby?" Meaning Nippy, who was then four years old.

"Nothing's wrong," John said. But I could tell by his voice he was lying.

"You better put her on the phone right now," I told him. I wasn't messing around.

I could hear his muffled voice saying something to her, and then she got on the phone. "Hi, Mommy," she said, her voice quiet and raspy and her diction funny. Something was very wrong—the child could hardly talk!

"Nippy!" I said. "What is wrong with you? What happened?"

"Nothing, Mommy," she said. "Don't worry. I'm fine."

"Put your daddy back on the phone, baby," I said, trying to control my temper. If I was going to yell at anyone, it wasn't her. It was my husband, for letting who-knows-what happen to my little girl while I was two thousand miles away.

When John got on the phone, I snapped, "You better tell me right now what the hell happened to Nippy!"

He sighed. "She's all right, Cissy. She just fell down, you

know? She's fine." But when he told me the details, I wanted to kill him. It seems that Nippy had been playing with Michael, running around the house and acting silly like they usually did. But for some reason, she'd stuck a wire coat hanger in her mouth. When her father yelled, "Stop that running!" she did—but she fell down and the hook of that hanger rammed right back toward her throat.

She screamed and yanked it out, and blood just started gushing out of her mouth. She ran to her daddy, and when John looked into her mouth he saw a nasty gash far back in her throat.

John drove her to the emergency room at nearby Beth Israel Hospital, and the doctors told him she was lucky—the hook had just missed piercing her vocal cords. He held Nippy while they stitched up her wound and filled her mouth with surgical packing, and they'd just gotten home from the emergency room when I had that bad feeling and called home.

John apologized for not being more careful, but even though I knew there wasn't much he could do to slow those kids down, I couldn't help myself—I was so mad, and being that far away from my baby, I felt helpless. I couldn't just leave the Sweets and come home, but for the rest of that tour with Aretha, I called home even more often than I had before. When I finally got back, Nippy's stitches were out and she sounded normal again. I remember thanking God and thinking that Nippy's escape from more serious injury had been a miracle.

And 1967 brought frightening times not just to our family, but to the entire city of Newark, too. Drugs were spreading everywhere, even creeping into our cozy little village on

Wainwright. The city was tense from the rise in crime and frustration with a civil rights movement that was moving a little too slowly and deliberately. In July, that tension exploded in seven days of violent rioting and looting that made national news.

Our home wasn't in the center of it, but we were close enough to smell the smoke, see the flames soaring above the Central Ward, and hear the pop-pop-pop of gunshots. At night we could hear footsteps of people running along the cobblestone streets, and the sound of gunfire. Our neighborhood no longer resembled the safe haven we had envisioned for our children.

After the riots, John and I started thinking about leaving Newark, but we knew that buying a new home would cost money that we just didn't have. I was stuck in a frustrating cycle—I was the family's main breadwinner, so despite wanting to spend more time with my children, I had to stay on the road. Atlantic kept recording the Sweets and trying to promote us, but they really wanted us to tour to promote the music. Our family needed the money, so I kept on working and touring. But I really wasn't happy about it.

And the touring itself had its ups and downs, too. For our road trips, Atlantic supplied us with a car because I didn't like riding on the bus with the rest of the crew—I never could stand the smell of marijuana and didn't want to be around it. Sometimes, if we could get our friend Phyllis Hardaway to take care of the kids, John would come drive the car and help manage the Sweets. During those times, we toured together all across America, mostly in the South and in Texas.

This was the South of the late 1960s, and we faced racism on the road at just about every turn. Black people often couldn't find places to stay, and even when we did, the people in the hotels were sometimes flat-out nasty to us. We had some close calls as we traveled through the South—just trying to get something to eat in one of those Jim Crow restaurants could lead to trouble. And forget about calling the police, because they were often just as hostile to us as everybody else.

Once, after we played a show in Texas, the two-bit, racist promoter didn't want to pay us the money we were owed. John started arguing with him—actually, all the Sweets did, because we were women who didn't take any stuff. Our pianist, Bernie, also carried a gun for extra protection, although it didn't have a firing pin, so it was probably more likely to get us into trouble than to get us out of it. Bernie was quick to wave that thing around, though, and with what I'll call a little aggressive coaxing, we managed to convince that promoter that he should pay us our money. And he did.

It wasn't all rough times on the road, though—we had a lot of fun, too. I loved all the Sweets—Sylvia, Myrna, and Estelle—and John was a good addition, as he liked to cut up and joke around with everyone. We'd laugh at Bernie, who in addition to playing the piano and waving his gun around was also the wardrobe man, because he always managed to leave something important behind. We'd be getting ready for a show, and Sylvia would yell, "Bernie, where's my hairpiece?" and he'd just shrug. She'd tell him off using some choice words, and we'd all laugh so hard.

One night, a girl named Deirdre was filling in for Myrna.

54

We were performing in these beautiful beaded shrimpcolored gowns, and as we were on stage, singing our hearts out, I happened to look down at Deidre's feet. Beneath the hem of that gorgeous gown, she was wearing plain brown loafers. Well, I nearly had a fit right there onstage. After we finished, I gave Bernie hell for that and told him never to do it again. Fun and games were okay, but we were professionals, and I was determined that especially onstage, we would look and act like it.

In fact, the Sweets and the band used to call me "the general," because I insisted on having things done the right way. I was the oldest of the four women in the Sweets, and I felt responsible for them, but besides that, I just like for things to be in order. Estelle and I were usually on the same side about that, and Myrna and Sylvia were a little more slack. Whenever we needed to, though, we all came together as one. The main thing was that we loved singing—and we loved singing together.

All of that touring and performing paid off. In 1968, besides promoting our own singles and album, the Sweets got to work with some of the biggest names in the music business. We went to Nashville to do a session with Dusty Springfield, and we also did some studio work in New York with Jimi Hendrix on his *Electric Ladyland* album. And finally, the next year, we got to work with the biggest name of all, Elvis Presley.

When Elvis came back to the stage after doing movies, he wanted the Sweets to come to Vegas and back him at his first big gig at the International Casino. At first, we couldn't believe it. But Elvis had heard our music back when the

Drinkards sang at the Newport Jazz Festival, and I guess we made an impression on him, because he still remembered.

Anyway, the promoters flew us all out to Vegas in July 1969, and they set us up with a big suite at the hotel. When I first met Elvis, my mouth just fell open. This was before he gained all that weight, and he was a gorgeous man—I mean *drop-dead* gorgeous. And just the sweetest man you can imagine.

John came with us to Vegas, and he and Elvis hit it off. John charmed Elvis's managers and crew, too, which would end up paying off for us down the road. While the Sweets would be rehearsing with Elvis, John would meet with "the boys" (and they really were good ol' boys) in the coffee shop and chat with them. He learned a lot from those guys, as they'd been working in the entertainment game for more than a decade and knew it from the bottom up. John was able to put that information to use when I started as a solo act, and again later when Nippy's career took off.

John just had a way with people—he was charming and could get along with anybody. I remember him hanging with Elvis during rehearsal breaks, joking about stuff most people would never have brought up. John would say things like, "Now, Elvis, are you sure you're not part black? 'Cause you sure got a lot of rhythm, man." Elvis would give him that aw-shucks smile and come right back at him. "I don't know about that," he'd say. "But John, you do look kinda like my uncle. You'll have to ask my daddy." We'd be cracking up, just watching the two of them go at it.

I loved performing with Elvis, but in Vegas you do so many shows in a row that the repetition can get boring. So

after a while, I'd start throwing in obbligatos—improvised counter-melodies that floated up over the melody. Whenever I did it, Elvis would always smile and look back at me. He'd tease me about it, too; he said there was something about the sound of those obbligatos that made him think I was squirrelly. So he started calling me "Squirrelly"—his special nickname for me.

Elvis loved singing gospel, and I think he felt something special about having four church sisters singing along with him. After the shows, when you'd think singing was the last thing on our minds, we'd all gather together and jam. And I don't know if I'd ever met anyone who was as generous as Elvis was. He'd give people things for no reason—even people he barely knew. He gave all the girls in the Sweets lovely diamond bracelets. Mine was solid gold, and inscribed on the outside "To Cissy," and on the inside, "Squirrelly." I still have it.

I heard later that Elvis gave one of the girls a car; I believe it was Myrna. There wasn't anything sneaky about it—I mean, he wasn't looking for anything from her in return. That's just the way he was, regular people, despite all the international fame. Elvis was always a gentleman when I knew him, though years later, the girls did kid me that he had a crush on me. All I could do was laugh and say, "Well, why didn't you tell me that when he was living, you know?"

We were with Elvis in Vegas for almost two months, and by the end I was missing my children desperately. I knew they were in good hands with Phyllis and Bae, and I'd call them every evening just before their bedtime. But it wasn't the same as being with them, and we all were suffering for it.

My oldest, Gary, never said much on the phone, but he was always one to keep his feelings to himself. And Nippy was so young, she was usually just running around the house, getting into some kind of mess she shouldn't have been into. Or she'd be watching TV or listening to Michael Jackson, her favorite performer.

My middle child, Michael, was the one I worried about most. From the time he was little, Michael loved family more than anything. Whenever he'd go to a friend's house for a sleepover, he'd call in the middle of the night, saying, "Come get me! I want to come home!" Michael was a momma's boy, something he admitted then and still admits today.

When I was gone on tour, Michael always took it harder than the other two. He'd cry so pitifully on the phone, and it just made me want to get up, go to the airport, and fly right home. It broke my heart, but there was nothing I could do. I'd just let him know what I expected him to do the next day, tell him I loved him, and remind him to make sure he prayed before going to bed. I didn't know what else to do.

Finally, in September 1969, the Sweets got a break from touring. While I was thrilled to get back home to Gary, Michael, and Nippy, I also knew the time had come to face up to the problem that was causing all of us such grief. Yes, touring brought in money, but being on the road was tearing me away from the most important things in my life. My children were growing up quickly, and I felt terrible not being there to help them with their problems, as if I'd just left them to find their own way.

Not only did I miss my children, but I'd also been forced to give up directing my beloved New Hope choir. And though

I'd promised my father I would always sing with the family, I was away so much that I could only do it on holidays.

I realized just how far I'd strayed from my family that year when my brother Larry suddenly got sick and fell into a mysterious coma. Larry had been my closest playmate growing up, and I was shocked and upset when he fell ill. I rushed home from the road and spent several days by his side, praying. Larry eventually came out of the coma, but he was never the same.

On top of everything else, life with the Sweets was getting more complicated. The times were changing, and Myrna and Sylvia wanted the Sweets to change, too—they kept pushing me to liven up our act with more revealing outfits onstage, because that's what other background groups were doing. I wasn't having any of that, as I saw myself as a mother and role model for my kids, first and foremost. I was onstage to sing, not bounce around and flaunt my business—but the pressure kept growing to do just that.

What could I do? If we ever wanted to get away from Wainwright, money wasn't just going to drop out of the sky—I was the one who had to make it happen. Touring with the Sweets was the only way I knew how to do it, but even that didn't seem like it could last forever. The situation felt impossible, and one night I went into my bedroom, shut the door, and just started crying. I cried, and I prayed, desperately trying to figure out how to fix this mess. After a long while, I finally realized that I couldn't, and that the only thing I could do was put my faith in God to take care of it. At that moment, I turned over my burden and trusted Him to show me the way. The next morning, I got up, readied myself, and packed a bag for a road trip that would take me away for a week. I said goodbye to Bae in the kitchen, finished my coffee, and started walking out to the car, where John was waiting. The kids were already outside playing as John put my bag in the trunk. I went to hug them goodbye, but when I reached down for Michael, he pulled away from me, plopped his little self down on the curb, and started crying. My heart felt like it might tear in half.

John called to me, "C'mon, now, Cissy. They'll be all right." I looked down at Michael, his sweet face streaked with tears, and reluctantly turned toward the car, to leave him as I'd done so many times before.

Just then, Gary and Nippy came running over and joined their brother; now all three were sitting on the curb, crying, and watching me through eyes filled with hurt. I looked at each of their faces, and that was it. Without thinking about the consequences, I walked straight to the trunk, pulled out my bag, and started walking back toward the house.

John yelled, "Cissy, get back here! We've got to go!" I may have heard him, but I certainly didn't listen. I just marched right back into the kitchen, with my children trailing behind me.

When John finally came inside, I looked at him and said, "I'm quitting the Sweet Inspirations."

CHAPTER 5

Life on Dodd Street

Z had finally done it—I'd left the Sweet Inspirations to spend more time with Nippy, Gary, and Michael. But now I had to figure out another way to make money. With ten years of experience doing backup, and the Sweets' reputation as a solid opening act, I decided it was time to try for a deal as a solo artist.

This is where all that time John spent hanging out with Elvis's people, and learning about the industry, came in handy. John was able to get in touch with Charles Koppelman, a veteran record man who was running the music division of a new label called Commonwealth United, and he pitched me as a solo artist. They signed me for a modest fifteen-thousand-dollar advance and we began recording right away—and in 1970, we released my first solo album, *Presenting Cissy Houston*.

With that advance we were finally able to leave the Wainwright neighborhood. John and I wasted no time finding a beautiful new home—a four-bedroom, white clapboard house at 362 Dodd Street in East Orange. The kids loved it, because not only did they have their own bedrooms for the first time ever, but the house also happened to have a big inground swimming pool in the backyard. And John installed a pool table in the finished basement, which was still big enough for me to use as a rehearsal studio. For all my worries about leaving the Sweets, things turned better than I could have hoped—this house was sensational.

I was still recording and doing session work in New York City, but because I wasn't constantly on the road, I could finally be more involved in my children's lives. And because we had that backyard pool, our house became a gathering place for them and their friends, so they were around a lot more than they had been at the old house.

That first summer, I think Nippy spent almost all of her time in the pool. Between that, the pool table in the basement, and John grilling burgers and hot dogs in the backyard, we always had a bunch of kids hanging around. They'd come over and eat with us and swim, and sometimes I'd find out that someone had slept in our basement without my even knowing it. Nippy, Michael, and Gary just treated everyone like family.

In fact, they were sometimes a little too friendly for my taste. They welcomed everybody, and anything they had, they'd share it with their friends. When I bought them clothes, shirts, or pants or whatever, they'd just give them to the other kids. I'd be saying, "What the hell are you doing,

giving your clothes away?" But that's just the kind of kids they were, all three of them. I think they felt a little guilty that they had so much—a nice house, a swimming pool, and anything they ever needed—so they wanted to share with kids who maybe didn't have so much. That was a generous idea, but I had to sit them down and tell them, "Mommy works hard. I don't mind you sharing, but let's not get crazy about this, you know?"

Ever since she was little, Nippy's first instinct was always generosity. I remember her watching television and seeing Michael Jackson—then in the Jackson Five—doing his thing. "Mommy," she announced, "I'm going to marry that boy."

"Really?" I asked.

"Yes," she told me. "I'm going to marry him, and I'm going to be a star, and I'm going to buy you a house."

"Well, thank you," I said, smiling at my little girl with her big dreams. "Thank you, Nippy."

I love my sons, but Nippy was the youngest, and a girl, and she was my heart. She was such a loving little girl, friendly, outgoing, and trusting from the time she was a tot.

When she was very small, I'd take her with me on errands to the bank or to the supermarket. I'd dress her up in cute little outfits and fix her hair with ribbons, and she always looked adorable. I had to keep an eye on her all the time, though, because she'd just walk right up to strangers and start talking. "Good morning," she'd chirp, talking to complete strangers like she'd known them all her life.

"Nippy!" I'd say. "You can't just walk up and start talking to people like that. You don't even know them!"

And she'd say, "Oh, Mommy, it's all right"—the words she always used when I pointed out something she didn't want to hear.

More than once, I tried to explain why it wasn't really all right, but she'd just look at me with those big eyes and say again, "Oh, Mommy." That was just how she was—she thought everyone was her friend. And that's why it ended up hurting her so bad later, when she found out that wasn't really the case.

As sweet and innocent as little Nippy was, my oldest, Gary, was growing up fast—too fast for my liking. At around the same age as my brother William had done, he started getting in with the wrong crowd and using drugs. And since John and I had agreed that I'd be the disciplinarian in the house, I had to deal with it. I told Gary that some of the friends he was bringing around didn't really have his best interests at heart. Of course, Gary was young and stubborn, and he didn't want to hear it. So, we had our clashes.

I even had to put him out once. I guess at sixteen, Gary thought he was already a man, but I'd told him to be home by eleven, and when he came home one night after midnight, he found the door locked. "Just go on back to wherever you came from," I told him through the door. "Because you are not coming in here."

Gary left, and when he didn't come home for a couple of days, it worried me half to death. I prayed for him, though, and when he finally came back and apologized, I just hugged him tight and tried to hold back the tears. I knew Gary thought I was tough on him, but that was how my daddy

had been with us, so it was the only way I knew how to do things.

Gary was a lot like Nippy in one way: He wanted everybody to like him. He didn't realize that some people never would, just because of who he was. He was tall, good-looking, a good singer, and a great athlete who would eventually go on to play in the NBA. But from the very beginning, kids would get on him because his cousin Dionne was a famous star and I was an entertainer. They'd say, "Oh, I guess you think you're all that!" Gary was introverted, and he didn't know quite how to deal with it. I think sometimes he felt like he had to come down a peg just to fit in. I always urged him to just be himself, and not to change for anyone just so he'd be liked.

Now, my younger son Michael didn't have that problem at all. He had a soft spot for his family, but other than that, he was tough—more like me. He didn't care what anyone thought, and he had a short fuse and wild temper.

Michael and Nippy were just two years apart, so they spent a lot of time together—and they'd fight and squabble like crazy, especially over curfew time. John would say, "Michael, you see those streetlights? By the time they go on, you better have Nippy home." So Michael would have to go out and find Nippy, and drag her home. Oh, she hated that she'd yell, "You black dog!" at him and put up a fight, and they'd end up punching each other and mouthing off all the way home.

To get back at him, she'd either tell on him or threaten to tell until he gave her something she wanted. We used to have family roundtable meetings, so John and I could find out what was going on with the kids. And when we'd sit them down and ask how things were, Nippy was always, "Michael hit me!" or "I saw Michael smoking a cigarette!" All he'd say was "I didn't do nothing!"

But the funny thing is, even with all that squabbling, it was obvious that Michael really loved Nippy. I knew that even though she tattled on him, he'd still take the blame for her sometimes when she did something wrong. I'd say, "Who did this?" And he'd just look up and say, "Yeah, Mommy, it was me." Michael wanted to protect Nippy which was a reaction she brought out in a lot of people throughout her life.

And they could be so funny together. When she was about nine or ten and thought she wanted to be a singer, she'd go down to my studio in the basement and put on my clothes. She'd have one of my gowns hanging off her and be trying to walk in my high-heeled shoes. She'd put on my earrings and even try to make herself up. Michael would come tell me about this, and I'd just say, "Don't stop her. Let her go!"

Then she'd somehow convince Michael and one of her cousins to pretend to be in a band. They'd have a broom and a bucket as though they were playing a guitar and drums. She loved Sonny and Cher at the time, so she'd dress up, put on one of my long wigs, pretend she was Cher—and then she'd do two or three costume changes, just like the real Cher. At the same time, she'd make Michael be Sonny which he hated—but he'd stand there all the same and sing, "Babe . . . I got you, babe!" over and over. She'd laugh and shout, "You're all off-key, Michael!" She had near-perfect

pitch even then, just playing around in the basement with her brother.

Other times, Nippy would want to play "ballerina," which meant that she'd go down the hallway, then get a running start and leap into Michael's arms like some kind of gazelle, just hoping he didn't drop her on her face. Or Nippy would be down in the basement by herself, singing and hollering so loud that John would come to me and say, "Can't you make that child shut up?!"

"No, I'm not making her shut up!" I'd tell him. "She's making her lungs strong. She wants to sing."

Those times in the basement were funny, but many years later, Michael told me stories about some of the mess they got into as children—and how fearless Nippy was. One time, in the weeks after the Newark riots, she caught him playing around the burnt-out buildings near our Wainwright Street house. John and I had specifically told Michael to stay away from that area, but of course he didn't listen. He piled up some old mattresses on the ground near one of the buildings, and then, with no common sense in his teenage-boy head, he'd climb up onto the roof and jump off.

Well, Nippy caught him one day, and she told him that if he didn't help her climb up onto that roof and let her jump, too, she'd come tell John and me what he was doing. Michael didn't want to let her do it, because he knew that if anything happened to her, I would personally kill him, but he brought her up on that roof with him. And then he went first, to show her how to do it—only when he landed, he busted his lip hitting it on his own knee. When Nippy saw Michael's bloody lip, she was too scared to jump. It took a while, but Michael finally convinced her to go on and do it, and she soared off the roof and onto those mattresses without getting a scratch. Luckily, she never asked to try it again.

Michael also told me about the time Nippy found out that he had "borrowed" John's car, a big, red, fishtailed El Dorado. We used to keep the keys under the mat, and everybody knew they were there, so it wasn't hard to do. When Nippy discovered that Michael had been out joyriding, she said, "You better take me out and let me drive, or I'm telling."

So while John and I were away, Michael got a pillow, put it on the driver's seat, and put little Nippy on top of it. He slid the seat up as close to the front as it would go, but Nippy could still barely reach the pedals and see out at the same time. She drove it up and down the street as Michael sat panicking in the passenger seat. And when they were done, Michael let out a big sigh of relief—until Nippy said, "All right! We're coming back out again tomorrow, right?"

"Nip! No way! We ain't doing this again," he said.

She just smiled and said those magic words: "I'm gonna tell." And so he took her out again the next day. I didn't know any of this at the time, of course. In fact, Michael didn't tell me about it until just a few months ago. He's lucky he didn't tell me any earlier—his little butt would still be sore.

We always had all kinds of mess going on at the house, and it wasn't always between Michael and Nippy. John was as bad as they were—he used to love to hide around corners and pop out to scare the kids. Or they'd be watching a scary

movie on TV, all snuggled up together, and John would suddenly shout, "Aaaaahhh!" They'd scream and giggle—and beg him to do it again.

We had a lot of laughter in our house. John would braid Nippy's hair into pigtails, and somehow one *always* came out much longer than the other. That child had the most lopsided-looking hair ever, but John just couldn't figure out how to make them even. And, even though I tried to dress her in nice clothes and little ribbons, she'd come back from school all smudged like a little tomboy. It was like a circus around our house sometimes.

During these years, John and I were really in love, but even so, we'd argue sometimes just like any other couple. Whenever we argued, we'd get to calling each other silly names and then just bust out laughing. Nothing ever seemed so serious that we couldn't laugh about it. I couldn't believe my good fortune, to be blessed with such a good husband who was a great father.

John and I took care of ourselves, and each other. When I decided one day that I wanted to stop drinking, John did, too. And for the next ten years, we really didn't drink at all. At the same time, I decided to quit smoking. I was never a big smoker—a pack might last me three days—but I knew it was terrible for me, especially being a singer. I was a little hoarse and I went to the doctor, who told me, "You can either sing or smoke." So one morning I just took my pack of cigarettes and threw it in the trash.

Well, you know how it goes—by that afternoon I thought, "Where are those cigarettes? I'll just have *one more*." I went looking in the trash and of course, the pack was gone. I

called Michael and Nippy into the room and said, "Did you all take those cigarettes to smoke?"

Nippy just looked at me all wide-eyed. "Oh no, Mommy," she said. "We took them out of the house to throw away, so you wouldn't be tempted by them anymore." Little Miss Innocent. I knew better, but Michael and Nippy stuck together on that story, so I let it slide.

When Nippy was a little girl, her life was pretty carefree. Between mixing it up with her brothers and playing around the house, she was never too far from people who cared about her. The same thing was true when she left the house, too. She and her brothers got to travel in private jets to see their cousin Dionne's concerts or visit her in Virginia. Dionne had two sons, and they always got so excited when Nippy came to see them. And I was so proud of her that I used to take her everywhere with me—even into Manhattan, to sessions at Atlantic. She'd hang with Aretha, who she called Aunt Ree, then run over and jump into one of the Sweets' laps. Everybody thought she was so cute and ladylike, they all made a fuss over her. She was a happy, happy child.

Things changed, though, when Nippy started at Franklin Elementary. I guess it was partly my fault—I was still dressing her in plaid skirts and buckskin shoes, and insisting she wear her hair in pigtails. That was the way I thought little girls should look, but as she pointed out to me later, I was dressing her right out of *Town & Country* when all the other girls in East Orange were dressing down, wearing jeans. They thought Nippy was acting like she was better than they were, and a group of them began bullying her.

70

I didn't know about all this until one day when Nippy came home at lunchtime. "My teacher says I don't have to go back to school today," she told me. I asked her why, and she told me the teacher just said she'd "done good." That didn't sound right, so I kept pressing her, and she finally told me that some girls had threatened to beat her up after school.

Nippy never liked confrontation, and she'd go out of her way to avoid it if she could. Like her brother Gary, she wanted to be liked—and she really couldn't understand it if someone *didn't* like her. I'd had to threaten to whoop Gary's butt myself one time when I found out he wouldn't fight back when some kid attacked him. It was only after I embarrassed him that he stood up for himself—and then he had to be pulled off that child.

I wasn't going to threaten Nippy that same way, but I was mad. I was angry at those girls for attacking my baby, because I knew she didn't do anything to deserve it. If Nippy was anything, she was *nice*. She loved people, and she just wanted everyone to get along. But these girls were taking her glasses and bending them up, and stealing things from her, like the gold ring engraved with her name that her cousin Dee Dee had given her. These girls were just plain bullies, and I wasn't going to stand for it.

Nippy might have been nonconfrontational, but I was not. And if you messed with any of my kids, you'd see very quickly just how confrontational I could be. I went down to the school and demanded that the principal take care of the problem. I also let him know that if he didn't, I would do so myself. I'm sure I made a scene down there that day, and that Nippy was embarrassed. But I was furious, and I really didn't care who knew it.

My protest might have helped some, but it didn't solve the problem. Those girls kept messing with Nippy, and she stopped telling me about it because she knew I'd be right back down there at her school making a scene.

"Mommy," she'd say, "I don't want you to-"

"Mommy nothing!" I'd tell her. "You have to be able to speak up for yourself, Nippy."

"But I don't want to fight. I just want us all to be friends," she'd say.

"Well, that's not the way the world is, baby," I told her. "Sometimes you have to just tell people to kiss your ass and keep on walking." I had somehow always known this, deep down, from the time I was very small. But Nippy didn't see the world that way, even in the face of mean girls and bullying. She was so trusting—she thought everybody was good. But I knew better. If people think you're weak, they'll go ten times as hard at you.

I tried to explain that to her, but she'd just say, "Mommy, you don't like *anybody*."

"Yes, I do," I'd tell her. "But if somebody doesn't like me, I don't care a thing about them. I'd like for people to like me. But if you don't, that's your problem, not mine." I tried so hard to teach Nippy that, because I was worried about her. I knew what kind of nastiness life had in store for her if she didn't learn that lesson. But I never could get through to her.

John didn't worry like I did—he just didn't get excited about things. If Nippy was really getting bullied, he'd just say to our sons, "Boys, take care of it." Looking back, I think

Nippy probably would have preferred that we all just let her deal with the problem in her own way, but there wasn't a chance of that happening. She was the baby of the family, and her brothers and I were going to get up in there and protect her.

And in the end, that's exactly what Gary and Michael did. While Gary was gentle, like Nippy, Michael was no joke—he was like me, ready to take someone on if they got in his face. He was always getting into trouble, getting into fights, because he wouldn't let anyone mess with his sister. He got suspended from school once because he went into a classroom, pulled a boy who'd been bothering Nippy out into the hallway, and started beating on him.

Sometimes, groups of girls would even chase Nippy home and threaten her. Usually, Michael would confront them and they'd run off. But one afternoon, I was the one who was home when six girls came walking up to our house and said they were going to whip Nippy's ass. I stood right up on our porch and called out to them, "You want to whip her ass? You got to whip mine first. Can you do that?" Those girls turned tail fast. They knew better.

After that episode, I told Nippy that if she didn't face those girls, they would never stop picking on her. "You have *got* to stand up for yourself!" I told her.

The very next day, those same girls followed her home again, and this time a few of them brought their boyfriends. Nippy and Michael met them in our front yard, and Michael said, "All right, c'mon. She'll fight any one of you, but I'm telling you right now that if you beat her, I will kick your ass." And you know, Nippy actually could have fought, be-

cause her brothers had taught her how. But that day, she didn't have to. Just standing up for herself worked, and the girls and their boyfriends went back to wherever they came from. Things eased up a little bit after that, although the bullying never really stopped—she had to deal with those girls all through elementary school.

I was proud of my boys for protecting Nippy, and I did think at the time we were all helping her out. But years later, as Nippy struggled with the cruelties and hardships life threw at her, I found myself wishing she'd grown a protective shell of her own. As one of eight kids, I always had to fight and scrabble my own way growing up—no matter what kind of mess came along, I was ready to fight. I sometimes wonder what might have been if Nippy had developed that kind of tough skin herself.

For as much trouble as she had with the other girls, Nippy was a good student, smart as a whip. During that time, she would talk about wanting to be a teacher, like her grandmother Elizabeth Houston had been. So, when she wasn't making Michael and her cousins play the bucket and broom as musical instruments, she'd get them to play along while she pretended to be a teacher. She'd stand in front of them and scribble on a little chalkboard we'd bought her, and they'd sit there watching intently like good students. If they stopped paying attention, or started giggling and playing around, she'd walk right over and smack them upside the head with a ruler. The boys thought this was hilarious, but if they giggled, she'd just keep whacking on them and shout, "You got detention!"

74

And I mean, you could hear those whacks all over the house. I'd hear this whack-whack-whack and come down the hallway—and when I saw those boys sitting there, letting Nippy beat them with a ruler, I said, "What the hell are y'all doing?" I looked at those laughing boys and said, "You all are so stupid—why are you letting her hit you?" But they just loved Nippy, so I guess that was the price they were willing to pay to play with her.

By the time Nippy was eleven or twelve, she and I were spending a lot of time together. I'd take her to sessions with me, where she got a chance to hear singers like Chaka Khan, Aretha, Roberta Flack, and Luther Vandross. And the other place I took her was New Hope.

At first, she fought me over going to church, saying she didn't like it. After a while, though, I could see a change in her. I think the problems she was having with the girls at school made her more accepting of the church. At New Hope, no one made fun of her clothes, and no one seemed jealous of her.

But it was at New Hope that Nippy got saved. I wasn't with her at the time, but she told me later that she'd cried and accepted the Savior into her life and heart. And she never let go of that faith, even through all the turmoil and hard times to come. Nippy's faith was a quiet one—as an adult, she didn't go to church often, and she never did talk a whole lot about it. Yet she prayed often, and she always took refuge in gospel music, singing it to warm herself up before performances. I know her conversion was real and lasting, and knowing that gives me strength.

Though her faith started to play a bigger part in her life,

her education was becoming a cause for concern. When Nippy got to the sixth grade, John and I started to worry about the quality of the instruction she was getting. At Franklin Elementary, they'd started some kind of "open classrooms" curriculum, where students could wander around and study at their own pace. I didn't like the sound of that—what kind of atmosphere was that for a child to learn in? A bunch of kids just doing their own thing, talking and wandering around?

I'd told Nippy that John and I were thinking about sending her to Mount Saint Dominic Academy, a Catholic school in nearby Caldwell with a good academic reputation and more traditional teaching methods. She didn't want to go, and she begged us to let her stay in public school. That is, until one day when I came up to Franklin for something and all the kids were running around in that "open classroom," just cutting up and yelling. Nippy saw me coming and, as she always told the story later, "I knew my ass was on the way to Catholic school."

She didn't want to go to Mount Saint Dominic's, but we didn't give her a choice. I was the mother and she was the daughter, and that's just the way it was—when you're a child, you don't get to make all your own decisions. But around this same time, there was another decision Nippy was making for herself. And that one, I didn't think I could stop.

Nippy had been hinting for a while that she wanted to sing professionally, but at age twelve, she told me she was sure. I tried to discourage her, as I knew how hard and how cutthroat the music business was. I wasn't sure if my sweet Nippy, the girl who wanted so badly to be liked and was so

easily bullied by her schoolmates, could face the rigors and meanness of that world. No matter how much I tried to talk her out of it, she held firm.

When I realized how determined she was, I finally said, "Okay. Then I'll help you." But I also told her there would be rules.

If she really wanted to sing, she had to learn to do it the *right* way. That meant rehearsing every day and singing with the choir every Sunday—no exceptions. At choir rehearsals, I constantly pushed her to aim higher and be better. I was tough on her—tougher than I would have been with someone who wasn't my own daughter. She'd get frustrated, and sometimes I felt bad about it. At the same time, this was the way I'd been taught by my sister Reebie—no playing around—and so that's how I did it, too.

"You have to know the melody," I'd tell her. "There's a reason the person who wrote the song wrote it that way, and you have to know it to sing the song properly." Once you learned it, then you could ad-lib and create your own flourishes, but I made sure Nippy would always know the melody backward and forward for any song she sang.

I also taught her to enunciate, to really pay attention to the words and make sure people listening could understand what she was singing. Because every song has a story—and if it's not a story, it's not a song. People write what they write for a reason. You owe it to them to perform the song in a way that puts their vision across. "Enunciate!" I would snap, if she was mealy-mouthing the words. I wanted her to really feel what she was singing—because otherwise, what was the point?

In teaching, you're often criticizing, because you want to help the person to do better. It's not always enjoyable, for either the teacher or the student. Nippy would sometimes say to me, "Mommy, you make me feel like I want to go through the floor, like I'm never going to be good enough." And I would say, "Baby, that's not my intent. I just want you to be the very best that you can be." And we'd keep hammering away.

Gary had a beautiful voice, and I taught him, too, at least for a little while. Eventually, though, he couldn't take it. "Mommy, you're too hard," he'd say, and eventually he gave up. Nippy thought I was hard on her, too, but really it was just that I wouldn't let her relax and get lazy. "You gotta represent!" I'd tell her. "You wanted to do this, you are going to do it right!"

She didn't like it, but she hung in there, listening and learning when she could easily have spent her time out socializing or partying. She didn't do much of that, partly because John and I didn't allow her to date—though John was a little less strict than I was, so she'd sometimes try to get permission for something by going to him instead of me. But more than that, she was truly dedicated to singing, so she accepted my rules and stuck with it. Sometimes she'd get so mad that she wouldn't even speak to me, but she was always ready for rehearsal the next day.

After a few months of intensive teaching, Nippy made her solo debut at New Hope. I couldn't be there that Sunday, as I had been called away at the last minute for an out-of-town performance. But John was there, and he, my sisters, Gary and Michael, and everyone else said Nippy absolutely tore

78

that place down. "There wasn't a dry eye in the church," John told me.

I was so sorry to miss her first solo in church, but I was there for the next one, and I saw what everyone was talking about. Let me tell you—in a black church, you don't have to wonder how people feel about things. If they like something, they'll be shouting and hollering and carrying on all the way through. And that's what they did when Nippy sang. Because there was something in her voice that no one could teach—it was partly genetic, but it was something else, too. It was something unique.

CHAPTER 6

Training the Voice

ippy and I were as close as we'd been since she was a little girl, but our relationship was changing now it was no longer strictly a mother-daughter thing. I was still "Mommy," of course, her parent who would guide and discipline and love her, but now we had a shared purpose beyond that. I continued to worry that the entertainment business was low-down and doggish, but Nippy wanted to sing, so I was committed to helping her, and we spent many hours together working on her technique.

At the same time, Nippy was having trouble adjusting to the Catholic school. She hated it and kept begging us to let her switch to the middle school in East Orange, where all the kids she knew were going. I made her stay right where she was, though. Mount Saint Dominic was different—smaller, with a more disciplined environment in the classroom—so I thought it would be better for her. And as we had hoped, her grades improved there.

These were such good years—I had steady work, John and I were happy, and the kids were growing up. But just as I'd learned as a little girl, even if things are good, you never know what's around the corner. And on one evening in September 1976, that proved as true as ever.

John had driven me into Manhattan to sing at one of my regular places, a jazz club on the Upper West Side called Mikell's. By the time we drove all the way back to East Orange, I was tired, so I went straight to bed. A little bit later the phone rang, but I didn't hear it—I was already sound asleep. Nippy woke up, though, and she picked up the phone. "We think your father is here at the hospital," the person on the other end told her. "We believe he's had a heart attack."

Nippy figured it was someone playing a joke. "My father is in bed sleeping," she said, then slammed the receiver down.

Seconds later, the phone rang again.

"Please, don't hang up!" the same voice said. "I need to speak to someone there. We believe we have Mr. John Houston here in the hospital."

This time, Nippy tiptoed into the bedroom to check. When she saw that her father wasn't in the bed, she hurried to shake me awake.

"What are you doing?" I snapped, but as soon as I saw her face I knew something was very wrong. Her eyes were wide and scared, like she'd seen a ghost.

"Mommy, something's wrong with Daddy," she said, and burst out crying. I got up and hurried to the phone, dreading what I might hear.

When the voice at the other end told me John had suffered a heart attack, a bolt of fear shot right through me. As quickly as we could, Nippy and I caught a cab to the hospital—our car wasn't in the garage, as John had apparently driven himself to the emergency room. All the way there, I just kept thinking that if John was dead, I didn't want to keep living.

Bae met us at the hospital, and a nurse took the three of us to see John in the emergency room. Nippy just broke down crying the minute she saw him, so Bae took her hand and led her gently out of the room. Lying there hooked up to all those tubes and monitors, John looked more frail and weak than I'd ever seen him. He had always looked so big, strong, and confident, but when he took my hand and tried to smile he just looked small and scared.

I had only seen that look on his face once before, on a flight from Madrid to Lisbon during a tour with Aretha in the late sixties. John was sitting beside me, and the Sweets were behind us, asleep. We were halfway to Lisbon when I noticed that the plane was descending fast—way too fast. Across the aisle, a few people started nervously straining to look out the window.

I turned to John and said, "Wake up, I think the damn plane's gonna crash!"

When I saw the expression on his face, it was obvious that he'd felt the plane dropping, too. John was already light-skinned, but now his face was pasty white, absolutely drained of color. And there were no tough-guy zingers or funny comebacks now—he just nodded and silently turned to stare out the window. A few seconds later, he looked at me and asked, "How does the rest of 'The Lord Is My Shepherd' go?"

I thought he might be joking, but he was dead serious. We began reciting the twenty-third psalm together as the plane kept on falling. Suddenly, about halfway through the psalm, the plane jerked before leveling off and beginning a slow climb. John exhaled with relief and grabbed my hand, holding it so tightly it hurt.

A minute later, one of the Sweets woke up. She leaned forward and whispered, "Cissy, I had a dream that the plane almost crashed." I didn't want to scare her, so I didn't say anything. But later, I told her that, no, it wasn't a dream—we had nearly crashed. After that, John and I rarely flew together. My worst fear was that something would happen to both of us, and our kids would be left alone.

Now, looking at John's scared face as he lay in that emergency room, I feared that our kids might be left without their daddy.

Over the next few days, the whole family spent day and night at the hospital. Gary was away on a basketball scholarship to DePaul University, but Nippy, Michael, John's parents, and my sisters were there practically the whole time and we all were praying constantly for John.

After a week or so, John seemed to be getting stronger, and the doctor finally said he could go home, but when we got home, I could see that something was different. The doctors had told me that after the heart attack, John's personality might change—and it certainly did. That's when all the bad stuff started happening between us.

John might have been fifty-six, thirteen years older than me, but he was not an old man. The heart attack came as a complete surprise, and it forced him to step back and review his life. I guess he might have been having a midlife crisis, but from that point on, John seemed to feel he hadn't accomplished all that he should have. He was an ambitious, intelligent black man caught up in a world where black men weren't permitted to achieve all they could. I think he felt cheated-robbed of the opportunity to really express himself. John always felt that if he'd been white, he would have made it big, but those who held the power just wouldn't let people like him in. Like so many black men, he was angry at the world, bitter about being denied. While John was happy to be alive, that anger just sat boiling within him. And soon, he wasn't just mad at the white establishment that had held him down. Soon, he began spewing his anger at me.

John decided that stress had set off his heart attack—and that I was the cause of much of that stress. With Gary in college and Nippy in private school, our expenses had soared, so John had been forced to take a nine-to-five job at Newark City Hall to help out. This meant he was working all day, then driving me back and forth to gigs in New York, too. It was a lot on his plate.

Making it worse, he always believed that I could have gone much further and earned much more—even become a star—if only I'd allowed him to push me as a solo artist. John believed that while background session work was fine, the real way to make money and beat the system was as a solo artist. He thought I was just being stubborn, not letting him push me to that next level. Well, I didn't agree. In fact, I had my own anger about how "the man"—in this case, the record industry—had treated the Sweet Inspirations. We turned out consistently high-quality work, became the standard for backup singers, and produced some great solo records. So we should have gotten a lot more support, from the arrangers to the producers to promotion. But for whatever reason, the labels never gave the Sweets the same kind of support they gave to acts that they really wanted to see make it.

Then, of course, there was the racist side of the business. The suits expected black acts to stick to rhythm and blues they didn't want us singing show tunes or pop. They wanted to keep black acts in a tidy little box, make sure we didn't get close to that exclusive white club where only the Sinatras and Streisands were allowed to enter. I mean, in what other industry could you have special divisions for black people? Those "Black Music" divisions are the clearest example of all that racism alive and well in the music business.

If the recording industry had treated groups like ours fairly, the Sweets would have done just fine. We added value to so many recordings, and we helped boost their sales like no other background group could. If we had been compensated properly for that, I wouldn't have had to pursue a solo career to make it big in the music business. And that would have suited me just fine, because the truth is, I never wanted to be a solo star, no matter how hard John pushed me. Because I knew what it could do to your life.

I'd seen what happened to good people who found themselves in the whirlwind of fame—there were so many pitfalls, so many distractions. I'd seen too many people get

86

taken in by the fanfare, thinking they were so big, so grand, that they forgot what was important in life. These weren't bad people, but in that world, fame and stardom can slip up on you and turn your life upside down. I just didn't want any part of that for myself. I liked my life just as it was, with my children, my husband, my home, and my church. I didn't need anything more than that.

John never could understand that, especially after his heart attack. He was feeling his mortality, and I guess it made him want to leave a bigger mark on the world. Suddenly, the fact that he hadn't been able to was somehow my fault. Either that, or he was just so angry at the world—a world that he couldn't change—that he decided to take it out on me. Whatever it was, John started acting like I was the one who'd held him back and helped create all that stress and then his heart attack.

When John first started making comments to this effect, I thought he was either joking or had lost his mind. I loved him, but there was no way I was taking responsibility for his illness. I couldn't believe he was serious about it, but he was. And that's when our relationship began to change. John and I had always had arguments, little verbal scuffles where we'd challenge and tease each other and then make up. Soon, our fights became more intense, and it started to take longer for us to make up. The fallout would end up affecting not only us, but Nippy, Michael, and Gary, too.

I kept on working Nippy hard—the only way I knew how to mold her. There were times at choir practice when I really got on her. She'd get mad at me, but most of the time she'd keep on going. Every once in a while it got to be too much for her, and we'd fight all the way home.

Once, when we'd argued all the way back to the house, she stormed out of the car, screaming, "I quit!"

I wasn't having any of that. "No!" I snapped as I followed her up to the front door. "You gave up *that* right a long time ago, when you told me you really wanted to do this!"

Right from the beginning, I had tried to talk her out of trying to become a professional singer. If she had walked away then, it would have been fine. But once we were in it, I was not about to let her back down.

Each time we fought, though, Nippy would bounce right back more determined than ever. She soaked up everything, watching me at rehearsals and recording sessions, picking up little things I'd do, and then trying them out herself the next time. All the artists loved her, and it wasn't long before a couple of them asked her to sing background on their records. When she was a young teenager, I let her do a few sessions, which I strictly supervised. She was a natural, right from the beginning.

When she'd had enough practice, Nippy entered the Garden State Competition, a singing contest for New Jersey teens. We spent months preparing, finding a dress and choosing just the right song and arrangement. We finally decided on Barbra Streisand's "Evergreen," and at the end of the competition, after hundreds of other girls had been cut, it was down to Nippy and one other girl—who, ironically, sang "The Greatest Love of All."

Nippy was a better singer than the other girl, but her timing was off that night and her song ran longer than the time

limit. The judges punished her for it, and Nippy ended up in second place.

She was so upset, but I just told her, "You came in second, and you know you can do better. And next time, you will." She still looked sad, so I pulled her to me and said, "Nippy, you're good now. But one day, you'll be the best." And I wasn't just talking, trying to make her feel better. I truly believed it.

Many years later, after Nippy released her hit version of "Greatest Love of All," she and I happened to be in a coffee shop where we saw the girl who beat her. She was beside herself at getting to meet Nippy, and we all three had a chance to talk for a little bit. It must have been discouraging for her to know that the girl she'd once beaten all those years ago was now a global superstar, but Nippy and I both told her the same thing that day—to just keep on singing.

It wasn't long after the Garden State Competition that Luther Vandross got in touch with me. While the first time I'd met Luther, he was just a high school boy playing hooky and coming to see the Sweets backstage at the Apollo, now he was a rising young singing sensation. Luther had just signed to do an album for Cotillion Records, a subsidiary of Atlantic, and he wanted to know if I would consider doing the background. I agreed, and brought Nippy to the session with me—and she and Luther hit it off the minute they met.

Luther became a dear friend, and he was also a big influence on Nippy during her teenage years. He gave her tips about the business—things like how to handle situations on the road and in the studio. He was a terrific vocalist, but I was just as impressed by the no-nonsense way he worked.

Luther was for real; there was absolutely nothing phony about him. And he was a taskmaster, like me. He wouldn't take no stuff from anybody.

In fact, Luther got to the point where he insisted on having me do background on his records, so I worked with him and his group—Brenda White-King, Fonzi Thornton, and Cindy Mizelle—all the time. We had so much fun together, and eventually Luther became like a brother to me. We always called each other when we were on the road—we'd laugh and joke about whatever was happening at home, and then he'd tell me all the dirt about what was happening on the road. I'd always fuss if he didn't call soon enough, and then the minute we were both back in town, we'd call and get together.

At around the same time, Nippy was doing background for some cuts on Chaka Khan's 1979 album, *Naughty*. She was learning so much so fast, getting better and more confident every day, so by the time she was fourteen or fifteen, I started bringing her with me to nightclubs, too. I was appearing regularly as a solo act in clubs like Sweetwaters, Reno Sweeney's, and Mikell's. I'd bring Nippy and her brother Gary, who had a wonderful voice, to sing backup for me.

Nippy was so good that after a while, I decided it was time for her to step out on her own—and not just in church. Though her voice was ready, she wasn't sure she was. She was shy, and just wanted to keep singing background for me. I knew if I just told her to do it, she'd only argue with me, so I came up with a plan.

One night before we left home for a show at Mikell's, I sat Nippy down and in a low, raspy voice, said, "Nippy, my

throat is killing me. I don't think I can sing tonight. But I can't leave Mikell's hanging, so I want you to go and take my place."

Her eyes got wide, and she just stared at me. "Aw, Mommy," she said, "you can do it!"

"No, honey," I rasped. "Listen to me, I can't even talk. I need you to do this. You know all the songs."

"But you always sing when you can't talk!" she whined. I could see she was scared now.

"No, Nippy, not this time. I'm sick and it hurts too bad," I told her. "Don't be scared—your brothers and your dad will be there. It's time, Nippy. You can do it!"

She argued with me a little while longer, but I wouldn't budge, and eventually she gave in. So John drove her, Gary, and Michael into the city, and that night marked Nippy's first appearance as a lead or single performer in a club. I was so nervous sitting at home—I desperately wanted to call the club and find out how she was doing, but I managed to stay away from the phone all night. I was nervous as a cat, but I hoped that having Gary back her up would help Nippy get over her nerves.

When they finally got home, John told me that she'd had a slow start but soon had the whole place jumping. "Nippy was fantastic," he told me, and then he couldn't resist teasing me—just getting in a little dig. "I don't know," he laughed, "but I think they might be hoping your throat is still bothering you next week."

The next morning, I hugged Nippy hard and told her how proud I was. This had been a crucial test for her, and she'd done better than even I expected. The girls and the managers

at Mikell's later told me that once she got started, she was as cool as could be. Everyone in the club was asking who she was, and no one could believe it was a first-time solo appearance. She was already acting like a seasoned veteran, like she owned the stage.

After that night, I never did worry about giving Nippy more lead time on the stage. She had shown that she was ready, that she wasn't afraid. From then on, whenever she appeared with me on any stage, I made sure she had a solo or was called up to sing a duet with me. She was on her way.

CHAPTER 7

Separation

fter Nippy's solo appearance at Mikell's, record industry people started sniffing around her for the second time. The first time was when she was just fourteen, when Arista scout Gerry Griffith offered her a contract after hearing her sing backup on the Michael Zager Band's hit "Life's a Party." But just as I'd done then, I put them off. It was just too early—I really wanted Nippy to have a chance to find out who she was and enjoy her teen years. "You'll thank me later," I told her, and though she may not have agreed with me, she had no choice but to accept it.

There was no way of keeping Nippy out of the limelight forever, though, and I knew it. She had just sung backup for Lou Rawls and Chaka Khan, and word was getting out that there was something special about her. And not only was she a great singer, but she was also beautiful. Even as a teen-

ager, without any makeup, Nippy was radiant. That's why I wasn't completely surprised that it was her looks rather than her voice that first pushed her into the spotlight.

I was appearing at Carnegie Hall at a benefit for the United Negro College Fund in 1979, and Nippy was singing backup for me. When I brought her out to sing a chorus of "Tomorrow" from the Broadway show *Annie*, she did a beautiful job, and we ended up getting a long ovation. There were photographers all over the place, and they were just snapping away—you know, I guess a mother and daughter onstage and a standing ovation make for a good story.

The next day I had a session in Manhattan, so I brought Nippy back into the city with me. We were walking along Seventh Avenue when a photographer from *Vogue* came up and asked if she had any interest in modeling. He'd taken some photos at Carnegie Hall the night before and thought she'd make a perfect teen model. "There's a new agency opening up," he told me. "You ought to go on over there and see them." I wasn't so sure about that, but I took the address anyway.

After he'd gone on his way, I looked at Nippy, with her beautiful skin and sweet smile. "Well, do you want to go?" I asked her.

"What do you think, Ma?" she said.

"Up to you," I told her. "If you want to go, we'll go." She nodded, so we walked on over to the address he'd given us. The agency was called Click, and they signed her that day.

The agency started booking modeling jobs for Nippy the very next week. She modeled all throughout high school, eventually switching from Click to the Wilhelmina agency,

and by the time she was a junior she was appearing in all the top magazines—*Vogue, Essence, Cosmopolitan, Harper's Bazaar,* and *Seventeen.* Her senior year, she was even on the cover of *Seventeen*—putting her among the first black women to have that honor. Photographers loved her because she was professional and easy to work with. She had as much modeling work as she wanted to do, though she did confess that she found all that standing around kind of boring. When she got to a point where it was too much for her, she'd just say, "Mommy, I got to stop now. I got to catch up on my schoolwork."

About once a week I'd let her get out of school to go do a shoot. But I'd always take her there myself, make sure she was okay, and then go to my job afterward. And when it was over, I'd pick her up and take her back home.

"I can do it myself," she'd say, trying to be all grown-up.

"Oh no you can't!" I told her. No way was she going to a photo shoot alone—I knew what happened in them doggone places, especially to beautiful, young, naïve girls. My baby needed protecting, and I planned to be there to do it. Yet as much as I wanted to protect Nippy, she was getting to be a young lady, and like any teenager she wanted more freedom and independence. She thought she was old enough to take the bus to and from New York by herself, and she'd beg me to let her do it.

One time, I did agree to let her stay a little while after a shoot, if she promised to catch a bus at Port Authority and be home in New Jersey by eight that evening. This was well before anybody had a cell phone, so when eight came and went . . . and then nine . . . and then ten . . . with no sign of

95

Nippy, I was frantic. I sent John out to drive around looking for her. And when she finally strolled on home, explaining that she'd only been window-shopping, I had to be stopped from giving her a good whipping.

Nippy and I may have had our moments, but we had a lot of fun together, too—like the trip we took together to Japan in 1979. I was invited to represent the United States at the Yamaha Music Festival, a song contest in Tokyo. I didn't want to go by myself, so I took Nippy with me—since she hadn't been abroad yet, I knew the trip would be good for her.

I wasn't too hip on flying, but Nippy loved it—she wasn't scared at all. The minute we got on the plane, she just closed her eyes and went to sleep, something that would become a lifelong habit on flights. Me, I just about went crazy for the fifteen hours or whatever it was to get to Tokyo. I was a wreck when we landed, and of course Nippy was raring to go. Her eyes just lit up as we rode from the airport to the hotel—she'd never seen anything like Tokyo.

We were staying at the Intercontinental Hotel, and when we arrived there I said, "All right, Nippy, we need to find a place to eat. Where do you want to go?"

"I don't know, Mommy, but I'm hungry," she said.

I'd seen a kind of deli-like place in the hotel lobby, and they had tuna sandwiches, so that's what we had. And that's what we ended up having the whole time we were there. I didn't feel like going in search of anything else, and Nippy liked those sandwiches. She was a skinny little thing, but she sure went to town on that tuna fish.

We were in Japan for ten days, and I took her everywhere

with me. I did a lot of rehearsing, and Nippy would always come along to watch; and when we weren't doing that, we were sightseeing. I got a massage in the hotel, but that Japanese masseuse just about tore me up—I thought my back would break and I'd never walk again. Nippy just laughed when I told her, and then of course rather than scare her away, my story just made her want a massage of her own.

Nippy loved Japan, even though she couldn't understand what anybody was saying and they couldn't understand her. But there was one moment when she got into an elevator with some Japanese people, and one of my songs was playing over the speaker. Nippy started shouting, "That's my mother! That's Mommy!" with a big smile on her face. They might not have known exactly what she was so happy about, but there was no mistaking that smile.

For my performance in the competition, I'd picked "You're My Fire," a song arranged by Michael Zager. The Yamaha Music Festival was big, with performers from three or four dozen different countries, a band of sixty or so pieces, and thousands of people packed into the stadium to watch. Nippy was in the audience cheering me on when I took the stage, and I have to say I sang the hell out of that song.

Bonnie Tyler won the highest award, the Grand Prix International, but I won the Most Outstanding Performance Award. Later, Nippy told me she was so excited that she was screaming, "Sing it, Mommy! Sing it!" all the way through my performance. It was a really special trip—one that neither of us would ever forget. Years later, Nippy would still tell people all about the fun she had on that trip to Japan with her mother.

Unfortunately, the joy from our vacation was short-lived. When we returned to New Jersey, things between John and me weren't going well at all—he and I were at each other's throats more than ever. We were fighting over the dumbest things anybody could think of—the dog hadn't been fed, or the car was nearly out of gas, or someone had forgotten to pick up the laundry. It didn't matter how slight the problem was. Everything turned into a knockdown verbal duel.

At this point, John and I weren't even really living as husband and wife anymore. For a while we were sleeping in separate beds, and as unimaginable as it would have been even a short time earlier, we didn't seem to have a reason to do otherwise. I didn't know it at the time, but John's ongoing health problems, which included diabetes, had a lot to do with our struggles.

All the strife was harder on John than on me. I at least had friends from church and the choir or my sisters that I could talk to, but John had few if any real friends. He had been Mr. Mom in our house for so many years that he was closer to our kids than to anyone else. But now Gary was in his senior year at DePaul in Chicago, and Michael had left for Hutchinson Community College in Kansas. Nippy was still living at home, but she was busy with school, modeling, and singing. So John didn't really have anyone to talk to.

I'd always been proud that we were raising our kids in a loving, Christian home, but now that stability was gone. John and I fought like crazy, and Nippy, as the only child left at home, was really suffering for it. She had grown up in a house filled with laughter, so all this fighting and arguing was something new. She absolutely hated to see us going at

98

each other—it really affected her, and some of her behavior started to change.

Even though Nippy was singing with stars like Aretha, Luther, and her cousin Dionne, and her picture was on the covers of fashion magazines, she started trying to convince people she was just an ordinary girl from the neighborhood. Trying to be like the other girls in East Orange, she started bragging about being from the projects, or "the bricks"—a habit that drove me crazy, especially since John and I had fought so hard to give our kids a solid middle-class upbringing.

Now, there's nothing wrong with being from the "bricks." A lot of wonderful people, including lawyers and doctors and everything else, come out of the projects. But I just didn't like that Nippy was lying about where she'd come from. I guess she got it from the summer John and I had spent with Elvis in Vegas—we had left her and Michael with our dear friend Phyllis who lived in Baxter Terrace, one of Newark's rougher neighborhoods. The kids were there for five weeks, so I guess in Nippy's mind that gave her some street cred, or something.

But oh, it made me mad to hear her say that. "What bricks?" I'd snap. "You ain't never lived in no damn projects! You ain't from no bricks. You're gonna get a brick upside your head."

I guess she was doing it to try to fit in, to find some kind of comfort outside a home that was now full of strife. Nippy started having a really hard time—her grades dropped, and she starting pulling away from John and me. She loved us, but she didn't want to be at home anymore because she couldn't take the fighting. Later on, she told an interviewer that she started "partying" during this time. I had no idea about Nippy's "partying" or anything else. But sometime during all of this, all three of my children fell prey to the lure of drugs and alcohol.

Gary was an all-American basketball player at DePaul, but he'd started to hang out with the wrong people and do a whole lot of crap he shouldn't have been doing. I even had to go check up on him in Chicago—Nippy was the one who told me he needed me up there. Gary really struggled with drugs, and ultimately they cut short a promising athletic career. He was drafted by the Denver Nuggets, but he played only one season in the NBA before drugs started affecting his performance. Gary could have been a big-time star, but instead he got cut—and later, he would end up in rehab. I know, because I'm the one who put him there.

I learned later that Michael had started doing drugs, too. Even though he wasn't living at home anymore, I believe he might have been the hardest hit by the problems John and I were having, as he was always the family's biggest cheerleader. Michael always loved those early days on Dodd Street, when John would grill burgers in the backyard and he and Nippy would spend happy days splashing in the pool with their friends. Nearly everything Michael did—from trying to run with his older brother to looking out for Nippy—was centered on family. He loved both John and me, and when he saw us fighting, there was just no way that he could take sides. He felt stuck in the middle, and torn.

Even now, looking back on this time with everything I've learned about Nippy, her struggles with drugs, and the signs of those struggles, I still have no idea if she started

using drugs back then or not. And the truth is, back then I didn't really want to know about it. I grew up in a time when young people would drink liquor if they wanted to get high—I don't think I ever knew anyone who did drugs when I was growing up. It was just something completely foreign to me, and I couldn't figure out why anyone would want to do it, as it just seemed to mess people up so much, to destroy their health and ruin their looks. I was too vain to want to do that, and I never could figure what people thought was so great about them.

John would sometimes say to me, "You need to learn more about this." So I tried to pay attention, to look for clues in our kids. I thought I was being a good parent, but I just didn't know the signs, what to look for. Instead, I just kept up my involvement in the church, prayed a lot, and tried to do the right thing. That turned out not to be enough, as all three of my children struggled with this demon that I just didn't understand.

It was around this time that Nippy met Robyn Crawford. I had told Nippy that she needed to get something to do—some kind of work in addition to modeling. So she got a job at a playground near our house, and she met Robyn the very first day.

I had a bad feeling about that child from the first time I saw her. There was something about the way she carried herself, a kind of arrogance, that I didn't like. Though she was a pretty girl, in my opinion Robyn wasn't as bright as Nippy. She also seemed abrasive and unapologetic about that. While Nippy would usually bend over backward to get along with

people—sometimes to a fault—Robyn had a strong, assertive personality and said exactly what she thought. As I would later learn, she was also gay, although that had nothing to do with why I didn't like her. I had my issues with her from the start, as I felt like Robyn could influence Nippy, and being the mother that I am, I didn't want her to lead my daughter to places that I didn't think were good for her.

I knew I didn't want Robyn around my daughter, and I told Nippy that. There wasn't much I could do, though. Nippy liked Robyn, and she was past the age when I could forbid her from seeing someone. Kids have a mind of their ownwhen they get older, they want to experiment with all kinds of things. I know there has been a lot of speculation over the years about the friendship between Nippy and Robyn and whether it was more than that. I don't honestly know what exactly went on between them, back when they first met or later on. Nippy never shared details of her personal life with me about things like that, but I do know that Nippy and Robyn cared a lot about each other. If I had to guess, I'd say that Nippy was drawn to Robyn's independence, her lack of concern about what other people thought. Nippy was fearless in a lot of ways, but she never stopped worrying about what people thought of her. I think she admired Robyn's ability to do whatever she wanted without worrying about anybody else's opinion.

Robyn also happened to come into the picture when Nippy was feeling particularly vulnerable. She still didn't have a lot of close friends at school, and the situation between John and me had made our home an uncomfortable place. Robyn

stepped in like she was going to protect Nippy, and I suppose Nippy found that comforting.

Whatever the reason, Robyn and Nippy became very close, very quickly, and it was the beginning of a lifelong friendship. I didn't like what I saw happening, but at that point I had so much on my mind that I couldn't focus on Nippy and Robyn. The situation between John and me just kept getting worse, and our marriage really seemed to be coming apart.

Our family and friends tried to help us get past our differences, but nothing helped. John and I had spent so much time focused on my work, and on our children and their problems, that we'd forgotten how to deal with our own problems. We still loved each other—as we always would but a lot of things had happened to John, and I just didn't know how to get past his anger in a way that would bring us back together again. So we finally decided it might be best to separate, step back for a while, in hopes that we could come back together later.

Before that happened, though, John and I had one furious argument that would end up having terrible consequences. He and I were yelling at each other, just going around and around in one of those arguments that seem to have no end. Back and forth and back and forth—we were just spitting angry words at each other, and then John shouted, "I'm just gonna walk out that door, Cissy! I am walking out that door!" But he kept on standing there as we went at it some more, and then once again, he yelled, "Cissy, I'm gonna walk right out that door!"

And then Nippy, who was watching this whole thing, startled us both by screaming, "Daddy, if you're gonna leave, then *just do it*!" John and I both turned to stare at her, stunned. My beautiful baby just stood there, crying. And she said again, "Just *stop arguing*, and *leave*!"

John loved Nippy more than just about anything, and I can only imagine what that felt like for him. She didn't want him to leave, of course, but that child just could not stand confrontation—she didn't want to be in it, and she didn't want to witness it. Seeing people scream, fuss, and fight, especially her mom and dad, was too much for her, so she yelled at John just to make it stop.

I don't think he had really intended to go. He was just worked up in the heat of argument, trying to find some way to push my buttons. But when Nippy said that to him, John just said, "All right." And soon after that, he moved out. He was furious—with both her and me—and I'm not sure he ever got over it. Later on, I believe he sometimes used it as an excuse when he treated Nippy badly. She was his adoring daughter, his princess, and in his mind, she had turned on him.

John moved to an apartment in Newark, and I stayed at Dodd Street with Nippy. I hated being separated from him, but in some ways our relationship didn't change all that much. He still drove me in and out of New York, to my regular gigs at Sweetwaters and Mikell's, and in fact, we were together so often that many of our friends didn't even know we'd separated. I never talked with the kids about any of it—"What happens between me and your father is our business," I would tell them.

104

Much later on, when Nippy was married with her own problems, she'd do the same with me, always avoiding discussions about what was going on between her and her husband. We just weren't inclined to get in each other's business that way—for better or for worse.

PART TWO

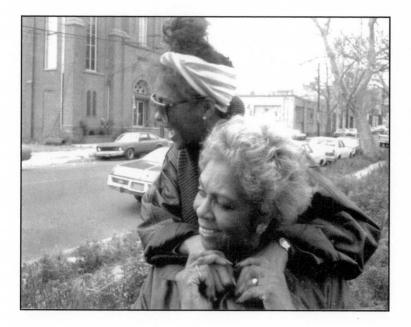

CHAPTER

Enter Clive Davis

ot long after John moved out of our house on Dodd Street, Nippy also decided to move out. I was just heartsick—my husband was gone, and now the last of my children, my beloved baby girl, was leaving, too. I tried to talk her out of it—tried to make her feel bad, even. She'd been hinting at it for a bit, but I didn't really believe it until I heard her say the words. We argued about it, and I had some harsh words for her, but she was stubborn. Nippy had graduated from high school in 1981, the same year she appeared on the cover of *Seventeen*, and she wanted to be all grown up. Moving out was a way she felt she could do that. It didn't help that, with both John and her brothers gone, home didn't feel like home for her any longer.

What made Nippy's move particularly hard for me was her decision to room with Robyn Crawford in an apartment in

Woodbridge, New Jersey. She knew how I felt about Robyn, but she was determined to live with her anyway. It wasn't that there was serious tension between Robyn and me—we just didn't see eye to eye. Still, we tried to be respectful of each other and of our places in Nippy's life, and we figured out how to give each other the necessary space. We had our love for Nippy in common, and though we rarely agreed, we were at least able to keep things from being too uncomfortable when we were all together.

Nippy and I did talk on the phone occasionally, and we'd see each other either in Newark or at gigs in Manhattan, but I never once visited Nippy in Woodbridge, even though I missed her terribly. She kept me at arm's length with regard to her personal life, and I could feel her pulling away, trying to establish her own space.

Years later, she told me how much she missed me during that time. "I used to pick up the phone, dial your number, and then hang up," she told me. I loved her and she loved me, but we didn't know how to reach across the divide that sometimes develops when children grow up, feel the need to be independent, disagree with their parents, and want to do what they want to do. It was a divide that had only been increased by John's and my separation.

While we started to spend less time together, the one thing that didn't stop was Nippy and her music, which was good because all of Nippy's learning, rehearsing, and performing was about to pay off. Despite being separated, John and I continued to work together on Nippy's career, and we hired a management agency, Tara Productions, to guide her as she prepared to step out on her own. She was still working with

me at gigs in Manhattan clubs, singing backup and occasionally stepping up to do a solo number herself. For a while, I thought she should go to college, but her talent was not to be denied—Nippy was ready to sing, ready to start a music career. Now we just had to decide how to take that next step.

The usual route for a new artist is to record some demos and take them around to record companies. But by hiring Tara Productions, John and I were hoping to go in a different direction. Right away, they launched a fast-paced campaign to bring Nippy into the public eye. In 1982, she released her first full lead vocal recording, "Memories," on the album *One Down* by the group Material, and she also got hired to do some advertising jingles for radio and television. In one 1983 ad for Canada Dry Ginger Ale, she sang a little ditty with two other women, dressed up like a diner waitress. She looked so cute, dancing around with her bottle of ginger ale and singing with a beautiful big smile on her face.

While Tara Productions was working to create interest in Nippy, Aretha called me to do background on her next album, *Get It Right*. Luther Vandross was producing, so I got to work with two of my best friends in the industry—and we had a ball doing that album. We'd have dinner together and reminisce about the turns our lives had taken—and we also talked about Nippy. Both Luther and Ree were convinced she was going to be a huge star.

Later on, I would tease Ree about supposedly being Nippy's godmother—a story that started years before, when I was touring with her and she came over to our house on Dodd Street. Nippy was so impressed with Aretha that she started telling all her friends she was her godmother, and the

story stuck because Ree never denied it. Eventually, reporters picked it up and everybody assumed it was true. And Nippy never did stop telling people that.

I loved hanging with my old friends, especially since being in that big old empty house without my family just made me feel sad. John's mother had moved in with me, but it wasn't the same as having a house full of kids and a husband. In 1983, I turned fifty, and I was lonely. But soon I found solace in a surprising place.

Though John and I were separated, our work together on Nippy's career and the fact that he gave me rides to my gigs in New York meant we still saw quite a lot of each other. And we never stopped being attracted to each other, so one thing led to another, and soon he and I were seeing even more of each other. We spent some weekends together in an out-of-state getaway he had bought, and we enjoyed ourselves more than we had in years. I think we both found some relief in getting away from the pressures of work and overseeing Nippy's career, and that distance enabled us to enjoy each other again.

Of course, back home in New Jersey, we each did our own thing, while also focusing on working with Tara Productions on Nippy's career. In 1983, Tara Productions decided to feature Nippy in a series of showcase events open only to record company honchos, including one at Sweetwaters that I helped them set up. Gerry Griffith, an A&R rep from Arista records, had tried to sign Nippy before, and he convinced his boss, Clive Davis, to come see the Sweetwaters showcase. That night, Nippy was unbelievable, and after she sang "Greatest Love of All," the whole place erupted. Be-

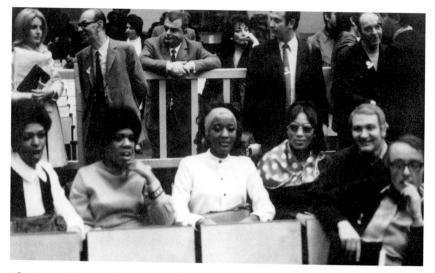

The Sweet Inspirations on our first trip to Europe in 1969. *Left to right:* me, Estelle Brown, Sylvia Shemwell, and Myrna Smith.

John Houston (*left*) in his army uniform during World War II. He could charm anybody, and you can see why in that smile.

Right after Nippy was born, the nurses took her all around the hospital to show her off. It was as if she belonged to the public from the start.

Even as a little girl, Nippy loved to perform. This shot of her and me dancing was taken in the late 1960s.

Nippy all dressed up, and smiling big, for her high school prom.

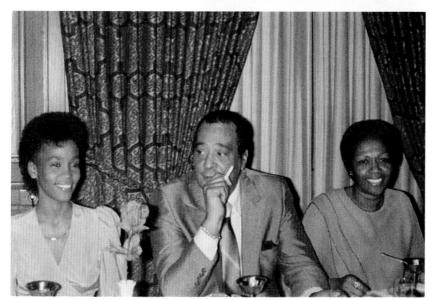

John and I had our differences at times, but we were always united in our love for Nippy.

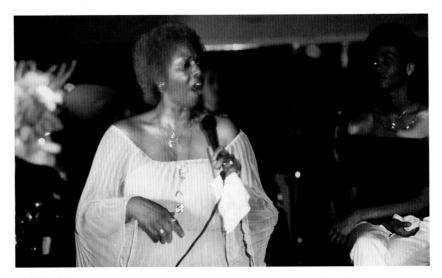

Before she went solo, Nippy (*seated, at right*) sang backup for me in some of my club shows in New York City. I always performed with a handkerchief to wipe the sweat from my face, and early on Nippy started doing the same.

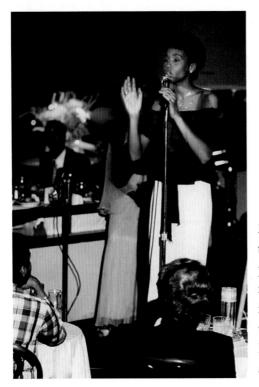

My son Michael used to joke about Nippy's performances, telling me she should be in jail for stealing all my vocal techniques. But Nippy had a style and a talent all her own.

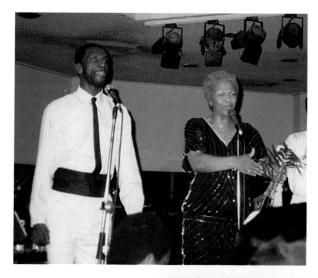

Nippy wasn't the only child in our family who sang backup for me my older son Gary often sang with us, too.

Nippy singing with me at Sweetwaters, the spot we eventually chose for the showcase that led Clive Davis to sign her.

Although Nippy had sung backup for a while, she was nervous about going onstage alone. One night I finally decided that the only way to get her up there was to fake being sick. I convinced Nippy to perform in my place, and she never looked back.

Nippy and me across the street from New Hope Baptist Church in Newark, my spiritual home and the place where we would one day hold her funeral.

Nippy and me with Merv Griffin during the taping of her first television performance, on *The Merv Griffin Show* in 1983. She was just nineteen.

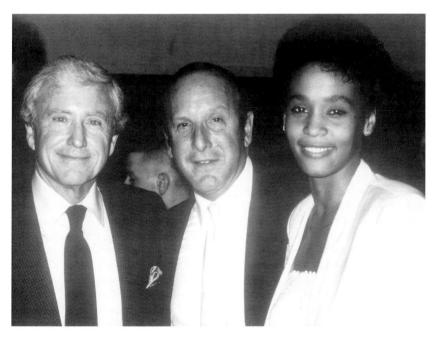

Nippy signed with Clive Davis because we all trusted him, and from the beginning he rewarded our faith. Clive really is, and always has been, the "Music Man." *Left to right:* Merv Griffin, Clive Davis, and Nippy.

Nippy surrounded by Omega Psi Phi alumni brothers, all volunteering at a Christmas party for homeless children sponsored by the Whitney Houston Foundation for Children.

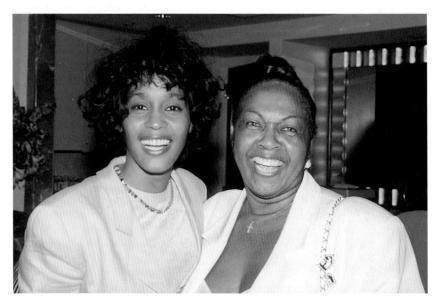

Whenever Nippy was on the road touring, I always tried to come meet her. Word would get out that "Big Cuda"—as in "barracuda"—was coming.

Gary, Nippy, and me at our house on Dodd Street in East Orange. When the kids were younger, we loved to have people over for barbecues and swimming.

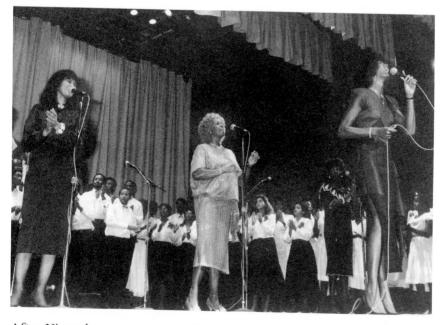

After Nippy became a star, she joined me in the U.S. Virgin Islands for a concert. She came to sing backup, but I asked her to take the lead on "Lead Me, Guide Me"—and she brought the place down.

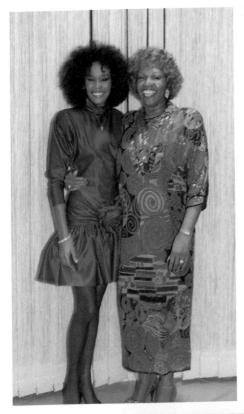

I was as proud as a mother could be when my baby girl became a star.

BELOW: And I was even more proud that Nippy gave her all onstage, for her fans, night after night. No matter how she was feeling.

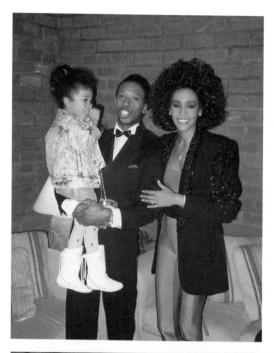

Before her debut album hit it big, Nippy opened for Jeffrey Osborne, pictured here with his daughter, on his tour in 1985.

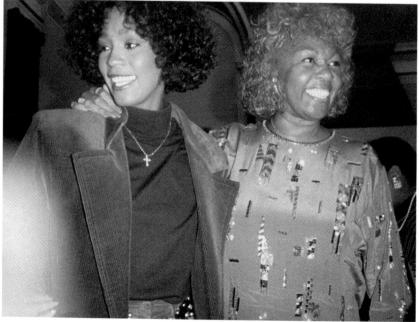

There were times when I couldn't believe that the beautiful girl who sang so well was really my daughter.

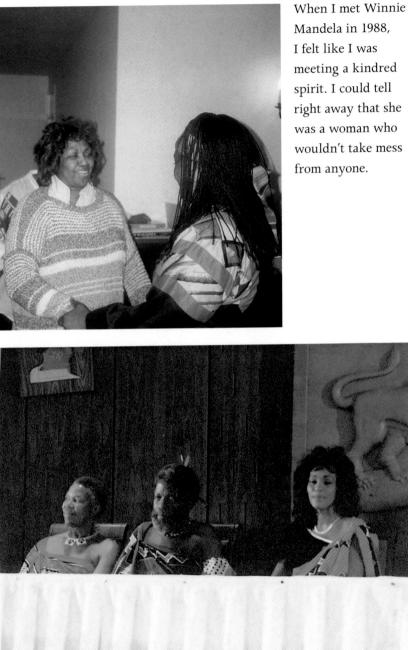

Mandela in 1988, I felt like I was meeting a kindred spirit. I could tell right away that she was a woman who wouldn't take mess from anyone.

Nippy with the royal family of Swaziland, following her concerts in South Africa in 1994.

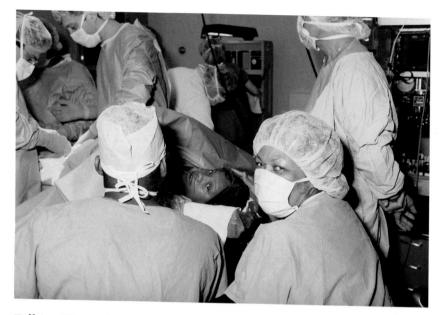

Talking Nippy through the pain as she gives birth to Bobbi Kristina in 1993.

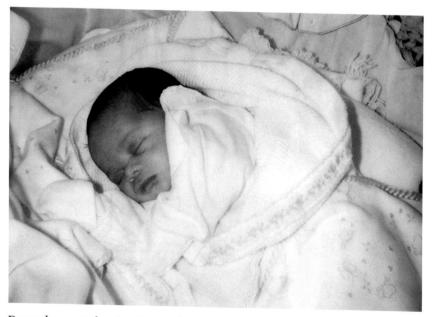

From the start, having Krissi changed Nippy. It was clear that caring for a child was something she was meant to do.

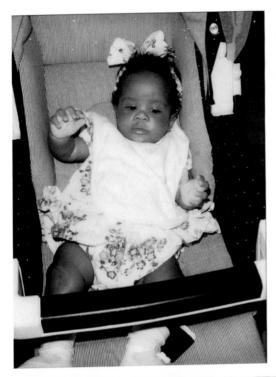

After Krissi was born, Nippy always joked, "Nobody ever comes to see me anymore! It's always, 'Where's Krissi? Is Krissi up?'''

Nippy, her nephew Gary, me, and Krissi on a family vacation.

Nippy thought about walking away from the music business after Krissi was born. A part of her just wanted to have a normal family life, but that never seemed to be possible.

I'm trying to get Krissi to look at the camera, but she's as stubborn as the rest of us.

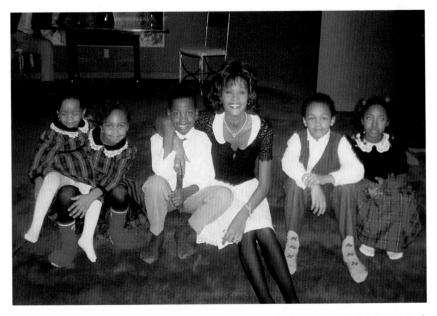

Nippy always loved kids. Here she is with some of my grandchildren. *Left to right:* Krissi, Michael's daughter Blaire, Gary's son Jonathan, Nippy, Michael's son "Little Gary," and Gary's daughter Aja.

With Gary and Pat's daughter, Raya Houston.

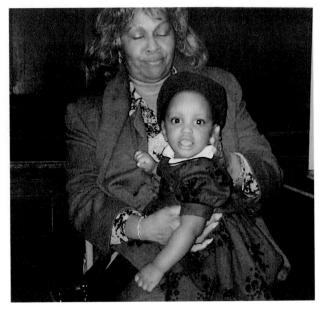

tween her voice, her looks, and her stage presence, she must have looked like a golden goose to those record executives.

All those years of learning, rehearsing, and performing had paid off. Young as she was, Nippy was a true professional. She had been watching me in sessions and onstage for years, picking up pacing, breathing, and microphone techniques, and then adding her own little nuances, too. My son Michael used to joke with me about Nippy's technique— "Ma," he'd say, "Nippy should be in jail for stealing all your riffs and everything. You should sue her." I appreciated Michael's admiration and loyalty, and Nippy did pick up a lot of things from me and others-every singer does. And though he was right that there was definitely a big piece of me in her performance, she'd also watched and learned from some of the greatest singers around, such as Chaka, Luther, Aretha, Dionne, Donny Hathaway, Roberta Flack, and many others. But from the minute she decided that all she wanted to do was sing, Nippy began developing a unique talent. And by the time she performed for those executives at Sweetwater's, she owed nothing to anyone or anything except that Godgiven talent. Nippy was absolutely spectacular, with a style all her own.

That night, Clive was as impressed as Griffith had been, and he immediately offered Nippy a contract. Clive didn't offer the biggest advance, nor was Arista the largest company to make Nippy an offer—Electra was. John wanted Nippy to sign with Electra because of the money. But I disagreed. "It's not about the money," I told John. "It's about the future."

Arista may have offered a smaller advance, but I was more impressed with the amount of money they budgeted for re-

cording and promoting Nippy's first album. Besides, Clive Davis was one of the biggest names in the industry—he wasn't called the "Music Man" for nothing. We signed with Clive because I trusted him to know what he was doing, and right from the start, he began taking steps to make Nippy a star.

On June 23, 1983, Nippy made her national television debut, with Clive at her side, on *The Merv Griffin Show*. She was just nineteen, and understandably a little nervous. I was there in the studio with her, and during rehearsal, when I noticed that the band sounded a little ragged, a little out of synch, I decided to do something about it. No way was I going to see my baby's television debut messed up by a band that didn't know the arrangement! No one saw me doing it, because the band was behind a curtain, but I just stepped up and directed them during Nippy's performance.

"Just be calm," I told her, "and sing it like it's supposed to be sung. Don't worry about the band or anything else." And she did—she sang her heart out. Looking at a clip of that performance now, I can't believe how young and excited she seems. Yet even though she was jittery beforehand, she just has a look of serenity on her face all the way through. Nippy was happy she did well, but she was also relieved when it was over. She was even happier when people really started to take notice of her because of that appearance.

Despite the excitement around her, the Arista execs took their time with Nippy—they didn't start working on her album right away, and when they did, it took two full years to complete it. Clive wanted to craft her image, and he wanted to make absolutely sure they chose the right songs and pro-

ducers for her debut. As they were mapping it out, sometimes she'd call me to ask about a song for her album—"What do you think, Mommy?" I always answered honestly, so even though Clive was behind the song selection, I had my voice in there, too.

Just because Clive took his time with Nippy didn't mean that she was doing nothing but recording the album fulltime. In 1984, Clive also arranged for Nippy to record a duet with Teddy Pendergrass. That song, "Hold Me," appeared on Pendergrass's album *Love Language*—and when it was released, it climbed to number five on the R&B charts, the first time she'd been on the charts. That summer, Nippy played a few TV roles, too, singing with Jermaine Jackson on the soap *As the World Turns*, and playing a bit part in the Nell Carter sitcom *Gimme a Break*!

At the same time, Nippy's managers kept working to build her image. They called in a designer to create a stage wardrobe for her, but when I saw it I almost lost my mind—those dresses were so revealing, I thought they'd been created for a stripper. Nippy hadn't objected, but I sure did.

"You can put all that crap right back," I told them. "I don't know who you got that for, but Whitney is not wearing it. She is not shaking no butt, showing no skin, nothing like that." Anybody could dress like a streetwalker, but my daughter didn't have to—she could sing! I told them I'd take care of Nippy's clothes, and I did for a little while, until she got her own wardrobe person and stylist.

I played a pretty active role in Nippy's career in those early days, but soon enough I stepped back and entrusted most of the responsibility to Clive. It felt a bit strange to step

back, but I knew that Nippy wanted and needed to find her own way professionally. And I had a lot of respect for Clive and his vision for her; he was someone I knew I could trust with my daughter's future. Nippy did still seek out my opinion about songs, and she almost always played them for me when she was choosing material, but from early on, Clive had a major part in shaping her career.

When Clive at last finalized the producers and songs for Nippy's album, it was a list of heavyweights, from songwriterproducer Kashif to Jermaine Jackson. This was an exciting time for Nippy—she was just twenty years old, and here she was being courted by some of the biggest names in the business. And a few of them took that "courting" a little bit too literally.

Jermaine Jackson, who was trying to step out of the shadow of his superstar brother Michael, turned out to be interested in Nippy for more than just her singing talent. And Jermaine was a nice enough guy—but he was married, so I wasn't too thrilled when Nippy went out with him a couple of times. She was always a big fan of Michael Jackson, so maybe that had something to do with it. And anyway, when I talked to her about it, she just said, "Mom, I ain't doing nothing." She was over eighteen and living on her own now, so there wasn't much of anything I could say to her about that.

After two full years of work, Arista finally released Nippy's debut album, *Whitney Houston*, in February 1985. The studio had set a budget of two hundred thousand dollars for it, but the final cost was more than twice that. Everybody was

anxious for the record to do well, so we were all a little disappointed when it started slowly—but over the spring, the album started to sell, and by the end of the summer it was on *Billboard*'s R&B and pop charts. And then the strangest thing happened: it just kept on selling.

I've always thought that one of the reasons that record's sales started slowly was that it had a lot of ballads for a pop album. Nippy was a real singer, and the arrangements on the record were meant to showcase her voice, so it took a little bit of time to get traction. But by the following summer, almost a year and a half after its release, *Whitney Houston* was the number one pop record in the country.

Even before the record hit stores, Clive Davis had set up a busy schedule of touring for Nippy. She started with a promotional tour, which is a busy, thankless time of flying all over the place to try to get people to pay attention to your upcoming record. She'd make two or three appearances a day, usually in small venues, and she had only her manager, Gene Harvey, traveling with her.

I think it got kind of lonely for Nippy on that promotional tour, especially since she knew she didn't have a happy, full house on Dodd Street to come home to anymore. For the first time, she got a taste of what it was like to be a star. And although she was always a fantastic performer and could connect with people onstage, I think it was tiring for her. Even though she would always smile and chat with strangers from the time she was young, a part of Nippy was actually very shy. She needed time to herself, and time with people who loved her. On that promotional tour, she didn't get a whole lot of either, while also discovering, for better and worse, what it was like to suddenly have your time belong to other people.

After the album came out, Clive had set up a regular tour for her. Now she was performing in bigger venues, though usually as an opener for a more established act. Because she only had the one album, she didn't even have enough material for a whole set, so she'd throw in some cover songs to fill it out. She was off on her own now, and when she was onstage, she had no one to fall back on—Nippy was the show, and she had to be great. It was a lot of pressure for a young woman who'd never really had to take care of herself. She knew she had to step up, and so she did. But it wasn't easy.

With the success of *Whitney Houston*, Nippy went from being a relatively unknown model and singer to a celebrity. Before, she could walk down any street in any city and never worry about people messing with her, but now, everybody suddenly wanted to talk to her, to touch her. It would have been overwhelming for anyone, but for Nippy, with her desire to please people and her natural shyness, having fame hit with such force was really difficult. She was the most exciting young singer to hit the airwaves in years, whether she was ready for that or not.

In February 1986, Nippy flew to Los Angeles for the Grammy Awards. She had been touring for months on end, so no one could blame her if she was feeling a little worn down by it all. Maybe I was just being overprotective, but I was a little worried about her. And I was also mad—as was Clive Davis—about the fact that she'd been snubbed in one of the Grammy categories.

Nippy had received four nominations, but she was left out of the Best New Artist category. Apparently, she was disqualified because of the duets she did on those albums by Teddy Pendergrass and Jermaine Jackson back in 1984. This just seemed silly, like she was being punished for nothing. She was obviously the best up-and-coming new artist around, even if she wouldn't get any official recognition for it.

I wondered whether Nippy's success wasn't stirring up some kind of resentment among other performers. Nippy was scheduled to sing during the ceremony, and when we went to the rehearsals, it seemed like some of the other artists were giving her a little bit of the cold shoulder. There was a whole group of musicians and performers standing around the first time we walked in, and Nippy, who was always pleasant, open, and welcoming, walked up to them and said "Hi, I'm Whitney." They knew who she was, of course, but they all just stood there looking at her. Nippy was stung by that, and when we walked away she asked me, "Mommy, what's wrong with them? Don't they like me?" I just told her not to worry about it—what else could I do?

I don't know, maybe those other performers were just shy, or maybe it's a Hollywood thing, or maybe, knowing she was young and came from a Christian family, they figured she was just a goody-two-shoes. Whatever the case was, being the newcomer made Nippy a little anxious, and she looked up to a lot of those other performers, so I just wish they could have been a little more gracious, or even just polite, to her. One person who was really sweet to her, though, was

Michael Jackson's oldest sister, Rebbie, who walked right up at the rehearsal and gave Nippy a big old hug. I know Nippy appreciated it, and I did, too.

At the awards show, Nippy gave a beautiful performance of "Saving All My Love for You," and later in the evening she won Best Pop Vocal Performance by a Female for that same song. Her cousin Dionne Warwick was the presenter, and Dionne was so excited, she just about squeezed the life out of Nippy when she came up to accept the award. As everybody clapped and cheered, Nippy looked out over the audience and said, "Do you believe this?!" I'm not sure she could—and yet this was only the beginning.

HAPTER 9

Fame

By the fall of 1986, Whitney Houston was still on top of the charts, Nippy had started working on her second album, and her success was growing. But success breeds criticism, and Nippy wasn't immune. In late September, when the MTV Video Music Awards were held, the backlash started.

Nippy was nominated in two categories for the awards, winning one for her "How Will I Know" video. She also performed "How Will I Know" and "Greatest Love of All" during the live show. But the MTV awards weren't like the Grammys, which had a history of honoring black artists in all types of music. MTV hadn't been around that long then, but it already had a reputation for ignoring videos by black performers.

Until Nippy came along, Michael Jackson was one of the

few black performers whose videos aired regularly on MTV. But once Nippy began putting out videos, MTV played those, too—she was the first black female artist the channel showed on a regular basis. I thought that was a good thing, a breakthrough for her and other black artists. But some people thought it meant something else: that Nippy's music wasn't "black enough."

This was the first time Nippy heard that particular criticism, and it wouldn't be the last. It bothered her, but I just told her she should be proud she was able to perform a whole variety of material, and not just R&B. "Sing the kind of music you can relate to, the kind you feel," I told her. "Don't be influenced by people who want to put you into some dumb little box." This was the first time this had ever come up for Nippy, and while it hurt her, I don't think she took it to heart. With her second album now in the works, it was more important than ever for her to stick to her own principles and shut out the noise of the critics.

Whitney Houston stayed on the charts so long, Arista had to postpone the release of Nippy's second album, Whitney. But when it finally came out in the summer of 1987, it set all kinds of new records. No woman had ever debuted at number one with any album, but Nippy did it. And in the months to come, she just kept on releasing hit singles and selling records.

Nippy had never cared a whole lot about money, and she didn't start now. She just was never one of those people who has to go out and buy the latest this and the most expensive that. But once she started getting some royalties in from her two records, she did decide to buy herself a new house.

Now, the truth is, John was the one in our family who was more interested in money. He told Nippy he'd help her figure out what kind of house to buy, and how to decorate it, and when she said yes, he just went to town. On his advice, she bought a magnificent five-bedroom mansion on a fiveacre estate in Mendham Township, New Jersey. And then she turned it over to her daddy to furnish and decorate it. On the night before her housewarming, she told a family friend that just a few hours earlier she had seen what it looked like for the first time. It wasn't really Nippy's style, but even she had to admit it was gorgeous.

I was thrilled with Nippy's new house and hoped it would be a place she could one day settle down and start a family. I was less thrilled, then, when she invited Robyn to move into the Mendham estate with her. Mendham was even farther away from my house than her place in Woodbridge had been, and I didn't like Robyn any more now than I had before, but my daughter was an adult and could make her own choices. I was not going to let my feelings about Robyn or anyone keep me from my baby forever. Besides, I didn't hate Robyn; I was just concerned about what I perceived to be her influence on Nippy.

But Nippy was generous enough to buy a place for me, too—a nice, sunny condo in Verona, New Jersey. John and I sold the Dodd Street house, which was just too big and inconvenient for me to keep up. John still lived in Newark, in a place of his own, but we kept on seeing each other. It didn't even feel like we were separated, except for the fact that we weren't living together. But I really hoped and be-

lieved that he and I would end up back together. I expected it to happen—the only question was when.

Nippy's "Moment of Truth" tour began on the Fourth of July 1987, and over the next sixteen months, she went absolutely all over the place—North America, Europe, Japan, Hong Kong, Australia. I couldn't come with her for most of the tour, as I was still working—doing backup for singers such as David Bowie, and doing my regular gigs at Sweetwaters and Fat Tuesday's. But although I only managed to see a few of her shows, I'd always call to check in on things and see how she was doing.

I knew Nippy was in good hands on this tour—Gary, Michael, and John all went with her, as did Aunt Bae. Michael was assistant road manager, Gary was singing background, and Bae was the "road mommy," there to look out for everybody. And John was traveling as the CEO of Nippy's new company, Nippy Inc., which she had formed to replace her old management agency.

Gary, Michael, and Nippy were still young, all of them in their twenties, and although they were working, they wanted to have fun, too. They had money and time, so they did some silly kid stuff, like turning a parking lot into a skating rink for a night. But Aunt Bae and John never let them get too far out of line. And Bae would cook for them whenever a hotel allowed her to use their kitchen. So even in France or Japan, they could have their favorite home-cooked meal—chicken wings and pork and beans.

Michael and Nippy were particularly close, and she loved having him with her on tour. She'd make him take

a hotel room just across the hall from hers and leave the latch open, so she could wander over in the middle of the night if she felt like it. They'd lie around in his room and watch QVC, ordering things off the TV late at night when she couldn't sleep.

Nippy was younger than Michael, but she liked calling him "son"—as in, the prodigal son. Later on, Michael would tell me about some of the mess they got themselves into, such as the time Nippy decided she wanted to walk down Bourbon Street in New Orleans. Without security. In a fur coat. She just thought it would be fun, so Michael followed her out, and the two of them wandered around the French Quarter, trailing a crowd of excited, drunk tourists behind them.

Nippy didn't seem to realize that it might not be safe for her to just wander out into crowds. She was famous everywhere by now, but if she got it in her head to go have a stroll somewhere, she'd do it. Sometimes she just didn't feel like facing the realities of the situation.

Michael told me about another time in Italy, when he'd been on tour with Nippy for several months. He hadn't seen his wife, Donna, and youngest son, little Gary, in a while, and he missed them. Or maybe it was just that Nippy missed little Gary—she adored that child, and later she would take him on tour with her, just because she liked having him around. Whatever the case, Nippy decided to fly Donna and little Gary over to Italy for a visit.

Everybody was staying in a hotel with a big courtyard, where hundreds of people would gather each day hoping to get a glimpse of Nippy. And on the day Donna and Gary were supposed to arrive, the crowd was getting unruly—they'd been out there the whole night before, shouting, "Whitney! Whitney!" so loudly that no one in the hotel could sleep.

At the time that Michael's family was scheduled to arrive, Nippy and Michael made their way down to the lobby to greet them. There was security and Italian police everywhere, and the police had already gotten a little rough with the crowd, even arresting some people. They were trying to keep things under control, but it wasn't easy.

When the car carrying Donna and little Gary pulled up in front of the hotel, someone shouted, "There they are!" and before Michael could grab her, Nippy just took off. She bolted from the hotel lobby toward the car, running past the security guards and police, and the crowd started to rush toward her. Michael told me she just started pushing people aside, knocking them left and right until she made it to the car. And then, miraculously, people stood back and left her alone. She grabbed little Gary and carried him in her arms back to the lobby, kissing and hugging him. And thankfully, the crowd let her pass.

I didn't like the idea of crowds rushing at Nippy, or of her just wandering into them. But she was just excited to see little Gary, and in the end everybody was safe. Even so, you can bet I gave John a piece of my mind when I heard this story. "You better keep an eye on her!" I told him.

It didn't matter where Nippy went now; everybody recognized her and wanted to come up to her. Once, when she and I had just flown back to New York together, we found out that the car that was supposed to pick her up had gone to the wrong airport. We had no car, no driver, no security—and it was a summer Friday, so JFK airport was jammed with all

kinds of people trying to get taxicabs. Nippy's attorney and friend Toni Chambers was with us, too, and while Toni was on the phone trying to get a limo, people started circling.

There was no way we could stand there and wait—Nippy was about to be swarmed. So we picked up our bags and hurried out toward the taxi area, and a man walked up and said, "You need a car?" He seemed to be the only person in the airport who had no idea who Nippy was, so we just looked at each other and Nippy started laughing. "Yes we do!" she said. "Let's go!" We followed the man through the crowds, past the taxi stand, and into the parking lot. And there was his car, a beat-up Toyota something or other with primer on the doors. We threw our bags into his trunk and piled in.

As we rode off down the highway in that ratty old Toyota, Nippy seemed to love it. She cranked down the window and stuck her head out, enjoying the fact that, just for a moment, she could be plain old Nippy rather than the famous Whitney Houston. When we rolled up to a stoplight, a couple of girls were sitting in the car next to us. One of them shrieked, "That's Whitney Houston!" And the other said, "Don't be stupid! Whitney Houston would never be riding in a car like that."

No matter how famous she got, Nippy still loved the same old simple things she always had. She loved Creamsicles, and if someone tried to bring her some kind of fancy sorbet with fruit, she'd say, "No! I just want a Creamsicle!" People would walk by this beautiful woman in jeans and a jacket, eating a Creamsicle, and think, "She looks just like Whitney Houston!"

Nippy always wanted to be just one of the girls, but it

got harder the more famous she became. After a while, she started separating out her public self from her private one. She'd say, "I'm tired, it's time for me to put Nippy to bed." Or, when she had to perform, she'd say, "Okay, it's time for me to go be Whitney Houston." It was just one of the ways she dealt with the craziness of fame.

Being a performer on the road is not easy. You have to know what you're out there for, the reason why you're doing it. A lot of people get lost in the whirlwind, and get wrapped up in people who aren't good for them. You have to carefully choose the kind of company you keep, because it can get wild out there on the road, and it's easy to get caught up in it.

I know, because I saw a little bit of everything when I was on the road all those years. I always tried to keep my head about me, because I was aware of having three kids and wanting to be an example for them. Not that I was a goodytwo-shoes, because I wasn't. But I tried to keep things under control, which was sometimes easier said than done. Now, with Nippy spending so much time on the road, and only sharing pieces of it with me, I didn't have the full picture of how she was handling it all. Pretty soon, I got a hint from someone I didn't expect—Robyn Crawford.

One afternoon in the late 1980s, Robyn came to visit me. I was surprised, since she and I never said much to each other, and I always tried to stay out of whatever was going on between her and my daughter. But Robyn came to me because she was worried about Nippy. She told me that Nippy was using drugs, which was news to me—I had no idea about anything like that. Robyn said that both she and Nippy were doing it on occasion, but that "Nippy likes it a little too

much." Apparently, if they had it in the house, Robyn could do some and stop. But Nippy would keep on doing it until everything was gone.

Now, I might not have liked certain things about Robyn, but I will say this: She cared a great deal for Nippy, and she wanted to protect her. Nobody had the courage to come tell me that Nippy was getting into something that was bad for her—nobody except Robyn. She didn't have any kind of relationship with me, but she still came to me in person to try to help Nippy. I always respected Robyn for that.

After that conversation with Robyn, I asked Nippy about using drugs. "Oh, Mommy," she said, "you don't need to worry about any of that." She just brushed off my concerns, saying she was fine and that Robyn was overreacting. Much as I wanted to press the issue further, I didn't have much choice but to accept what she was saying—at that point, she was doing everything she was supposed to be doing: touring, recording, making appearances, and everything else. And whenever I talked to her, she seemed to be fine. I didn't have any proof that anything was wrong, and without proof, I couldn't push the issue with Nippy, since all she would do is deny it. I had checked in on her and made my concerns known—what else could I do?

Much later, I would find out that John was worried about Nippy during this time, too. As he watched Nippy's fame grow, and saw her dealing with all the pressures of touring and being responsible for the livelihoods of dozens, if not hundreds, of people, he began to wonder if she had the strength to handle it all. He knew Gary and Michael were struggling with drug use, too, but as he told one family friend, "You know, the one I'm really worried about is Nippy. If she has to meet some real crisis or disappointment, I'm worried she won't survive it. Because she's never had to."

And John had a good point. He and I had done such a good job of protecting her that Nippy had never faced any real trauma in her life up to then. Proud as I was of the life we'd given her, with this instant surge of fame she was experiencing, I couldn't help but worry about what might happen whenever she finally did face some kind of hardship. I just hoped she would come to me if she needed my help.

But there was one other thing that happened during this time period—one time when Nippy did come to me, and I pushed her away. It's one of the few moments in my life I truly regret.

I was scheduled to do a concert in the U.S. Virgin Islands, and Nippy had asked if she could come along. She was already a star by this time, but she wanted to come sing background for me, just like we'd done for so many years in the New York clubs. She didn't want to take over the show or anything—she just wanted to support me up onstage.

People went crazy, of course, even though she was just backing me up—so when the next song was a gospel number called "Lead Me, Guide Me," I asked Nippy to step forward and sing the lead. She smiled and did as I asked, and I'm telling you—that whole place just about turned inside out. People were whooping and clapping, and waving their hands around like they were in church. The Spirit was there that night, it really was. This wasn't the magic of Whitney Houston—it was the magic of a mom and her little girl up onstage, singing the songs of faith we loved.

The whole evening was so magical that it still pains me to think about what I did that night. Ever since she was a little girl, Nippy sometimes liked to crawl into bed and sleep with me. She did that in our hotel that night, too. But Nippy had developed a terrible habit of grinding her teeth when she slept, and she was doing it so loud that it was keeping me awake. I poked her and said, "Nippy! Go sleep in your own bed!"

She said, "Mommy, I want to stay here."

I said, "No, baby, you've got to go, because I can't get any sleep with that noise!" So, off she went, shuffling out just as sad as could be. I'm sure I hurt her feelings that night, and if I could take it back, I would. But life doesn't work that way.

Nippy kept on performing, and as her fame grew she started to try to do some good with it. In the summer of 1988, she sang at a benefit concert at Madison Square Garden that raised a lot of money for the United Negro College Fund. And that June, she performed in London at a big tribute concert for Nelson Mandela's seventieth birthday.

Mandela was still imprisoned in South Africa at the time, and apartheid was still in force. South Africa was a touchy subject then, and the organizers of the birthday tribute were having a hard time convincing artists to perform. Nobody wanted to agree to do it until others had agreed to do it first, because everybody seemed scared of some kind of backlash. Nippy didn't hesitate, though. As soon as the organizers asked her to perform, she said yes. There was nothing that could hold her back from honoring Mandela, whom she admired so much for his courage. She wasn't afraid, and I was proud of her for that. But it was the following year that she did something that made me even more proud.

Nippy had always cared about the underdog—about people who didn't have as much as she did. I saw it when she was a child, when I had to tell her not to give all of her stuff away to the other kids. She just had a very tender heart when it came to people who were less fortunate, so as soon as she started making some real money, she put it to use trying to help others.

Most of her charitable work and gifts weren't publicized that's the way she wanted it. But she gave of her time and money to organizations like the NAACP, the Barbara Davis Center for Childhood Diabetes, the United Negro College Fund, the Red Cross, and many more local charities than I could possibly name. Nippy had such a strong conscience that even when she was modeling as a teenager, she refused to work for agencies that did business with South Africa. She understood how fortunate she was, and she felt a duty to give back.

By the late eighties, she was getting hundreds of requests to do benefit performances. She tried to do as many as she could, but it was just getting out of hand. People didn't realize that when you do a benefit, even if you donate your services, there are still heavy costs. If Nippy wasn't on tour, she'd have to bring back the band and the singers for special rehearsals. Professional musicians and background singers get paid for their rehearsal time, of course, and then she'd also have to rent rehearsal space, pay for everybody's transportation and hotel, per diems, and on and on . . . In the end, it could cost several hundred thousand dollars just to do a single benefit.

Nippy knew there had to be a better way to put that money to use, so in 1989 she started her own nonprofit—the Whitney Houston Foundation for Children, with a focus on kids who were homeless or had cancer or HIV. She asked if I would serve as president and chairman of the board, and I gladly accepted, and then she hired Toni Chambers as the executive director. She wanted all the money that came in to go straight to the kids, so she underwrote the entire cost of the foundation—all the expenses for salaries, office supplies, and everything else—herself. From day one, Nippy was determined there would never be a question about how money was spent or where donations went. When anybody asked about her foundation, she'd say with pride, "My stuff is taken care of."

Nippy's foundation did amazing work. We organized a Youth Leadership Program in Washington, D.C., for teenfocused nonprofits, from 4H clubs to suicide prevention hotlines. More than a hundred kids came from all over America to D.C. for a week—all kinds of kids, some physically challenged, some confined to wheelchairs, some who were hearing-impaired, black kids, white kids, Asian and Hispanic kids. For that week they were able to meet people they'd never have gotten to meet otherwise, and bond with those who might have shunned them. They taught and learned from each other, and then took some of the ideas they learned back to their own communities. I was so proud of that project, and so proud of my daughter and her foundation.

Nippy worked hard to contribute and do some good in the world, which is one reason it made me angry when people criticized her for stupid things. Some people just want to tear you down if they see you doing well, and people really went after Nippy. And the criticism she got most was all that mess about not being "black enough."

Now, all my life, I've appreciated good music and tried to make good music. When my generation came of age in the fifties and sixties, we aimed to spread out and be good at whatever we did—not just put ourselves in a little box, the way generations before might have done. And that's what I tried to teach Nippy. My baby could sing anything—why should she limit herself to a certain type of "approved" music? She sang songs she felt strongly about, and she sang them beautifully. I never could figure out how someone could criticize that. It started at the 1986 MTV Video Music Awards, but it sure didn't end there.

The worst was the night of the 1989 Soul Train Awards. When Nippy was announced as a nominee for Best Female R&B single for "Where Do Broken Hearts Go," a few people started booing, and up in the balcony someone started yelling "White-ey! White-ey!" like it was something clever. This was just a bunch of kids trying to be smart and get everybody's attention, but it really hurt her feelings—all the more because she didn't deserve it. Nippy was never trying to be white; she just wanted to sing, to share her God-given talent and be herself. If they didn't like it that she didn't take off her clothes and shake her ass and all that mess, well—that was their problem.

By the end of the night, though, she had won so many awards that she received a standing ovation—a fitting end to what was ultimately a difficult evening. Nippy was strong

in some ways, but that same sensitivity to criticism that had bothered her when she was little never went away. This was exactly the kind of thing I had feared back when I told her I didn't want her going into the music business. I knew that she would suffer, and although I tried to counsel her just to ignore people, or even tell them off, she couldn't do it. She just got her feelings hurt, as I had known she would. And as her mother, well, I was pissed off.

After the show, when Nippy was still upset, I just held her and told her, "Baby, you're going to be all right. Those people don't know no better. If they knew better, they'd do better."

The heckling hurt her, but in public she handled it pretty well, mostly ignoring it except for making a couple of statements. When one writer for *Essence* magazine asked her about the perception that she wasn't black enough, her response was perfect. "What's black?" she shot back. "I've been trying to figure this out since I've been in the business. I don't know how to sing black—and I don't know how to sing white, either. I know how to sing. Music is not a color to me. It's an art."

CHAPTER IO

Welcome Home Heroes

The 1989 Soul Train Awards show was significant for Nippy for more than just the booing. That was also the evening she met Bobby Brown.

I didn't know much about Bobby before that night, although I had seen him perform. I knew he had a bad-boy reputation, but the first time I met him, he was absolutely respectful to me. And in the beginning, when I saw him and Nippy together, their relationship just seemed like one of those schoolboy, I'll-carry-your-books-home kind of things. They seemed smitten, like high school sweethearts.

Over the years, Nippy's name had been connected with a few different guys, and though she never really shared details with me, I always assumed that nothing was too serious, because she rarely talked about marriage or anything like that. Eddie Murphy, Philadelphia Eagles quarterback

Randall Cunningham, and the handsome actor Blair Underwood all went out with her at one time or another. I'm not sure which of them were more than friends—Eddie says now that's all he and Nippy were, though a lot of people don't believe him. But I think it's the truth.

Nippy and Eddie seemed to have a real connection. For one thing, Nippy was funny—she had grown up in a house where everybody was joking and laughing all the time, and she could cut up with the best of them. There were times when Nippy would have you laughing so hard you were crying, and I think Eddie appreciated that. One night, I saw them sitting together at a record listening party, surrounded by photographers. As the flashbulbs popped all around them, they just sat there laughing and talking to each other like they didn't even notice. And I do know that Eddie once gave Nippy a gorgeous ring, though it wasn't an engagement ring.

Now, Randall Cunningham—I believe he did want to marry her. He just loved Nippy to death. They had a few dates right around the time her debut album was released, and they saw each other a few more times after that. I liked Randall, and I don't know what ever happened with them. Maybe she was so tied up with her music and he was so busy playing football that they just didn't have time for a relationship. There really wasn't anyone who just swept Nippy up until Bobby came along.

One of the first things I realized about Bobby was how different he and Nippy were. I didn't think he was a bad guy, but it was clear that he and Nippy had very different personalities, and his family life didn't seem much like ours, either.

And even back then, he couldn't seem to stay out of trouble.

I'll be honest—I tried to tell Nippy from the beginning that I didn't think Bobby was good for her. We didn't have a big confrontation about it, but I brought it up a few times, and I could tell that she didn't appreciate hearing about my disapproval. She wanted to be with him, so I decided to let it go. After all, my sisters tried to tell me not to get together with John Houston, too—and you see how much I listened to that. Well, Nippy was the same way. She loved who she loved, and when she made up her mind that Bobby was the one for her, nobody could tell her any different.

Throughout most of 1990, Nippy was working on her third album, *I'm Your Baby Tonight*. Clive Davis had always been the one to choose the songs for her records, but this time around she wanted to have more of a say herself.

Nippy would be the first person to defend Clive and his choice of songs on those first two albums. She loved all the songs and didn't feel like there was anything wrong with them. But at the same time, she had been hurt by those young black people booing and calling her "Whitey," and by the black critics who accused her of turning her back on black audiences. Clive agreed with the slight change in direction, so, for *I'm Your Baby Tonight*, he and Nippy brought in Luther Vandross and the team of Babyface and L. A. Reid as producers, aiming for a more urban feel to the songs—a little R&B mixed in with the pop. When it came out, *I'm Your Baby Tonight* didn't sell as well as the first two albums, but it did quiet some of Nippy's critics, anyway. And of course, a Whitney Houston album that "didn't sell as well" was still

huge by anybody else's standard, becoming the number-one R&B record of 1991 and selling eight million copies.

Two months after *I'm Your Baby Tonight* was released, in January 1991, Nippy was scheduled to perform "The Star-Spangled Banner" at the Super Bowl. This was a big honor, and she was excited to do it, but the week before the game, the organizers asked her to make a "safety tape," which is an advance recording of the song. This was standard practice, an insurance in case Nippy lost her voice or something else happened with the broadcast. They also needed the tape because there was going to be a fighter jet flyover during the song and they needed to time the flyover to her hitting a particular spot in the song. But after she recorded the song and the people at the NFL heard it, they were not happy.

"Oh no," they told us, "this is too jazzy. She needs to do it straighter." Nippy hadn't done the typical white-bread rendering that most performers did, and those conservative NFL folks just weren't ready for that.

That was when John stepped up and told them, "No, this is the way Whitney is going to sing the song. If you want her to sing it, this is it." He wouldn't back down, and the NFL people finally agreed to let her sing the song her way.

The day of the Super Bowl, I had hoped to be in the stadium, but I couldn't make it to Tampa, as I had shattered my ankle and it wasn't healing well. I had broken it in such a silly way—Luther Vandross had sent flowers to me at home, and as I was carrying them to my apartment I caught my heel between the elevator and the floor and went down hard. It was just one little accidental moment, but it would lead to surgery and pins and screws and years of pain.

And right then, it meant I couldn't go see Nippy perform live at the Super Bowl. I had promised her I would be there, but I'd had to call and tell her it just wasn't possible. "Don't worry," I told her. "You know what to do. And I'll be watching you."

I sat on my sofa at home and watched, and though I knew as well as anyone what Nippy could do, even I was amazed at that performance. In all the days of my life, I was never so proud as when I saw my baby up there, singing the national anthem with such power that the whole world could've probably heard it. The producers had wanted her to lip-synch it, but Nippy was like me—she couldn't do it. She couldn't keep time with a song unless she was really singing it, and at the Super Bowl, you could tell looking at her that she was singing the whole time. When she hit that final note, and then the jets flew overhead, I can't imagine there was a dry eye in that stadium.

Afterward, Nippy called me and said, "Mommy, how was it? How did I do?"

I said, "Are you kidding me? You were fantastic, baby. If you never do anything else in your life, you did that like it was *supposed* to be done."

I wasn't the only one who felt that way. I heard later that after she sang, so many calls came into her office that the lines froze up. People flooded Arista with phone calls and messages, asking for a copy of the recording, so Arista and BMG decided to release it as a single. And to everyone's surprise, it went right to the Top 20 on the charts. This was during the first Gulf War, so patriotic feeling was running high, and Nippy and her foundation, the Whitney Houston

Foundation for Children, Arista, and BMG donated all their share of the proceeds—more than \$1 million—to the American Red Cross Gulf Crisis Fund.

Nippy wanted to do her part to support the American troops fighting in Desert Storm, so she began talking about going to the Middle East to make an appearance there. She had her management team contact military authorities to discuss the logistics and scheduling; she was planning to launch a world tour in support of *I'm Your Baby Tonight* in London, so she'd have to do it before then.

The military officer on the call said, "Can we get off this phone? I want to call you back on a secure line."

When he called back, he told Nippy's management, "If I were you, I wouldn't let her do it." Asked why, he replied, "Because of the war. Whitney Houston is an American treasure, and the risk of having her kidnapped or killed while abroad is just too high." Her manager tried to argue that Nippy always had security with her, but the officer interrupted to say, "You don't have security like the president has. And even with the Secret Service protecting him, if someone wants to kill the president and is ready to die doing it, he can. So believe me, Ms. Houston does not have enough security to protect her if someone wants to get to her."

At that point, Nippy's team had to scramble and make some decisions. They consulted with more authorities in Washington, and again they were told, "Don't let her go." Someone went to Washington and talked with the authorities about the touring, and again, they were told, "She shouldn't go. You can't protect her." That's when they decided to post-

pone the European leg of her I'm Your Baby Tonight tour altogether.

A lot of folks who were involved in scheduling Nippy's tour were disappointed, but I wasn't. I felt a lot better when I heard she wasn't going on either the tour or any visit to the Gulf just yet.

Ever since John had become CEO of Nippy Inc., he seemed like a new man. He looked better, seemed healthier, and carried himself with more assurance. In many ways, his role as CEO seemed to be the answer he'd been looking for after his heart attack, giving him the sense of purpose that had been missing for him. He had put together a great management team for Nippy, and he was happy wheeling and dealing with industry big shots. The dreams he'd had since way back when he was pushing to manage the Drinkard Singers were finally coming true.

Nippy Inc. had opened an office in Fort Lee, New Jersey, and John was there a lot of the time, so we didn't see each other all that much. And I was busy, too, working with Nippy's foundation, directing the New Hope choir, and doing my gigs in New York. I also was still doing background singing, on records such as Bette Midler's *Some People's Lives* and Luther Vandross's *The Power of Love*. We didn't see each other as often as we used to, but I hadn't noticed any kind of change in the casual intimacy John and I had shared since we separated.

Sometime in the winter of 1991, though, John started keeping his distance from me. I had a strange feeling that

something was going on. And one day in February, when I was in the hospital because of complications with my ankle, I found out that I was right.

John had filed for divorce.

I was floored—surprised, and sad, and angry. We had shared so many wonderful years as a couple, and as a family—I just couldn't believe John would throw all that away. I knew he'd been seeing someone, but I honestly never thought he would actually divorce me. I just couldn't imagine it.

I knew that our children had long harbored hope that he and I would get back together. And I had let myself believe that it was not only possible, but even probable. Most people still didn't even realize we were separated—when we went on tour with Nippy, John and I shared a hotel room together, and we still spent some weekends together. For a while, at least, it had felt like we were dating again. I knew John better than anyone on this earth, and no one knew me better than he did.

But ultimately, I guess I didn't know him as well as I'd thought. I had always believed we had an unspoken understanding that, even if we lived apart, we would remain husband and wife—we would still always be the Houston family. When I received those divorce papers, though, that was the end of that. Laid up in the hospital, shocked at this new turn of events, I felt sad and angry. And of course, when I looked back, I finally realized that the new air of confidence John was exuding wasn't just about his work. It was at least partly about the fact that he had gotten involved with a woman much younger than he was.

Gary, Michael, and Nippy were just as shocked as I was.

But the boys wouldn't take my side, and although it hurt, I couldn't really blame them. After all, the whole time they were growing up, John was always there for them. While I was out working and touring, trying to bring home enough money to pay the bills, he was at home being Mr. Mom. John was the one who took care of their scrapes and problems, and I was the disciplinarian who was so often away. It was no wonder they couldn't bring themselves to put blame on him.

Now, Nippy was another story. She was angry. Bae later told me she was there when Nippy found out the news, and that Nippy called John right then and told him, "If you divorce my mother, you divorce me."

Nippy must have been upset to say that, because she adored her father, and while I was comforted to know my daughter was taking up for me, I also knew that John was doing a good job as CEO of Nippy's company and that she needed him. Nippy clearly knew that, too, because John stayed in his position. Ultimately, Nippy didn't pick sides between us—she was torn and didn't know what to do, but then again none of us did. Frustrated as I was, deep down I didn't really want Nippy to stay mad at her father. No matter how angry or disappointed I was, it didn't make any sense to drive a wedge between John and my children, though I admit that sometimes I would have liked to.

Still, I was so hurt. John and I were friends who had shared some wonderful and difficult times. Our arrangement following our separation might have been unspoken, but it had gone on for so long that I felt I had every right to be upset. In my anger, I decided I wouldn't make it easy for him to

divorce me. I responded to his divorce papers with a lawyer, and over the next year, I did everything I could to slow the process down. John wasn't going to get away without a fight.

Now that Nippy wasn't going to the Middle East with the president, she wanted to find another way to support the fighting forces there. For a while, HBO had been begging Nippy to do a special, but she had always said no, since there wasn't any real reason to stage another concert in addition to the ones she did on her tours. That's when John had the idea for Nippy to do an HBO television special for the troops.

The result was the *Welcome Home Heroes* concert, which was scheduled for March 31, 1991—Easter Sunday. By the end of that February, a cease-fire had been declared in the Gulf War, so the concert was planned as a tribute for troops returning from the Middle East, with Nippy doing a live performance in a huge hangar at the naval air station in Norfolk, Virginia. It would also be Nippy's first solo televised concert.

That morning, there was a sunrise service on the USS *Dwight D. Eisenhower*, a giant aircraft carrier docked at the base. I was invited to sing at the service, but there was only one problem. I was still in a wheelchair because of my ankle, and that big old ship didn't have any kind of elevator on it. I don't like the water, and I had never been that close to a navy ship before, so I didn't realize just how high up a carrier deck was.

"How am I supposed to get up there?" I asked. "Don't worry," a handsome young marine told me. "We'll take care of you."

And they did, too. Four young men just picked up my wheelchair and carried me up more flights of stairs than you can imagine. The stairs were on the outside of the carrier, and I was so scared—we just kept going higher and higher, all I could do was try not to look down. But they didn't even break a sweat, and when we finally got to the top, they just put me down so gently, like it was nothing. I don't remember what I sang at that service, but I can tell you that whatever it was, it was a song of thanksgiving for me that day.

That evening, I went to the concert in the hangar, and everybody there had to go through metal detectors and security. It was a long day for me—performing at the break of day, getting carried up and down the side of that ship in my wheelchair, and then going through all that tight security just to get into the hangar. But it was worth it; crippled and all, I got to see my baby sing. As I was wheeled in, I looked around at the hangar and all those military people, and I said, "All this, just for my baby girl." My little girl from Newark, New Jersey.

Of course, Nippy was sensational, at her absolute best onstage that night. Wearing a blue flight suit with her name on it that the aviators had given to her, she opened with "The Star-Spangled Banner"—and everybody in that hangar just about went crazy. Only Marines and sailors who had served in the Gulf were invited to the show, and a bunch of them were trying to give her the hats from their dress uniforms. Nippy sang about a dozen songs, ending with a gorgeous rendition of "The Battle Hymn of the Republic," while John and I sat side by side, the proud parents watching our incredible daughter. In the years after, she often said that the

Welcome Home Heroes show and visiting the troops were among the greatest experiences of her career.

The concert was televised live and broadcast by satellite to our troops who were still in the Middle East. Nippy had also performed a show the night before, as a safety for the live broadcast. But as it turned out, the safety wasn't necessary. The live event was overpowering, and HBO even unscrambled their signal so more people could see the show. And just as she had done with her proceeds from the national anthem single, Nippy donated the proceeds from the video sales of the HBO special to the Red Cross.

I think people appreciated what Nippy did even more because it was obvious how deeply she felt about it. A few days before the concert, Nippy had been flown out to another carrier, the USS *Saratoga*, whose crew had suffered casualties in the fighting, to personally welcome some of the returning troops. There were thousands of people on that ship, and she must have shaken hands and signed autographs for every one of them. She also served food in the mess hall, hung out in the infirmary, sang for the guys, had a great time listening to some of the guys sing for her, and spent the night on the carrier. Even after she left, she couldn't stop talking about how much fun she had and how kind those sailors and marines had been.

The next day, when she was scheduled to fly back to Norfolk, her navy escort told her, "We can take you a back way to get on the helicopter. You don't have to go out and greet everybody all over again."

She just looked at him and said, "Now, why would I do that? The whole reason I'm here is to see them!"

Nippy went right out onto the carrier deck, where a huge crowd of sailors and marines broke out in cheers. And when she boarded the helicopter, they spontaneously saluted her hundreds of men and women, showing her their respect and gratitude just for having taken the time. Nippy looked out at all those faces and burst into tears.

A couple of weeks later, Nippy launched the U.S. leg of her *I'm Your Baby Tonight* tour in Knoxville, Tennessee. I was still laid up, so I couldn't go on the tour with her, but John, Michael, and Bae were there from the start, and I did eventually manage to get to a few shows. It wasn't always easy being around John, since I was still upset with him, but we kept things as light as we could.

As always, Nippy was in good hands, but there were still some scary moments on that tour—in particular, one incident in Kentucky that made me want to get out of my wheelchair and go kick someone's butt.

Nippy and Michael told me it all started when they were at the hotel lounge one night, hanging out with their security guy David Roberts and a few other people. Nippy had just finished a show, and they wanted some time to themselves, to unwind. But there were two guys there who wanted to get an autograph or talk to Nippy, something like that. They were fans, but they had been drinking a lot, and they just wouldn't let up. Finally, Nippy got tired of dealing with it. She decided to go upstairs, and she and David left the rest of them to finish their drinks in the lounge.

Later on, when Michael and the others came upstairs, they discovered that these two guys had somehow gotten

on Nippy's floor. They weren't supposed to be there, as the whole floor was supposed to be secured. These guys, who were white, were drunk by now, and one of them said something racial to Michael. Michael tried to ignore him, but the guy wouldn't let it go, and he started saying other stuff and getting all up in Michael's face. As I mentioned before, Michael's like me: he's got a temper. If you push him too far, you're going to know it quick.

Michael stepped toward the man and asked, "What did you say?" And suddenly the guy went after him and it was a fight. Michael got scratched or cut somehow, and he started bleeding all over the place, which only made him more angry. As they were punching each other, Michael suddenly grabbed the man and picked him up near the top of a spiral staircase. Aunt Bae heard the shouting in the hallway and came running out, and when she saw Michael holding that guy aloft at the top of the stairs, she knew all hell was about to break loose.

Now the other guy rushed in, too, and things were threatening to turn into a full-scale brawl. Nippy's security man finally heard the commotion, so he ran out and mixed it up with the guy who was scuffling with Michael. And then Nippy appeared. She came running out of her room, and when she saw Michael bleeding, she just about went crazy. Though Nippy didn't like confrontation, if anybody tried to mess with someone in our family—particularly Michael or me—you can bet she was ready to fight.

Because her security was wrestling with one of the guys, there was no one to hold Nippy back—she grabbed a lamp from a table in the hallway and started screaming, "You get

off my brother!" She charged up behind the guy fighting with Michael and, well, the next thing anybody knew, he was on the floor. I'm not saying how, because I wasn't there and I don't want to stir up a legal hornet's nest. But that man went down. And just after he went down, Aunt Bae did, too. She was trying to pull Nippy out of the craziness, and Nippy didn't realize she was there. When Nippy stepped backward onto Bae's foot, she broke Bae's toe.

"What you doin'!" Michael shouted at Nippy. "You could've got hurt! Mommy would have killed me if anything happened to you." He was right about that; if anything had happened to Nippy on the road, you can bet somebody would have paid for it. But outside of Bae breaking her toe, everybody was fine. One of the guys threatened to sue, but nothing ever came of it. And in fact, he ended up becoming a topic for late-night television hosts when they showed pictures of this big, muscular guy alongside the skinny little girl who had supposedly knocked him out. That year, Nippy was at her peak, and it seemed like nothing, and no one, could ever knock her down.

CHAPTER II

The Bodyguard ... and Bobby Brown

fter Nippy finished her *I'm Your Baby Tonight* tour, Kevin Costner started calling her. A few months earlier, he had sent her the script of a movie he wanted to make, and ever since, he'd been trying to convince her to star in it with him.

At first, Nippy didn't want to do *The Bodyguard*—and Clive Davis didn't want her to, either. Clive had read the script, about a famous singer named Rachel Marron who falls in love with her bodyguard, and he thought Rachel was a diva. Clive was worried that if Nippy did a good job playing her, people would just assume it was because she was a diva herself.

Kevin kept on pushing, though, because he didn't want to

make the movie with anybody else. Though he didn't know her, he was convinced she was the one for the role. So when Nippy's tour came to an end in the fall of 1991, he kept on calling until she finally agreed to do it. The way the agreements were drawn up, Nippy took very little money up front, but she got a great deal on the back end and the soundtrack. Once Clive had a chance to review the music deal, he didn't waste any time deciding this movie was a pretty good idea after all.

The movie's producers asked Nippy to fly out to Los Angeles to test with Kevin to see how they looked together on camera. Because Kevin had so many recent hits, movies like *Bull Durham* and *Dances with Wolves*, he had a lot of clout in Hollywood, so the role was already Nippy's, just because Kevin said he wanted her. She went out for a screen test anyway, though, because that was what the studio wanted. And she was anxious. You know, she had never done anything but small TV roles before, little guest spots on shows like *Silver Spoons* and *Gimme a Break*. So, as talented as she was, Nippy hadn't faced a challenge on this scale in a long time. She wasn't one to let fear keep her from trying something, but this was the kind of big risk that made her second-guess herself. So I did my best to encourage her.

"Just put your mind to it," I told her. "You can do anything you want to do." She might not have believed it quite yet, but I did.

When she arrived for the screen test, Kevin could tell she was nervous, so he just told her, "Be yourself. Be natural." He said that wherever she'd pause in regular conversation,

that's where she should pause in her lines. "Just say it like you're speaking to a friend," he told her.

And that's what she did. In the end, she was so natural onscreen and looked so good with Kevin, the studio couldn't wait to go. They scheduled shooting to start in the late fall of 1991.

In the meantime, Nippy was still riding high after *Welcome Home Heroes* and her *I'm Your Baby Tonight* tour. And that summer, *People* magazine had also chosen her as one of their 50 Most Beautiful People. I'm not sure that really impressed her one way or another, but it seemed to impress pretty much everybody else, as I found out one morning.

I had been sleeping, and when I woke up I saw some doctor on television drawing lines on a giant picture of Nippy's face. What was going on? Had something happened to Nippy? I was still half asleep, and all I could think was, *What in the hell is that man doing to my baby*? But as I focused on the screen, I finally understood that the doctor was a plastic surgeon, and he was pointing out the lines and symmetry on Nippy's face, saying it was as close to a perfect face as possible. I just laughed. I knew Nippy was beautiful, but I never in my life would have imagined waking up to find a doctor on TV telling the whole world how perfect she was.

In an interview for the *People* magazine article, the reporter asked Nippy about the ring on her finger, trying to get the lowdown on who she was dating by saying, "And who is going to be your baby tonight?" Nippy just smiled and answered, "He knows who he is."

Well, we in the family knew who he was, too, and most

of us weren't all that happy about it. After meeting Bobby Brown at the Soul Train Awards in 1989, Nippy had invited him to her twenty-sixth-birthday party in Mendham later that year, and pretty soon they started dating.

At first, it seemed pretty casual. Bobby was six years younger than she was, and he didn't really appear to be the settling-down type, if you know what I mean. They would see each other when he was in New York or if they happened to be in the same town. Occasionally she would travel to visit him, but that didn't happen too much; they just had very different lifestyles. Something seemed to change, though, after she sang the national anthem at the Super Bowl. Suddenly they started seeing more of each other.

In the time that Nippy and Bobby had been dating, I'd had a chance to learn a little bit more about him. I'd heard that as a kid in Boston he'd grown up rough, and supposedly he even got shot once at a block party, which didn't impress me very much. I also learned that he already had a few kids, and there were lots of rumors flying around the music world about his supposed bad-boy reputation and other female artists who had a thing for him.

Bobby could be charming, there was no doubt about that. And I'm sure when he turned his attentions on Nippy, she liked it, especially since he had that image of being such a street-smart tough guy. I don't know, maybe that was the reason she liked him. Maybe she got tired of that middle-class, churchgoing, good-girl image she had. She'd been telling everybody a few years earlier she was from "the bricks"—well, here was somebody who really was from the bricks. And he had chosen her.

After Nippy and Bobby got serious, there wasn't a whole lot of conversation with Nippy about Bobby being bad for her. I'd told her early on that I didn't know if he was the right choice, and I think that's how most everyone around Nippy felt, but it wasn't something that kept coming up over and over again. People close to her knew it might not be the best choice, but it was what Nippy wanted. And eventually, I was willing to support whatever Nippy decided to do when it came to taking the next step with Bobby. If they were going to get married, I wasn't about to try to talk her out of it.

When she began shooting *The Bodyguard* in Los Angeles during the last months of 1991, Nippy was already secretly engaged to Bobby—and had been since April. Very few people outside the family knew about the engagement, but when I'd first heard the news, I wasn't surprised. After they got engaged, they'd been able to keep it quiet because she wasn't on tour and she didn't announce it. In the months since, they'd actually set and postponed a small ceremony twice. Then, while Nippy was in Los Angeles filming *The Bodyguard*, she lived in a house with Bae, and her friends Carol Ensminger, Tommy Watley, and Robyn. Bobby was spending a lot of time out there, too. And that's when they chose the date for their wedding: July 18, 1992.

It was about that time that I got another shock from John. Just as Nippy started preparing for her own wedding, I discovered that John had gotten remarried, not long after our divorce had become final. He had married his girlfriend Peggy, and they had invited only a few friends. Not only did he not invite Nippy, Michael, and Gary—he hadn't even told them it was happening. I just couldn't believe it—both that he'd gotten remarried, and that he'd kept it secret from everybody, including his children. And what was worse, John then asked Nippy if he could bring Peggy to *her* wedding in July.

Now, John was a Virgo, so he wasn't above trying to hurt people. And he liked to control things, too. But he never could control me, and when Nippy was grown, he couldn't control her, either. She was still very close to John, but she didn't even hesitate. "You can't bring Peggy," she told her father. "Not if Mommy's gonna be there." Nippy wanted her wedding day to be a happy one for all of us, not some kind of drama-filled mess.

John didn't like that too much, and so he continued to press Nippy and everyone else he felt might have some influence with her, but Nippy was firm. He told her that he'd come alone, then, to walk her down the aisle. But he said he'd be leaving after that. And she told him she hoped he wouldn't actually do that, but if that's how he felt, then it was his choice.

The Bodyguard started shooting in Los Angeles, but in early 1992, the production moved to Lake Tahoe and Florida for location filming. By the time she got to Tahoe, Nippy was pregnant. But when she got to Florida a few weeks later, she had a miscarriage.

It was so early in the pregnancy that Nippy hadn't even been showing, and she hadn't told anyone, so none of the movie people were even aware of it. But as soon as she told Kevin Costner and the producers, they shut down production for a week. I had no idea Nippy had even been pregnant

until she called me from Miami and told me the news. And then she said what I always hoped she would say. "Mommy," she told me, "I need you. Please come." I went straight to Florida, as she knew I would.

Nippy was in okay shape when I saw her. She was sad, of course; she had wanted that baby, but it was early enough in the pregnancy that she felt pretty strong. She wanted me there, and she wanted her daddy there, too. So she'd called John to come, too, and he did.

Even with everything John and I had been through, we couldn't help but get along most of the time. He was a dog, and would sometimes tease me about his supposed "size two" wife, who was younger than the milk in my refrigerator. I mean, if he was fool enough to want that, there was nothing I could do to set him straight. But I did poke at him a little bit about how he'd come down in the world after me, and despite everything, he had to laugh.

After a few days of rest, Nippy was feeling better and the shooting resumed. And so I was lucky enough to be there in Florida when they filmed Nippy, as Rachel, singing "I Will Always Love You." Kevin Costner had chosen the song, which was written and originally recorded as a kind of country ballad by Dolly Parton. Nippy didn't like the song when she first heard it, but Kevin loved it and asked her to give it a try. Together with producer David Foster, Nippy rearranged it as a soul ballad, and as they worked on it she grew to love it. Everyone loved that song, especially Clive Davis, who declared that he thought it would be bigger than anything Nippy had done yet.

Well, I didn't know about that. Nippy's rendition of

"Greatest Love of All" was one of the most beautiful songs she ever recorded, as far as I was concerned, and it had become her signature song. I didn't think anything could surpass it. But Clive was convinced, and in fact he came down to Florida to see Nippy sing it for the movie.

Ordinarily, Nippy would have recorded the song in the studio, and then the movie folks would have shot it. But they had decided to do things a little differently this time. They wanted to record Nippy singing the song as they were shooting it, right there on location, because they thought it would have more power and emotion if Nippy did the song in character, as Rachel.

The day they shot it, at the Fontainebleau Hotel ballroom in Miami Beach, I went to the set to watch. The first thing I thought when I saw Nippy was, *Damn, she is just so beautiful*. And then I thought, *That's my daughter!* Some things just don't seem real, you know? You could see people on the set stopping to stare when she went by—and these were people who had seen plenty of movie stars. But Nippy was just a gorgeous girl, inside and out.

Then she stood up there on the stage and sang those first notes—"If I should stay . . . I would only be in your way" and I just started crying. I cried because that song was so beautiful in the first place, but Nippy turned it into something else entirely. She just turned it around from the way Dolly Parton had sung it and made it a whole other thing. As a mother, when you think of the trials and tribulations you've tried to bring your child through, it's just emotional. You cry. That's what mothers do.

But the other thing about that song is, it's a song of good-

bye. "I will always love you" . . . yet I can't be with you. John and I were both here, both watching our daughter sing, and the tears were just rolling down my face. I couldn't even look at John, and I surely didn't want him to see me crying. But I couldn't stop. I was thinking of him at that point—thinking about how even though we would never be together again, I would always love John, and he would always love me. And we did. We did.

That July, Nippy and Bobby got married at her estate in Mendham. It was a big, beautiful party on a gorgeous summer day, and even though John had threatened to leave right after the ceremony, he ended up staying for hours, like I knew he would. And you know, we actually ended up having fun together. It was just that kind of a day.

Everybody started smiling the minute Michael's two-anda-half-year-old daughter, Blaire, started walking down the aisle. All the flower girls and other kids in the wedding had gotten their hair combed and fixed before the ceremony, but Blaire stamped her feet and refused. The child just wasn't having it, and although Nippy was a little put out at first, she finally said, "Okay, if Blaire doesn't want to get her hair done, just leave her alone."

So when Blaire started coming down the aisle, she was just skipping around with her wild hair bouncing all over the place. She was tossing her flower petals left and right, everywhere but where they were supposed to be, and everybody watching couldn't help but laugh.

When John walked Nippy down the aisle, I wasn't thinking about Bobby's past, about whether he was right for Nippy, or about whether he was a so-called bad boy. I put aside whatever hesitations I'd felt, and the only thought running through my mind was that I couldn't believe how beautiful my daughter was. Bobby was up at the front watching her, and he must have thought so, too, because the tears just started spilling out of his eyes. As worried as I was about what kind of husband Bobby Brown would be, I have to say that on that day, he seemed completely devoted to Nippy. The two of them seemed in love, and as the gospel singer and pastor Marvin Winans, who was a close family friend, went through the ceremony, Bobby kept asking, "Can I kiss her now?" He'd keep reaching for her, with a big smile on his face, and Marvin would say, "Not yet, son."

Finally, at the end of the ceremony, Bobby asked again, "Now can I kiss her?"

Marvin started laughing and said, "Yes, you can kiss her now," and Bobby picked Nippy right up off her feet as everybody stood up and clapped. For better or for worse, my baby was married.

The reception was on the lawn, and there were lavender flowers everywhere—Nippy's favorite color. She had asked me to welcome the guests, so I gave a little speech and toast. After everybody got a little bit of champagne in them, people hit the dance floor—even, at one point, John and me together. It was a beautiful night, and the party just went on and on. And there were so many people there who loved and supported Nippy—Clive Davis, Dionne, Kevin Costner, the Winans family, and all our family, of course. If the future of a marriage could be predicted by how good the wedding was, this one would have gone on forever.

The next day, Nippy and Bobby left for their honeymoon, a ten-day Mediterranean cruise that was a wedding gift from Arista and MCA. Nippy wanted some company other than Bobby, though, so she invited her brother Michael and his wife, Donna, to come along, too. I'm not sure Bobby was all that keen on having his new in-laws come along for the honeymoon—I know I wouldn't have been—but they all got along really well and often did things together. Michael loved it, too, and he loved telling funny stories about their time on that yacht.

One day, Michael said, he, Nippy, and Bobby went out on Jet-Skis. Nippy and Michael always loved the water, because of that pool we had on Dodd Street. They were both good swimmers and loved oceans, lakes, pools—anything where they could get wet. But Bobby didn't know how to swim, and when he accidentally turned over his Jet-Ski in the Mediterranean, he panicked. Michael said that Bobby, who was never in any danger, kept screaming "Help me! Help me!" while Michael and Nippy just sat floating nearby on their Jet-Skis, cracking up. Bobby was mad, and while he didn't talk to Michael for the rest of that day, for the most part they had a great time.

When they got back from their honeymoon, Nippy and Bobby went right back to work. Nippy was finishing the soundtrack album for *The Bodyguard*, which would come out just before the movie in November. And Bobby was planning a tour to promote his new album, *Bobby*, which had come out just before the wedding.

Now, I knew Bobby had some success as a singer. I knew his group New Edition was popular, and that kids seemed to

think he was cool. But I really didn't care for his music. And I especially didn't understand the appeal of his big hit song at the time, something called "Humpin' Around." It may have been successful, but I couldn't stand that song or the video he made to promote it, where he was dancing and fooling around with a bunch of women on camera. I understood that Bobby's stage act involved suggestive dancing and all that mess, with dancers and even some audience members, but a lot of people thought that "Humpin' Around" went a little too far.

If you look at Nippy's songs, they're all about love—"The Greatest Love," "I Will Always Love You," "Saving All My Love for You" . . . Nippy sang about things that lifted you up, that meant something. From the time she was little, I always counseled her to pay attention to lyrics, and so she always tried to sing songs that had purpose and meaning to them. I don't know what other people thought, but I'm not sure a song called "Humpin' Around" had either purpose *or* meaning.

I still wasn't sure what to think about Bobby at that point, but all we could do was hope that Nippy would be happy with him. There wasn't much anyone could do now except wait and see how things would turn out.

164

CHAPTER 12

"I Never Asked for This Madness"

 \mathbb{Z}^n the fall of 1992, just a few months after the wed-ding, Nippy announced that she was pregnant, and after what had happened before, I hoped and prayed that this time everything would go well. At least the timing was good-instead of all the stress of traveling and shooting a movie, she'd be able to stay at home in Mendham while she finished up work on The Bodyguard soundtrack. And Bobby had gone on tour for his record, so Bae moved in with Nippy to look after her. I knew I could trust Bae to take care of Nippy, and she did. Bae looked after Nippy like she was one of her own.

Bobby's tour started around November, and my sons Gary and Michael both went with him, Gary to sing background,

and Michael as part of security. They were scheduled to be on the road for four months, traveling across the country from New York to California. I never saw any of those shows, of course, but Michael liked to talk about them when he got back. After touring with Nippy for so long, he was amazed at how different it was to be on the road with Bobby.

When Nippy was on tour, she was a big enough star to have absolutely everything she needed—the best accommodations, luxurious tour buses, all kinds of staff and security, and pretty much anything else she had a mind to ask for. Bobby's tour was a little more shoestring. And it was more like those old shows at the Apollo, where there were four or five acts leading up to the headliner. Those shows could go on for hours, and they always ended very late at night.

Compared to a Whitney Houston concert, where singing was the main attraction, Bobby's stage act was more about the dancing and entertaining. People said he had a natural talent as a dancer, and he had that rough edge that some people seemed to love. He would invite girls up on stage from the audience, and when he did his "Humpin' Around" thing, it got him in trouble with the authorities once or twice. And Michael said that unlike Nippy, who usually wanted to go back to the hotel and just hang out with friends after a concert, when Bobby finished a show they would go out and party with his crew.

Nippy was a little nervous about being at home, pregnant, while Bobby was out on tour, so she asked Michael to just keep an eye on him and make sure he remembered he was a married man now. Bobby had been an entertainer since he was very young, and he definitely knew how to enjoy drink-

ing and partying. Just knowing that was enough to make Nippy anxious.

Yet although Nippy was sometimes nervous about what Bobby was up to, there were also moments when it was clear how much Bobby really did love her. Once, Nippy threw a party at the end of one of her tours. Bobby was there and I happened to be there, too. Bobby was drunk that night, but not falling-down drunk, and he just wandered around with a big silly smile on his face. Someone had given him a bottle of very old Scotch, and he walked around carrying that thing, offering it to anybody who looked thirsty.

At one point in the evening, he walked right up to me and said, "I am married to Whitney Houston." He was smiling so big, like he had just won the lottery.

I just touched his face and said, "Bobby, if you want to continue to be married to her, you'd best go on to bed."

At moments like that one, I did like Bobby—there was something childlike about him. I always felt that starting in the music business as early as he did led him to live out his teenage years in his twenties. But even though Bobby had done his share of bad things, and I didn't like the way he sometimes treated Nippy, I thought deep down he was a good person. I still believe that.

The whole time Nippy was pregnant, she just looked so healthy; she had a glow. And she sang her ass off, too, just like I'd done when I was carrying her. She recorded the video for "I Will Always Love You" when she was about six months along, sitting in a chair and leaning forward to hide her pregnant belly. I think she enjoyed being pregnant, although by the last couple of months, when her feet and legs started swelling up, she was ready to be done with it.

And she was also scared about giving birth. Nippy couldn't take any kind of physical pain, and even when she had bad cramps she'd just stay in bed all day. I don't think she'd ever really thought about what it was like to actually have a baby, but now that it was about to happen, she was scared of the pain.

She went into labor on March 4, 1993, and I went to St. Barnabas Medical Center, in Livingston, New Jersey, to be with her. I was with her there in the delivery room, and she was so tired, just holding my hand and crying. "Maaa!" she wailed when the pain got too bad. All I could say was "It won't be long now, baby. Just hang in there." After hours of labor, the doctors finally gave Nippy a Caesarean, and she gave birth to a beautiful little girl.

They named her Bobbi Kristina—which was a hell of a lot better than what they'd initially chosen for her. A few days earlier, when I had asked Bobby and Nippy what they were naming the baby, Bobby said some kind of crazy name I couldn't even pronounce—*Tekatia*, or *Takeka*, or some mess like that.

"Oh, no," I said, giving him a look. "That is not happening. You can't do that to that poor child!"

Nippy said, "Mommy!" but she couldn't help herself—she cracked up laughing.

"That child will have to carry that name through her whole life!" I said. "You are not giving my grandbaby that name!"

And Nippy, still laughing, said, "Mommy, he's her father!" I said, "I don't give a damn if he's Houdini! That is not happening! That name is not coming into this family!"

"Well, what do you want to name her, then?" Nippy asked.

"I don't know! Just name her Christina or something, some nice name like that," I said. And so they ended up naming her Bobbi Kristina—because I suppose Christina with a *C* was still too conventional for them.

Bobby may have given Nippy some flak later about all that, but I didn't care. That was some flak she had to take. I still feel like I saved Bobbi Kristina, who we called Bobbi Kris for a while, and then just Krissi, from a lifetime of trouble with that other name.

Oh, how we loved that baby girl—everybody, from Nippy's friends to family to people who worked for her, just couldn't get enough of that child. She was so pretty, and such a sweet baby, laughing and smiling all the time, that people always wanted to see her and hold her. A few months after Krissi was born, Nippy called me, pretending to be all huffy. "What's up with all this?" she complained. "Nobody ever comes to see me anymore—it's always, 'Where's Krissi? Is Krissi up?'" But I could hear the smile in her voice— Nippy was so proud of that baby. And she spoiled her half to death.

Of course, I loved Krissi as well, but I tried not to indulge her too much. When she was just a little thing, maybe a year old, we did a cover shoot for *Ebony* magazine in Phoenix, where Nippy was shooting *Waiting to Exhale*. We were sitting by a pool, and the photographer was trying to get a

good photo of the three of us, but Krissi was acting out. I was holding her, but she just kept on squirming and whining, no matter how we tried to calm her down.

Finally, I said, "Okay, that's it. Nippy, I'm just going to throw this child into the pool." And Nippy busted out laughing. Krissi quieted right down, and because Nippy and I were both cracking up, the photographer quickly snapped a couple of shots. On the cover of the May 1995 issue of *Ebony*, there's a beautiful photo of Nippy and me laughing, with little Krissi just looking straight into the camera like the best-behaved child you ever saw.

Just four months after Krissi was born, Nippy went on tour again, this time to promote the soundtrack to *The Bodyguard*. Even though she was a new mother with a new baby, Nippy never had any debate about the travel arrangements: she was taking Krissi on the road. When Nippy was busy with her responsibilities, Bae took care of Krissi and made sure she had everything she needed or wanted. It didn't take long for traveling with Krissi to be perfectly normal, and by the time she was a year old she'd already been around the world.

Fun as it was for Nippy to have Krissi with her, that tour in 1994 was tough. Ever since the release of her first record back in 1985, Nippy's life had been a constant wave of concerts, interviews, promotions, awards shows, and everything else. Nine years of all that, plus having a new baby, was taking its toll on her—and on her voice.

A few weeks after the tour started, in mid-July 1994, Nippy was scheduled to perform at the closing ceremony of soccer's World Cup, which was held that year in Los Ange-

les. This was a big concert at an outdoor stadium, for a lot of money, but Nippy's voice was shot.

This wasn't the first time something like this had come up. Nippy was getting older, and from time to time, it showed in her voice. When she was nineteen or twenty, she'd get hoarse every now and then, but the next day she'd bounce back just fine. Now that she was thirty, though, things were starting to change, and her voice required a little more healing time.

She felt so bad about letting everybody down for this World Cup concert, she just didn't know what to do. So she told one of her assistants who was traveling with her, "Call Mommy. I need her here."

I took the first flight I could get to Los Angeles, and when I arrived at Nippy's hotel, I went straight to her and pulled her into my arms. Nippy started to cry. "Mommy," she said, "What am I going to do?" We sat down on her couch, and she laid her head in my lap, like she'd done when she was a little girl, and the tears kept on coming.

Nippy was in a state, because even though her throat was a mess, the promoters kept pushing her to perform. She had seen a doctor, who advised her that her throat was ulcerated and she risked permanent damage if she didn't give her vocal cords a rest. The doctor wanted her to cancel not only the World Cup concert, but the next two weeks of shows, too.

As was standard practice for big outdoor events, Nippy had made a safety tape just a few days before her voice gave out. She always hated doing it, but the contract required it, and in this case it was a good thing she had. The promoters really didn't want to use it, but the next morning when we all met, I just said, "We are going to use that tape." And then, turning to Nippy, I said, "Your doctors have told you to cancel the next two weeks of shows while your throat heals, so that's what you're going to do. Your team will take care of whatever comes after that. Don't you worry."

Now, up to this point, Nippy had rarely missed shows and whenever she did miss, it was never for a frivolous reason. She knew that people were depending on her, from the band to the crew to the people who paid good money to hear her sing. If she took a night off, she understood that the ripple effect went on and on, affecting hundreds if not thousands of people. And she took that very seriously.

If we were going to cancel the next two weeks of her tour, it meant we had to get all her band and crew back home, and they would be out their pay for those two weeks. Nippy was miserable. "These people are counting on me, Mommy. They have families to feed," she said. "But I just can't do it." She couldn't stand to leave them hanging, so she worked out a financial arrangement with everyone for those two weeks. It wasn't something she was required to do, but she just believed it was the right thing to do.

Nippy did perform at that World Cup concert as scheduled, but it was the one time she actually allowed the safety tape to be used. As much as she hated it, she knew that in the end it would have been worse not to do the concert at all.

Nippy's brother Michael was often on tour with her, and he was constantly amazed at how she pushed herself to perform. "Hundreds of people on payroll, thousands of fans, show after show after show," he'd say. "And it's all on Nip's

skinny little shoulders." He didn't see how she could hold up. I think at this point, she was probably starting to wonder about that herself.

She was thirty now, and she had a husband and a baby and all the money she would ever need. She had done more, seen more, than most people ever get a chance to in life. She didn't talk to me about it then, but I later learned that Nippy seriously considered walking away from it all after Krissi was born. She was tired.

Everybody was pulling at her all the time, and Nippy was someone who just couldn't be rude to people. She'd be sitting at a restaurant, or walking to her car, and people would go right up and grab her to take a picture—without even asking or saying a damn thing to her. On planes, the flight attendants would even ask her for autographs. After *The Bodyguard* came out, Nippy, who was already one of the most famous people in the world, somehow became an even bigger star. Even if she wanted to walk away—where was she gonna go?

She would sometimes say to me, "Ma, I'm tired." And I'd tell her, "Baby, you don't have to keep doing this." But this was the business she had chosen, and maybe she didn't know how to leave it. One time, she was looking out a window, just thinking, and she said, "You know, I never asked for this madness. I couldn't have imagined it." There was no way anyone could have prepared for what she ended up going through.

The truth is, all Nippy ever wanted to do was sing. But because she was so gifted, and so beautiful, just singing wasn't

ever going to be an option. "God was good to you, baby," I told her. I wouldn't be surprised if sometimes she wished otherwise.

Yet Nippy always had a sense of responsibility about it. No matter how tired she was, or how much her throat was bothering her, or how much she just wanted to stay at home with Bobby and little Krissi, she always came through for her fans. She gave her all, night after night after night.

Because he'd come into the business as a child, Bobby had a different attitude about these things. He'd tell Nippy she didn't have to go to work if she didn't want to, even though she'd made a commitment—that she didn't have to serve "the Man." After he finished his "Humpin' Around" tour, Bobby was taking it easy, and he told Nippy she should, too.

Once, I was with Bobby and Nippy when she had been tired and complaining. He started urging her to renege on one of her commitments, and I let him know exactly what I thought about it.

Nippy had been booked to sing several nights running in an Atlantic City casino after the release of *The Bodyguard*. But when the movie turned out to be such a huge success, Nippy did so much press and performing that the last thing she wanted was to go sing three nights in a row in a casino. She never liked those kinds of venues, and the money really wasn't worth it.

Atlantic City was just a two-hour drive from my house, so I went to see Nippy while she was there. We were all in the hotel together, and Nippy was complaining about having to do those shows. "I'm so tired," she said. "I just wish I didn't have to do them." I was all for Nippy taking time off

174

when she needed to, but once she'd made a commitment, she needed to honor it. And I told her that.

When Nippy left the room for a minute, Bobby piped up. "She doesn't have to do these shows. What are they gonna do, blackball her?" He puffed himself up and said, "They tried to blackball me, and *I'm* still here."

I just lowered my chin and looked straight at him. "Mmmhmm," I said. "And where are you working now?"

Bobby didn't like that too much, because he apparently complained to Nippy about it. She came up to me later that night, trying not to giggle, and said, "Ma! What did you say to Bobby? You hurt his feelings!" We both just burst out laughing. She loved him, but she knew when he was being ridiculous.

In October 1994, Nippy got the tremendous honor of singing at the White House. That would have been amazing enough for anyone, but even better was that she was going to sing at a State Dinner for one of her personal heroes, Nelson Mandela.

Nippy really cared about the struggles black people were facing in South Africa, and she had for some time. As I mentioned earlier, when she was modeling as a teenager, she wouldn't work with companies that invested in the apartheid regime. She was also one of the first artists to commit to performing at Nelson Mandela's seventieth-birthday concert in 1988, when he was still in prison. Not only did she perform there, but she actually canceled a concert date in Italy and flew specially to London to do it.

Mandela, who had since been released from prison and

elected president of South Africa, knew about Nippy's dedication to his cause. As much as she was a fan of his, he was a fan of hers, too. So when she came to that State Dinner and sang "People," "Love's in Need of Love," and "The Greatest Love," Mandela gave Nippy a big hug, and then asked her if she would come to South Africa to perform. Nippy couldn't say yes fast enough. She agreed to do three concerts in November 1994, which would make her the first major artist to perform in post-apartheid South Africa.

The mini-tour of three shows was named "Whitney—The Concert for a New South Africa," and Nippy pledged to donate all her proceeds from ticket sales to children's charities there, including orphanages and a museum that was led by people who'd taught black children to read during the time when teaching them was against the law. And because the *Welcome Home Heroes* concert had been such a success, HBO wanted to film one of her concerts in South Africa for another special. Nippy agreed, and so plans were made for her second concert, held at Ellis Park in Johannesburg, to be televised live.

Nippy asked me to come with her, but at first I didn't want to do it. I've never liked airplane travel, and Africa was a *long* way away. But when I thought about it, I realized how important all of this was. Nippy was going to perform the first live show for an integrated audience in South Africa that was a big deal, so I agreed to come over for the concert in Johannesburg.

Before I arrived, Nippy was scheduled to do a press conference and a show in Durban. She had the chance to meet Nelson Mandela's family there, including his daughter Zindzi.

She and Nippy hit it off, and Zindzi took her to Soweto to show her the house she grew up in, where Nelson Mandela lived with his family before his arrest in 1962. It was a humble house, with cement floors and holes in the walls, and Zindzi showed her where the family used to sit and have dinner in the tiny dining room, such as it was. Nippy was so moved, she and Zindzi just held each other and wept.

Nippy had never been to South Africa before this trip, but she felt a kinship with the land and its people that changed her. At a press conference she gave, announcing her donation to the children's museum, she teared up again as she spoke. "When I was a little girl," she told the crowd, "Africa was a place on a map for me. Now, it's a place in my heart."

Even so, South Africa was still a troubled place, and before the first concert in Durban, there were rumors of death threats. Apparently, people weren't unhappy with Nippy, but with how the concerts had been put together—who was investing and who was making money. There was some talk of delaying that first concert, but the security team convinced everyone they had things under control. Even so, when there weren't enough tickets for everyone, crowds gathered outside the stadium and threatened to riot. Nippy just went out there and did her thing, as she always did. She would never let all those people down—not after how many decades they had waited for a show like hers.

Johannesburg was next, and that was where I joined Nippy. I wasn't even over jet lag yet when she and I, along with our friends and family traveling with us, were invited to meet with Nelson Mandela at his office.

I'll tell you something, Nelson Mandela is an impressive

man. I could see why everybody loved him—he was a flirt, telling Nippy and me how beautiful we were and just laughing and smiling all the time. He told us about what it was like in prison, and how he survived it, and I told him how much my ex-husband John had always admired him.

"John couldn't come on this trip because he's been sick," I told Mandela. "He was so disappointed, because you have always been one of his heroes."

"Really?" Mandela asked. "What's his number?" And as we sat right there in his office, he picked up the phone and made the call. When John answered, he said, "Hello, John. It's Nelson Mandela here."

We couldn't see or hear John, of course, but I have no doubt that he just about fell out when he heard Mandela's voice. "I'm so sorry you couldn't be here with us!" Mandela said, then corrected himself. "Well, I'm a *little* bit sorry, but not really sorry. Because this way, I have both of these beautiful women all to myself!"

Mandela talked to John for about five minutes, kidding him about Nippy and me and going on and on about Nippy's smile. That call must have made John's day—how many people get a call from Nelson Mandela while they're having their morning cup of coffee?

President Mandela was as warm and welcoming as he could be, and he treated us like old friends. But I have to say, I was just as impressed with Winnie Mandela, whom we met separately because they were no longer together. Winnie and I got along like a house on fire, and when someone asked me later what she was like, I said, "Like me." Winnie

178

was tough. She didn't take no mess, and that's what I really liked about her.

At one event, I was standing nearby when a man asked Winnie about the kinds of things she'd done during the struggle for South Africa's independence. And Winnie looked right at him and said, "If I thought my mother had betrayed the people, and she came through that door right now, I would do all I could to destroy her." She was a fighter through and through, and you didn't have to spend very long with Winnie to understand what she was willing to do for her cause. I had to respect that.

The final concert was in Cape Town, and Bobby made a surprise visit. He hadn't been able to come for the first two concerts because of his own work commitments, but in the middle of that third show he walked out onstage—and Nippy looked stunned. Bobby and Nippy sat down on the stage steps and sang together, and it was a lovely moment between them. He stayed to the end of the trip, and of all the times I saw them together, this was one of the happiest I can remember—because soon, happy times like these were harder to come by.

CHAPTER 13

"I Know Him So Well"

fter *The Bodyguard*, people in Hollywood weren't worried anymore about whether Whitney Houston could act. So when the writer Terry McMillan was making her novel *Waiting to Exhale* into a movie, she got in touch with Nippy to ask her to be in it.

At first, Terry wanted Nippy to be Bernadine Harris, a woman whose husband was leaving her for another woman, but when Nippy read the script, she decided she wanted to play Savannah Jackson, a TV producer who was in a relationship with a married man. The producers had already offered that role to Angela Bassett, but Nippy felt she was more suited to play the role of Savannah than Bernadine, so she got down to business trying to make that happen.

Nippy sent Terry a dozen roses—her favorites, Sterling Silver roses with a touch of purple. She included a note that

simply said, "I'm Savannah." When Terry got back to her, she agreed: "Okay, Whitney, you can be anybody you want, if you'll just be in my movie!"

The production budget for *Waiting to Exhale* was small, just about \$16 million. After *The Bodyguard*, Nippy could have commanded more than half that amount just for herself, but she really wanted this movie to get made, so she agreed to take very little money up front. She was excited to get the chance to work with Angela Bassett, and with Forest Whitaker, who was directing.

Of course, Nippy also wanted to do the soundtrack. Clive Davis wanted her to record the entire album herself, but Nippy had other ideas. She told Clive she'd do one side, but she wanted some other artists, including young up-andcoming singers, to contribute songs to the other side. She figured that if the whole movie was about women being empowered, why shouldn't the soundtrack reflect that, too?

It was here that Nippy brought in her business smarts. A few years earlier, she and Robyn Crawford, who'd been around all this time—first as Nippy's executive assistant and now as her business partner—had founded a record label called Better Place Records. They had some bright young artists, with one in particular whom they wanted to highlight, and so they proposed having her do a song for the soundtrack. In the end, that record had a whole roster of great singers, mixing lesser-known artists with voices like Aretha, Mary J. Blige, Toni Braxton, Brandy, and Patti La-Belle. No matter what the movie did, Arista had to know that soundtrack was going to sell.

As it turned out, the movie didn't need any help. It opened

at number one in December 1995, and it made money so fast that Nippy started getting residuals on the back end even before the film was out of theaters. It opened during the holiday season, and women all over the country were lining up to take their mothers, daughters, sisters, and girlfriends to see it. And the soundtrack album, released in January, did even better.

The biggest single off that record was Nippy's "Exhale (Shoop Shoop)," which came about in a funny way. Babyface was writing most of the songs for the movie, but for this one, he wrote the music and just the first few lines. He gave it to Nippy and asked her to add some more lyrics, but when he checked in again a week later, she still didn't have anything. So when they started going over it, she just started singing, "Shoop, shoop," in place of where the lyrics would go. And everybody liked it so much, Babyface wrote the rest of the song around that phrase.

Nippy told me that she was having dinner with Forest Whitaker and the other girls from the movie—Angela Bassett, Loretta Devine, and Lela Rochon—at the Ivy restaurant in Los Angeles, when she suddenly decided she wanted to play them the song. The only CD player they had was in Forest's car, so they all just crowded in to listen. He turned the music up loud, and the five of them sat in the car listening, just like at the end of the movie. Nippy had a great time with those girls.

In fact, she had a good time during that whole shoot. The movie was filmed in Phoenix, and she was there with Krissi, with Aunt Bae living there, too, to manage the house. I got to come visit—that's where we did the *Ebony* cover shoot

with Krissi. And John and Bobby came and spent some time, too, although they both tried to avoid the set on days when Nippy was filming love scenes. Neither one of them could take too much of that.

Those months in Phoenix really were good ones for Nippy. She was in a good place in her life, and suddenly the issues between career and family, which only a few months earlier had been weighing down on her, didn't feel as overwhelming. She wasn't recording a new album every year anymore, and she seemed to have found a balance she'd been searching for between acting, singing, being the head of her own multimillion-dollar corporation, being a wife, and of course raising Krissi. She was doing projects that she was passionate about, and acting allowed for a different kind of schedule than touring and recording.

Unfortunately, all that good feeling didn't last, and it was shortly after she finished work on *Waiting to Exhale* that things started to get messy.

With two big movies, Nippy was now in demand as an actress as much as a singer. After *Waiting to Exhale*, she was asked to star in *The Preacher's Wife*, a Christmas movie about an angel who comes to earth to save a church and a marriage. The film was actually a remake of a movie called *The Bishop's Wife*, which had starred Loretta Young, Cary Grant, and David Niven, and this new version was going to have a little bit of everything, including gospel music, a love story, a great director in Penny Marshall—and Denzel Washington, of course.

Nippy really wanted to do the movie, but Bobby didn't

want her to. All during negotiations with the producers, he kept nagging at her not to do it, even though they were offering her \$10 million, which would make her one of the highest-paid actresses in Hollywood. The producers were desperate, offering her whatever she wanted in hopes of getting that signature on their agreement.

At one point, Nippy's agent even came over to talk to Nippy and Bobby together, to explain what a great opportunity this was and try to get him on board. Now, ordinarily, Bobby didn't dictate what projects she would do. Nippy would often ask him his opinion about her projects, but he rarely stood in her way. But for some reason, he was really vocal about not wanting her to do *The Preacher's Wife*; it was one of the only times I can remember when they seemed seriously at odds over one of her career decisions.

Nobody could figure out what Bobby's problem was. Who would turn down a payday like that, for a holiday movie with a big star like Denzel? It just didn't make any sense unless in Bobby's mind, Denzel was actually the problem. During one screening of *The Bodyguard*, Bobby had actually left the theater during scenes where Nippy's and Kevin Costner's characters were kissing. He just couldn't take it—he was too jealous. So I wouldn't be surprised if Bobby was jealous of Denzel, too, and maybe intimidated by him. Denzel was handsome, accomplished, and one of the most beloved actors around. And Bobby, like many men, might have been too insecure to want his wife to be around that.

But after weeks of back-and-forth, Bobby finally gave in. Nippy signed on to do the movie, and I was offered a small role, too, as the choir director Mrs. Havergal. Even though

we didn't have much screen time together, I was excited to be in a movie with my daughter, especially with all that gospel music and a church theme. I thought it would be fun—and most of it was. But as I found out later, Nippy was apparently struggling with drugs the whole time during that movie.

Even now, I don't really know what went on during the filming of that movie, or what Nippy was on. What I've been told by people who were there is that she had begun using drugs more frequently. Yet while it was apparently bad, it never interfered to the point of causing her to miss a shoot or be unprofessional—which would have been the only way that I could have found out about it. Whatever Nippy was doing, she certainly kept it out of my sight. Because not only did I not see any drugs, I also never saw any evidence of them in her behavior.

We had a lot of early-morning call times, and it was hard and tiring—you'd have to get up at two in the morning, get ready, and then they might not call you to shoot until five. Nippy had never been a morning person in her whole life, and she didn't start now. I knew she was sometimes late, and that she missed a few call times, but I really didn't think anything of it—those call times were one aspect of moviemaking that she always hated, and on each of her movies, there were moments during filming when she was late to the set. But that didn't seem so unusual. You know, I didn't particularly like getting up at 2 a.m., either, and it wasn't because I was doing any kind of drug.

Doing *The Preacher's Wife* was very emotional for me, because the music was dear to my heart. Nippy sang all the songs beautifully—and they were songs I loved to hear her

sing. And I got to do one, too: "The Lord Is My Shepherd," with the Hezekiah Walker Choir. For me, that whole period is one I remember happily. I had no idea how bad it already was with her, or how much worse it was about to become.

The Preacher's Wife came out in December 1996, and for one reason or another, I didn't see Nippy for a while after that. She shot the TV movie *Cinderella* in the spring, but it was an incident afterward, in the summer of 1997, that I believe changed things for her.

She and Bobby had decided to go on another cruise with Michael and Donna that summer, like the one they'd taken for their honeymoon. They were on a yacht in the Mediterranean, and sometime during the night of July 21, Nippy suffered a deep cut to her face. Nippy and Bobby swore up and down later that it was just a freak accident, that Bobby was acting out about something and slammed his fist down on a table. They said a piece of china on the table broke, and a shard flew up and hit Nippy right in the face, tearing a nasty two-inch gash in her cheek.

Everybody got serious very fast. Donna pressed a towel to Nippy's cheek, and they rushed ashore so they could get her straight to a hospital. This was no joke—this was Nippy's face, and if she didn't have treatment right away she might be left with a big scar, or worse, since facial nerve damage was possible. Michael was asleep when it happened, so Donna decided not to wake him—which was all the better, because he might have gone after Bobby, even if it was just an accident. As it was, Nippy was apparently yelling at Bobby, "You're a dead man! You are a goddamn dead man when my mother sees this!"

The Italian doctors put in two stitches, just enough to close the wound so Nippy could fly back to the United States. She had a doctor in Miami who was a world-renowned plastic surgeon, so the hope was that he'd have the know-how to keep her from ending up with any visible damage. Donna called me to tell me what had happened, and to let me know when they would be arriving in Miami. I flew down there as soon as I could, worried sick about what was going to happen to Nippy's face, and about what had really happened between her and Bobby.

When I got to Miami, I went right to the hospital. Nippy had already had surgery, and when I walked into her room and saw that big old bandage on her face, I was like a mama bear ready to rampage—and she knew it. Right away, she started begging me not to say or do anything to Bobby, who was sitting there on the floor. "Mommy, please," she said. "It was an accident. I promise!"

I looked at Bobby. "Don't you say a word to me," I told him. "I don't want to hear nothing you have to say." And he didn't.

Now, I knew there were people who thought Bobby hit Nippy and caused that cut on her face. But Nippy told me it was an accident, and Donna told me it was an accident, and I wasn't there, so I had no choice but to believe them. But even if it was an accident, it was an accident that Bobby caused. He may not have cut her on purpose, but he was still the one who cut her. And I really could have killed him for it.

I kept myself in control—for Nippy's sake. I didn't want to upset her any more than she already was. I didn't say a word to Bobby—didn't even look at him. It took every

ounce of strength I had not to wring that man's neck, but I controlled myself.

Ever since Nippy was little, and getting bullied by those girls in middle school, she knew I would fight anybody who tried to hurt her. It's how I've always been as a mother—you can mess with me, but don't mess with my kids. Bobby knew that, too, and at least when I was present, he usually behaved himself. So no matter what anyone else was saying, I had no reason to interfere with anything happening between them.

And Nippy never, ever complained to me about Bobby. She just didn't talk about him, unless it was something good. She knew that I hadn't approved of her relationship with him at the start, and so I think she was always careful to share the good and avoid the bad when it came to talking about Bobby with me. She just wanted to be a grown-up and handle her own business. When she wanted my advice, she asked for it. Other times, she kept her mouth shut.

More than that, she was a loyal wife, and she really wanted her marriage to work. Of course I heard the rumors about trouble in their marriage. Everybody did. On the very few occasions I ever mentioned them to Nippy, she'd just brush it off, saying, "Mommy, you know how people are. They'll say anything." Which was certainly true. So, what could I say to that?

Here is one thing I will say, though: I do believe Bobby had a hard time living in Nippy's shadow. She was one of the biggest stars in the world, and he was just never as big as she was. For a man like Bobby, it's not easy to be called "Mr. Whitney Houston." Nippy knew that, and she'd go to great lengths to make him feel like the boss. Personally I

think that's why she gave him say in decisions like whether she should do *The Preacher's Wife*—because she hoped that his participation in major decisions like that would help him feel in charge. She'd say to people, "I'm Mrs. Brown, not the other way around." If Bobby had been a stronger man, more sure of himself, maybe none of that would have mattered. But he was still young—only twenty-six or twenty-seven at that time—and he never could deal with the dynamics of being Whitney Houston's husband.

I never knew exactly what was going on between them, and for Nippy's sake, I tried to stay out of the picture. I didn't want to cause any more problems than she already had, or embarrass her. And I didn't want to embarrass him, either, though in the end I felt Bobby embarrassed himself more than anybody else could have. Still, I knew Bobby to be reckless, not violent. As far as what I saw, I didn't believe then, and don't believe now, that Bobby hurt Nippy deliberately.

At any rate, something changed in Nippy after her face got cut. Her doctor did a fantastic job of minimizing the scar tissue, and he even reconnected the nerves in her face so there wouldn't be any sagging. But even though she recovered so well physically, she seemed sadder after that, like something had been taken away from her. She might not have been badly damaged on the outside, but the inside was perhaps a different story.

At the same time all this was going on, Nippy's daddy was also not doing well. By the late 1990s, John was nearly eighty

years old, and he had all kinds of health problems. He was diabetic, he had heart problems, and he couldn't walk very well. He had finally retired from running Nippy's company, but he was so anxious to have a hand in everything that he wouldn't let them clean out his office. It still had all his stuff in it, as if he might walk in any minute and keep on working.

Nippy loved her daddy, and she wanted to make sure he was taken care of. For the most part they got along great, though like every father-daughter relationship, theirs had its complications, and when he was CEO of her company, he sometimes seemed to be looking out for himself as much as for her. As I say, they still always did get along. But there was one thing in particular John did, not long after he married Peggy, that really hurt Nippy.

Growing up, Nippy was John's princess—she was his only daughter, and he adored her. On holidays, if John gave me flowers, he would always give her flowers, too, and in ways big and small he made her feel loved and appreciated. Nippy needed to be loved, and she counted on her father's attentions. And even later on, when things got more complicated, he still knew how to make her feel special, like she was his treasure.

When John married Peggy, she already had a young daughter named Alana from a previous relationship. Now, that wasn't a problem, obviously. The problem came when John decided he was going to adopt Alana—in secret. He didn't want Nippy to know.

One afternoon a couple of years after John married Peggy, Nippy called over to their house. Alana answered the phone, and Nippy asked if she could speak to John. Alana said sure, and then she yelled, "Daddy!" Nippy was so stunned, she just hung up the phone.

Not long after that, Nippy asked Bae, "What's up with my father and Alana?" Bae told her she didn't know, but she said she'd ask John about it. When she did, John admitted that he had adopted the girl.

Bae said, "Okay, but did you tell Nippy?"

"No," he snapped. "Why do I have to tell her?"

And there it stood, until one day when Nippy, John, and Bae were all in his office together, talking and laughing about something or other. Nippy suddenly said, "Hey, Daddy—I hear I have a new sister." Bae got up to leave the room, but Nippy said, "No, Bae. I want you to stay."

There was an awkward moment, and then John said, "What do you mean? Did I *tell* you you have a sister?"

"No," said Nippy. "But I heard it."

"Well, you don't have one until I *tell* you you have one," he said. And he turned and walked out of the room. He never did admit to Nippy that he'd adopted that girl, but she knew it. And the fact that he'd lied about it probably hurt her more than anything. It didn't stop her from talking to him, but it made her sad to feel like someone had taken her place with her father.

Nippy might have been able to move past the situation with Alana, but the whole thing demonstrated a darker side to John that had been emerging slowly. As the CEO of Nippy's company, he'd had enormous power, and at times he'd displayed a manipulative side that came from his need for control. When he wanted, John could still be the same man

who'd charmed Elvis all those years ago, but as he got older, he always made it clear that he was in charge, which is exactly what happened when Nippy confronted him about Alana.

Yet even when John hurt her, Nippy loved her daddy fiercely. So when he started having heart problems, she wanted to take care of him. In early October 1997, John had made an appointment to see a renowned cardiologist in the Washington, D.C., area. And coincidentally, Nippy, Michael, Gary, and I were all going to be down there, too, for Nippy's third HBO special, *Classic Whitney*.

Because we were all there together, we decided to have a family meeting to talk about John's health care. By that time, I almost never had anything to do with John and his issues, but I admit that it was nice to feel a little bit involved again. And it was wonderful to have all five of us together again, for the first time in years. The timing was terrible for Nippy, though, as she was frantically trying to rehearse and prepare for her concert, all while dealing with this family drama.

Nippy's first two specials had been big hits, and now HBO wanted to broadcast her October 5 performance live from DAR Constitution Hall, so she needed to put together a whole show—a mix of her hits and some gospel songs, some tributes to other singers, and a whole narrative to pull the thing together. It's a lot of work to create a show like that, and the fact that the whole family was in town, talking endlessly about what to do about John—and the fact that I was worried about him—certainly didn't help her any. This was also her first big performance after having surgery on her face, so she might have been a little self-conscious about that, too.

And unfortunately, Nippy wasn't in the best voice for that show. For years she had been used to singing absolutely anything, and hitting any notes, that she wanted to. But after twelve years of nonstop performing, she was tired. That, plus the emotion of dealing with her father and his various health problems, as well as her apparently escalating drug problem, affected her during the *Classic Whitney* concert.

I was scheduled to sing with Nippy on her second song, a ballad she and I had recorded on her album *Whitney*, called "I Know Him So Well," from the musical *Chess*. The song is a duet—a wife and a mistress singing about the same man. But the lyrics really could have been about John, too:

Though I move my world to be with him Still the gap between us is too wide....

Nippy and I were sitting in chairs, facing each other as we sang, and we just locked in with each other. Between the lyrics and the interplay of those two parts, with their beautiful harmonies, there was just a lot of emotion between us on that stage. We clasped hands toward the end, singing the final phrase, "I know him so well. . . . It took time to understand him . . . but I know him so well." And then Nippy stood up and pulled me to her in a big hug.

"Thank you, Mama," she said, before turning to the audience and saying, "That's my mom! My *mom*!" I was so proud, and so happy, as always, to have been able to share the stage with my baby girl.

Later in the concert, Nippy brought little Krissi to the stage, holding her in her arms as she sang "Exhale (Shoop

Shoop)." In fact, she brought all of Bobby's kids up to the stage, and then her nieces and nephews, too. She wanted them all up there with her, and so she improvised, singing, "Come on up with me . . . I know you want to be up here . . . Come on up, I know I'll never hear the end of it . . ." while the whole audience cracked up laughing.

And of course, she brought Bobby onstage. Whenever Bobby was in town for one of her shows, Nippy tried to include him. He was a very talented, though inconsistent, dancer and entertainer. Sometimes he was brilliant, but other times his performance would make me wonder. She'd bring him out and he would dance, even though Bobby's kind of dancing didn't really fit with Nippy's music. He'd be tearing off his shirt, dancing in that street style he had—and at Constitution Hall that night, even though he was dancing to "Mr. Bojangles," he still had to unbutton his shirt and show off his chest at the end. It was a strange sight, Nippy in her long, glamorous gown and Bobby with his shirt hanging open, but after the show she told everyone who would listen how good he was.

Nippy knew her performance in *Classic Whitney* wasn't as good as it could have been, and she cried after the show was over. Then, always the loyal wife, she said, "But at least Bobby was good."

CHAPTER 14

A Very Bad Year

Even though Nippy's movies and their soundtracks had done well, it had been seven years since she had recorded a studio album. Clive Davis was itching to get her back in the studio, but unbeknownst to me at the time, he had a bigger concern than that.

As Nippy's representatives, Toni Chambers and the attorney Sheldon Platt went to talk to Clive about when she might start recording a new album, but Clive had been hearing some things about Nippy, and he knew some of her recent performances hadn't been up to par. She had even started bowing out of a few shows here and there, which had been extremely rare until recently.

Clive loved Nippy too much to mess around. "What are you going to do about the drugs?" he asked point-blank. "I've been hearing some things, and they're not good."

Now, at this point, I still didn't know anything about Nippy doing drugs. Back in the late 1980s, I'd had that one conversation with Robyn Crawford and then asked Nippy about it. But Nippy and I had never talked about it again, and I assumed she had been able to take care of it. If she was getting high, she certainly wasn't doing it around me. And if she was doing it around other people, they certainly weren't telling me about it.

I'd heard about her canceling a couple of shows here and there, and while I wasn't happy about it, I believed the reasons Nippy gave me about why she backed out of those shows—that she was either sick or having problems with her voice. Behind the scenes, she may have been getting worse and canceling because she was partying or wasn't in any shape to sing, but I'd never seen any signs of that. As far as I knew, the whole idea of Nippy and drugs was all in the past with that lone conversation I'd had with Robyn Crawford ten years earlier.

But Clive obviously knew some things I didn't, because he was really concerned. And when Toni relayed his message to Nippy, she got scared that people knew she had a problem. She'd been able to keep her secret for several years, and the idea that people in the industry were starting to know what she was doing frightened her. So, as she sometimes did, she called her daddy to intercede.

Though John had supposedly retired from working for her, he agreed to step in to talk with Clive. And when Clive recommended sending Nippy to rehab—and even suggested a place in Connecticut—John decided he'd check it out. But

instead of consulting with me, John just took Robyn to go see the facility, without ever saying one word to me.

Much later, when I found out that John and Robyn had done that, in secret, without even having the courtesy to let me know, I was livid. Since we'd divorced, there'd been times that John had tried to keep me out of one decision or another, and I mostly let those roll off my back. But this was going too far. John was a good man, a kind father, and wonderful husband, but when it came to the safety of my children he knew better than to withhold this kind of information from me. If Nippy was in that much trouble, and if she was going to be getting some kind of treatment, I needed to know about it. I needed to have some input. Yes, John was her daddy, but I was her mother. If anything, it should have been John and me—not John and Robyn—making that kind of decision.

Nippy didn't end up going to any rehab at that point, and she must have convinced Clive that she was fine, because she went ahead and recorded a new album for Arista: *My Love Is Your Love*. Despite what she was going through, she did a beautiful job on that record. At first, Clive just wanted a greatest hits album with a few new songs, but the recording sessions went so well that Arista released an entirely new album. It came out in November 1998, and while it didn't sell as well as Nippy's earlier records, a lot of people felt it was her best one yet. Whatever else was going on with her, my baby girl still could sing.

In the summer of 1999, Nippy went on tour in support of *My Love Is Your Love*. But this time, instead of the huge stage shows of her earlier tours, she performed in theaters and other smaller venues, because she wanted a little more intimate setting. Nippy was thirty-five now, and her new album was more adult-oriented. She wanted to do a show for grown-ups.

I think she also hoped that doing shows in smaller venues would help preserve her voice. Though her voice came through just fine in the studio, Nippy was having more trouble than ever with her throat in live performances, and again she had to cancel a few dates—two of them before her hometown audience in Newark. People said all kinds of things when she canceled those shows, of course—everybody in the world thought they knew what was going on with her, even if no one really did. But the truth was, the very real struggles she was having with her voice as she got older were made even worse by the partying she was doing, which, as I found out later, included smoking cigarettes and smoking other things.

Nippy was better than anybody I know at keeping her stuff private—or at least, keeping it private from me, even when I got the chance to spend time with her. Ever since her first album, I would always come see her do a few shows on each tour. And everyone who was with her always knew that when I came to town, they'd better get their stuff together. Early on, Robyn Crawford nicknamed me "Big Cuda"—short for *barracuda*—and that suited me just fine. The name stuck, and from then out, whenever I'd be coming somewhere to see Nippy, people would warn each other that Big Cuda was coming.

Now, obviously, the people who worked closely with

Nippy could see if she was having problems—with drugs or Bobby or anything else. But Nippy was their boss, and if she didn't want me to find something out, they were damn sure not going to tell me about it. They knew she would feel betrayed, and they didn't want to lose their jobs. So even if they wanted to warn me about something that was going on, it wasn't so easy to do.

And you know, as much as I love my daughter, Nippy was no angel. She could be a straight-up heifer to people if they revealed things she didn't want them to. She was the head of a multimillion-dollar enterprise, a company that was built around her and that would come crashing down without her. So she wasn't shy about doing everything possible to keep things the way she wanted them. It definitely put the people she worked with in a difficult position.

As Nippy encouraged people to keep me in the dark, she was helped by the fact that I never read the tabloids. For years, avoiding those rags had kept me safe from a whole lot of baseless rumors and the nastiness of the gossip business, but when Nippy actually started to have a problem with drugs, it also meant that I was sheltered from the speculation about how bad things really were.

Yet even through all these barriers, every once in a while I'd hear about something. Very often it wasn't anything too specific—someone would say they'd heard Nippy was doing this, or Nippy and Bobby were doing that. Just enough to make me think that something could be wrong, but not enough to know what to do or whether to believe it. Other times, I even dreamed about things that were happening. And I'd want to check in, to make sure Nippy was okay. There were times when I'd call Toni and say, "What's going on with Nippy?" and Toni would hem and haw and try not to answer. And I would just say, "Toni, I don't have time for your shit today. What is going on with my daughter?"

I had no choice but to ask the people who were close to her, because Nippy didn't call me very often during these years. It's hard to say when exactly it started, but a distance had begun to grow between us. Nippy knew that if I picked up on something being wrong, I would come right to her, and she didn't want that. She wanted to handle things herself, so part of her solution was for us not to talk, to keep me from getting involved.

She also knew that I would tell her the truth, and she didn't necessarily want that, either. Nippy, Michael, and Gary all grew up knowing that Mama was going to tell you what's on her mind. If I needed to hold her and kiss her and take care of her, I'd do that, too. But I was going to tell her the truth, unlike some of the people who worked for her, who didn't want to upset her. She could occasionally be intimidating to people, and she wasn't afraid to use that.

Michael always used to say that he and I were the only ones who wouldn't let Nippy get away with anything. So, if she wasn't ready to face up to something, she'd just keep us at bay. I never understood the point of keeping all those secrets, though. I used to tell her, "Nippy, you have to stop keeping things from people." She'd just say, "Oh, Ma, I don't want to worry you." But she worried me so much more by *not* telling me—it frustrated the hell out of me, and sometimes I just wanted to snatch her by the scruff of the neck and say, "What is wrong with you, child?"

202

There was one other reason she didn't tell me things and for her, I guess it was the biggest reason of all. Nippy was always afraid of disappointing me. She would rather act like everything was okay, and shoulder all her burdens by herself, than reveal her weaknesses and have me be disappointed in her. I tried to tell her that everybody falls short sometimes, but she never wanted to do that in front of me. That's a lot of pressure for anyone, but it was part of our relationship. Whatever part of her wasn't perfect, she didn't want to show to me—and maybe she was afraid I didn't really want to see it, either.

I don't know, maybe Nippy thought I just wanted her to be that pretty little girl with ribbons in her hair, who knew how to smile and charm everybody. Maybe she felt like if she were less than that, nobody would love her. I know I was hard on Nippy sometimes, but I never meant to make her feel that way. Even if I was disappointed in her behavior sometimes, I wasn't disappointed in her as a daughter. And I never, ever stopped loving her.

All I can do now is hope and pray that my baby understood that. I wish I had said it to her more.

In January 2000, Bobby and Nippy were about to fly back from Hawaii when airport security officers found marijuana in her purse. The security people went to get the police, and Nippy decided she didn't feel like waiting around to get arrested. She and Bobby just went ahead and boarded their flight, and although the plane was still on the ground when the police got there, they decided not to stop her because the amount they'd found was small.

People all got to talking about that, because Nippy had never been in trouble with the law before. Bobby was another matter, of course—he'd been arrested so many times for so many things, they used to joke that he had a lawyer in every town they went to. I didn't know what exactly happened in Hawaii, but I just couldn't believe Nippy would have been walking around with marijuana in her purse. I'd heard that she'd smoked marijuana before and I knew that people around her smoked, so it wasn't like this was suddenly proof of the rumors I'd been hearing about bigger problems. Concerned as I was, I still didn't take that episode in Hawaii as a sign that something was really wrong with Nippy. Because it seemed like such a surprising, isolated incident, I was willing to look past it.

That was only the beginning of what would soon turn into a very bad year. The next month, Nippy was scheduled to sing at the Academy Awards show, for which Burt Bacharach, who had been a friend of the family for many years, was serving as music director. But at the rehearsals, she apparently wasn't performing up to snuff. According to people who were there, she appeared to be high. Bobby was with her and she kept singing to him, missing her cues, singing songs that she wanted to sing rather than what she was supposed to sing, walking off the stage to hug Bobby, and generally behaving inappropriately. After a while, Burt asked her to leave, and understandably, he was very upset with her.

Now, Nippy had sung at many awards shows at this point. And unlike most performers, she sang live rather than lipsynching, so she was used to being the hit of every show. She always pulled herself together to perform, no matter what,

204

and I suspect she thought she could just do the same thing this time. But the Academy Awards are broadcast live, and Burt just wasn't willing to take a chance. So he replaced her.

Nippy was really shocked when he let her go, because up to that point, the stage was the one place she always knew she was in control. She was so confident onstage, in ways that she wasn't in everyday life. She knew she could get up there and sing and do whatever she wanted to with her voice, and for years, even the shows where she wasn't at her best were still magnificent. Nippy loved to sing, and the way she expressed herself best was through her voice. For those reasons, she always owned whatever stage she was on. Now she was even losing control of that. And while that loss of control scared her, I don't think she was able to make the connection between problems with her performances and her escalating drug use. She just didn't seem to know what to do about it.

By this point, bit by bit, I'd come to understand that something really was wrong. There was never one big "aha" moment, but all the little things I'd been hearing began to add up, and as I started asking more questions, it became harder and harder for the people around Nippy to cover for her.

Finally, one week while Nippy was in Los Angeles, her film agent Nicole David helped arrange an intervention and asked me to come be a part of it. I know some people will call me naïve, but I truly was surprised when I found out just how much trouble Nippy was really in. Though I'd been putting the pieces together for a while, she was so good at hiding things from me that I didn't understand how bad it had gotten. Maybe if I read the gossip magazines and watched the

tabloid TV shows, I would have realized sooner. But the only times I ever knew Nippy was in trouble were the times when I'd either seen it with my own eyes, or I was told by people I trusted. And when neither of those things happened, I always assumed Nippy was okay.

I flew out to Los Angeles, and along with Robyn Crawford, CeCe Winans, and Michael's wife, Donna, we all confronted Nippy at her hotel. "We're here to get you the help you need, baby," I told her. She was shocked to see us all, and right away she started crying, and pleading with us not to send her to any rehab.

"Mommy," she said, "please don't let them do this to me. I can take care of it." I wasn't convinced that she could, but she wouldn't give in, saying, "Let's you and me do this together. Just come stay at my house, and you can look after me, and I'll quit. I promise! Please, Mommy"—she was just begging now—"I know we can do this together."

And you know, I let her talk me into it. Deep down, I didn't really believe her. After learning the extent of her problem, I didn't think she could really quit on her own. But hearing my baby say she needed me, and having her ask me to come to Mendham to help, was more than I could bear. So I told her I would do whatever she needed. "All right, baby," I said. "I'll come with you. I'll help you."

So I moved into Nippy's home in Mendham for a few weeks. But that house was so big, with so many different rooms and suites, that Nippy would just lock herself up somewhere and not come out. When she did show her face, she swore up and down that she wasn't doing anything. But she spent too many hours hiding herself for me to believe that was true. I

would have done whatever it took to get Nippy clean, but as I suppose she knew, there was no way for me to keep an eye on her in that house.

I think Nippy really did want to stop at that point, but she didn't know how. And because I couldn't force her to stop, I eventually just moved on back home. I had hoped that together, Nippy and I could face her demons. But I never should have let her talk me into abandoning the intervention, because the truth was that I really didn't know how to help her. I only knew that she had asked me to help her and I couldn't say no. Nippy knew I would come whenever I thought the situation involved her and me against the world. Only this time, I hadn't been able to fix it. She was still in trouble, and things were about to get even worse.

Around this time, Nippy really started keeping more to herself. Robyn resigned from the company, which wasn't good because, despite whatever I thought of her, she at least tried to look after Nippy. And I still wasn't seeing very much of Nippy, either, because as long as she was having trouble, that was how she wanted it. Though she had been pulling slowly away for a while before the intervention, it seemed to get worse after I moved out of her house. After that she didn't call much, and she often didn't pick up when I called.

Her brother Michael did spend a lot of time with her, but he was unfortunately also doing drugs. Michael and Nippy were so close, and he would have done anything for her. If she called him in the middle of the night, he'd leave Donna and his two children to go to her, sometimes staying for weeks at a time.

Nippy just started to close in on herself. She wasn't spending time with anyone but her brother, Bobby, and Krissi, and Michael later told me that things between her and Bobby weren't good. Bobby was constantly in trouble with the law, and he even went to jail in Florida in May 2000, for a drunk driving charge. Nippy stood by him, though, and when he got out in July, she threw herself at him like he'd just come home from a war. Her whole world seemed to have shrunk down to one thing: what was happening with Bobby.

With all of Bobby's flaws, Nippy remained devoted to him. In some ways, I think Bobby was Nippy's rebellion. Around him, she didn't have to be the perfect girl, or America's sweetheart, and she felt she could relax and just be the person she truly was. Of course, drugs complicated their relationship. Yet unlike a lot of people, I don't blame Bobby for introducing Nippy to drugs or for the things that ended up happening to her. At the same time, I also don't believe he did much to help her. He had his own demons to fight, and spent his fair share of time going to court-ordered rehab and trying to stay straight. But when it came to getting clean, he and Nippy never seemed to be in the same place at the same time, and that made the process much harder.

The people who were around Nippy in that period felt she was depressed during that whole time. If Bobby wasn't there, she'd walk around that big house wearing her slippers all day, and sometimes Michael would find her just shuffling around late at night, not knowing what to do with herself. She began losing weight, and Nippy wasn't a big woman to begin with, so she didn't have a lot to give.

Despite all the upheaval, Arista signed Nippy to a new

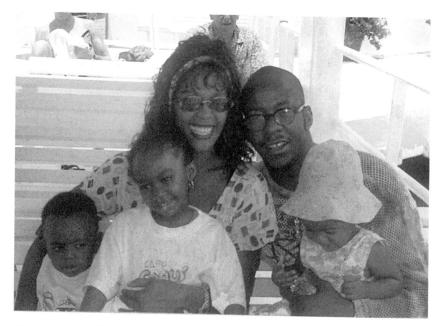

Nippy with Bobby Brown, his kids Bobby Jr. and LaPrincia, and Krissi in her pink hat.

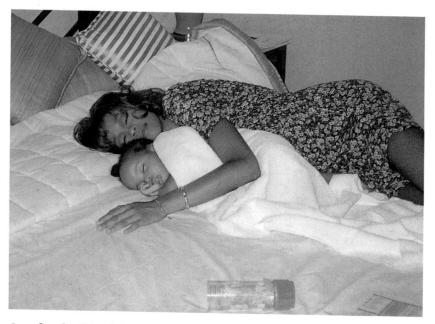

Our family friend Laurie snapped this precious picture of Nippy and Krissi napping.

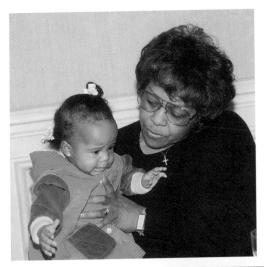

She's a little fussy in this picture, but Krissi really was a sweet baby.

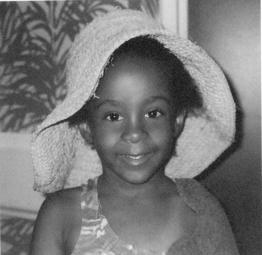

This shot by Ellin Lavar shows Krissi all ready for the sun in her floppy hat and bathing suit.

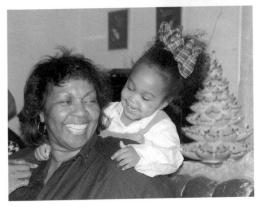

Here I am with Blaire, my son Michael's daughter. Of all my grandchildren, I think she's the one who looks most like me.

In 1997, Nippy spoke at the dedication ceremony when her elementary school was renamed the Whitney E. Houston Academy for Creative and Performing Arts. She'd come a long way from being that skinny little girl with the big voice in East Orange.

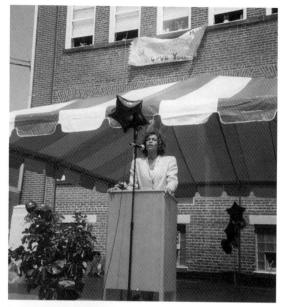

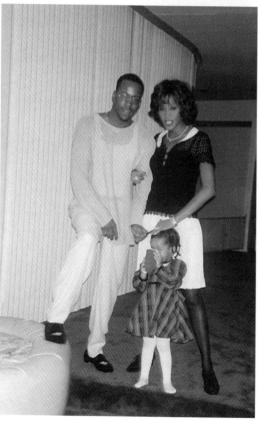

Bobby, Nippy, and Krissi at their home in Mendham, New Jersey.

Nippy was blessed with such an amazing voice. I used to say to her, "God was good to you, baby." For all she went through, I wouldn't be surprised if sometimes she wished otherwise.

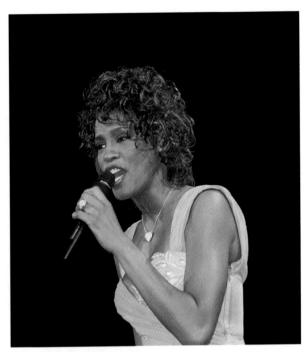

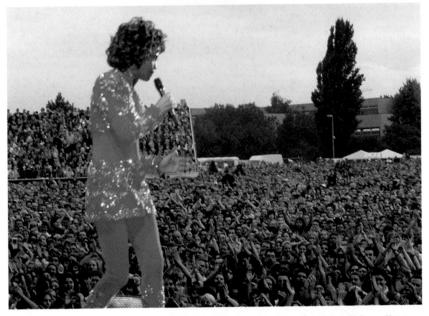

Back when Nippy was a girl and would sing in church, I'd tell her, "Bring them to their feet, baby, and then drop them to their knees." And Lord, she could do it.

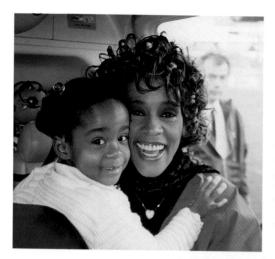

Once, when Nippy was touring in Germany, crowds had blocked all the roads to get to her concert—so she and Krissi ended up having to take a helicopter to bypass them. (Photo by Ellin Lavar)

Not every three-yearold gets a chance to have a private helicopter ride, but I'm not sure Krissi was old enough to appreciate it. (Photo by Ellin Lavar)

Krissi poses with her dog Doogie before an awards show. (Photo by Ellin Lavar)

Nippy and her brother Gary onstage.

Another show, another dressing room. Nippy always took her work seriously, even when the pressures of touring started to wear on her.

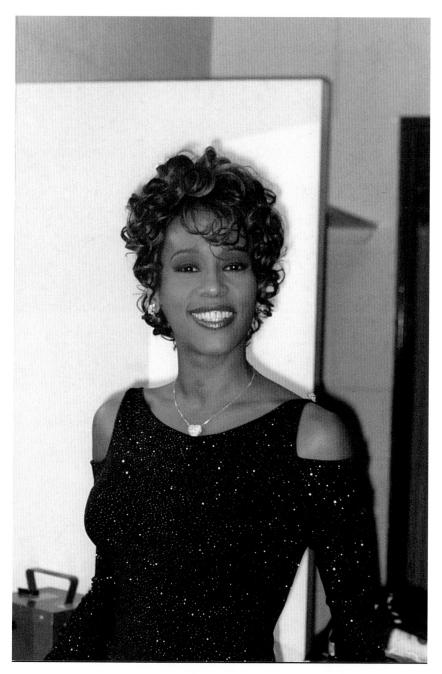

I'm grateful that Nippy was able to leave her mark on the world, but I would trade it all just to have my baby back.

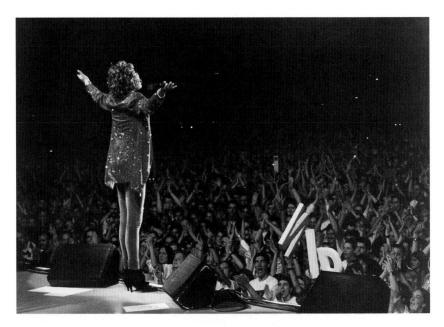

The long tours took a toll on her voice, but for years Nippy delivered electrifying performances.

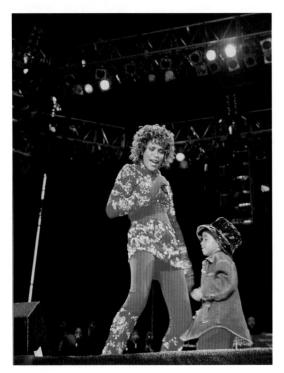

Krissi joins Nippy onstage. Nippy also loved to bring Bobby out onstage to dance, too.

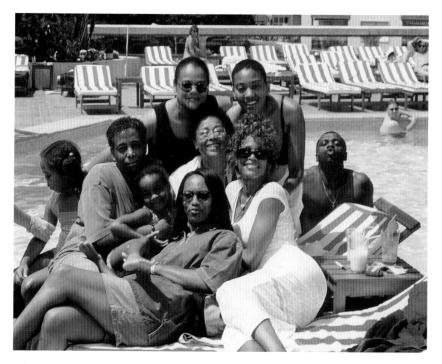

I love this family picture, taken in Monte Carlo during Nippy's 1998 European tour. *Left to right: front row,* Krissi, Michael's wife, Donna, Nippy; *middle row,* Blaire, Toni Chambers, Bae White; *back row,* Laurie Badami, Robyn Crawford. *In the pool, acting up:* Gary.

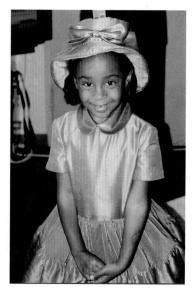

Krissi in her Sunday best.

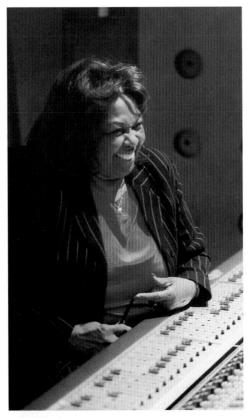

I've been recording in studios since the late 1950s, and I've never gotten tired of it.

BELOW: Directing singers in the studio.

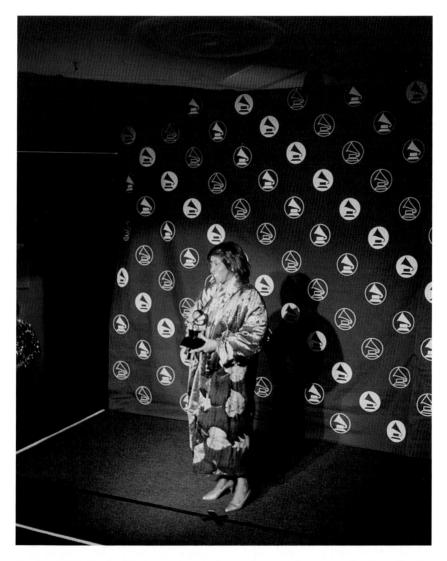

In the 1990s, I was fortunate enough to win two Grammys for Best Traditional Soul Gospel Album—for *Face to Face* and *He Leadeth Me*.

From working as New Hope Baptist Church's minister of music to directing background arrangements, I've always loved working with other singers.

I learned from my father that in singing gospel, you inspire others and strengthen your own faith. Singing with me in the backup choir are Gary (*fifth from right*) and his wife, Pat (*third from right*).

Nippy loved working on her collaboration with Kelly Price (*left*) and Faith Evans (*right*), "It's Not Right but It's Okay."

Sometimes, before going out onstage, Nippy would say, "Okay, I've got to go be Whitney Houston now."

Nippy was surrounded by people who worked very hard for her, including these talented backup dancers.

By the time this video was shot in the late 1990s, rumors had started to circulate about what was really going on with Nippy. But she still went out and did her job every day.

Reverend Joe Carter, my pastor at New Hope Baptist Church, helped me celebrate at my seventieth birthday party.

Dancing with Gary, my firstborn.

My sons Gary (*left*) and Michael (*right*). From the time Nippy was small, her brothers looked out for her.

Sometimes I just ache, wishing I could hug my Nippy one last time. I never, ever thought she would go before me.

Nippy, I will always love you.

record deal in August 2001. Even with everything that had gone on, Clive still believed in Nippy and her talent, and L.A. Reid, who was head of Arista at that time, signed her to do six new albums. Clive saw it as the beginning of a comeback, her chance to show that whatever problems she had were behind her, and L.A., who had worked with her when he and Babyface wrote and produced several of her recordings and had become a friend, believed it was a chance to show the world she was still Whitney Houston. In September, after the 9/11 attacks, Arista also rereleased Nippy's recording of "The Star-Spangled Banner," which inspired people all over again and reminded people of the magic Nippy could create with her voice.

But the good feelings wouldn't last. Because in September 2001, at a thirtieth-anniversary concert for Michael Jackson, Nippy shocked everybody with her appearance.

The concert was at Madison Square Garden in New York City, so I came into town to see Nippy perform. When I walked into her dressing room, I couldn't believe my eyes. She was just as thin as she could be, almost skeletal. Her face was gaunt, and she looked like she hadn't slept in a while. I was scared to death, seeing her like that. What was happening to my baby? But I was so afraid of scaring her away, I didn't even say a word to her about her appearance. I feared that if I said something, she would shut me out.

And you know, Nippy knew what she looked like. It wasn't like some magic word from me was going to suddenly make her change her ways. I had to console myself by thinking, *At least she is letting me see her. At least I am in her life*. The way things had been going, I was afraid she would just

disappear forever. Nippy was a stubborn, hardheaded girl. She would not let herself be led by anyone, and especially not by her mother, so I tried to give her space and respect. Yet she still thought I was trying to run her life, and I knew she just didn't want to hear it.

Seeing her that day, I knew that my staying at her house hadn't gotten her clean. But this was one of the only times that I can remember when I didn't tell Nippy what I really thought. I had always trusted her to know when she was pushing things too far, and clearly that wasn't the right choice on my part—but at that point, it was the only way that I felt I could stay in her life. And I didn't know how to change our dynamic so that I could actually help her.

Ever since Nippy had been living in Mendham—first with Robyn, then with Bobby—I didn't go around there much. Sometimes when Krissi had a school thing, I'd go up, and once in a blue moon I'd just stop by if I felt like seeing my daughter. Nippy would always say, "Mommy, would you please call before you come?" But sometimes I just felt the need to see her, so I'd drive on over and drop in.

One day I went up there, and when she opened the door, I looked at her in shock. She was just as high as she could be. I had never seen anything like that before—her eyes were glassy and she was completely out of it. I said, "Nippy, what the hell are you doing?"

She said, "Oh, Ma. Don't worry so much about everything."

I was so angry at her, I started shaking. "You better get yourself straightened out," I said, "before I straighten you out myself!" I had never seen my baby like this, and it fright-

ened me. And I wouldn't let it go. I guess that was why she didn't want me coming around—maybe she knew I would go crazy if I saw her in that state. Maybe she just wanted to do whatever she did without anyone seeing. Up to that point, I had never seen my daughter high before. That's why, no matter what other people were saying, I'd stubbornly held on to the idea that things really weren't as bad as other people said they were.

Nippy tried to blow off my concerns, but I wasn't having any of it—because now I had seen with my own eyes that she had a problem. I felt overwhelmed, and there was no way to reason with her in that state, so I just turned around and left. When I tried to talk to her later on, she didn't want to hear it. "I'm not addicted," she told me. "I'm a grown woman. I can take care of myself."

Now, I'm no better mother than anyone else—I loved my daughter just like any mother loves her daughter. But Nippy broke my heart that day. That's all I can say. She broke my heart.

And you know, her brothers did, too, because they were all doing that same thing. I was so surprised at them, and disgusted, too. They were supposed to protect her, but the same thing happened to her that was happening to them. I was shocked, and hurt, and confused. I didn't understand it then, and I still don't. I suppose I never will.

PART THREE

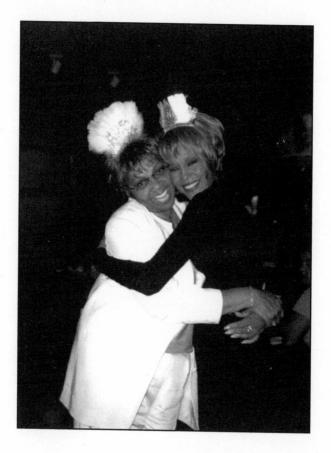

CHAPTER 15

Atlanta

ohn had managed to shock me pretty good a few times over the years, from filing for divorce to secretly marrying Peggy. But in August 2002, he shocked the hell out of not just me but everybody else, too, when his company, John Houston Entertainment, filed a lawsuit against Nippy—for \$100 million.

The suit accused Nippy of not paying what she owed for management services. Now, before John had his own company, he had been CEO of Nippy's company, and I can guarantee you that she paid him fairly—and then some—for his work. Even after he retired, Nippy always made sure he was taken care of. So, the idea that he would sue her for not paying him was far beyond any kind of rationality. And it hurt Nippy very badly, at a time when she needed his support more than anything.

I had been angry with John many times, but never as angry as when I heard about this lawsuit. I could get over him hurting me, but hurting our kids was different. I just couldn't understand how anyone in his right mind could possibly believe that Nippy would try to cheat her father.

That's when I realized that maybe John wasn't in his right mind, after all. You know, he was in his eighties and I thought maybe he was a little bit senile at this point. And he had a young guy working with him, someone named Kevin Skinner, who must have persuaded him to do something this dumb. Skinner apparently told everyone who would listen that the suit was coming from both him and John, but I don't believe it. I have to believe he talked John into it. And it's a damn shame, because it really upset Nippy. She felt betrayed; she couldn't believe that her father, her beloved Daddy, had done this.

The whole thing was made more difficult by the fact that John's health was poor. He was still plagued by diabetes and heart problems and all the complications those bring, and not long after that suit was filed he was rushed to the hospital. Kevin Skinner actually came to his hospital bed and apparently convinced John to say some kind of mess about Nippy on TV. Michael was so angry after that, he hired a guard to stand watch at the door of John's hospital room.

No matter what happened in her life, Nippy had always known she could count on her family. She and Michael were as close as twins, talking late into the night whenever Nippy couldn't sleep. She was also close to Gary and his wife, Pat, who had begun to travel with her. And although she didn't do it as often as I would have liked, Nippy knew she could

216

call me if she needed anything. Up until that lawsuit, she had counted on her daddy, too. But now, in what turned out to be the twilight of his life, he'd done this stupid thing to push her away. It was the same kind of thing he'd done with me, all those years ago, after his heart attack. Back then, he felt vulnerable and sick and blamed me for his troubles. And now he was blaming Nippy.

Nippy was struggling, and at this point Bobby was in trouble with the law about every other minute or so. He was getting himself arrested all over the place, from DUIs to assaults and everything in between. He just could not stay out of trouble, and he and Nippy both were still doing drugs. If anyone wasn't sure about that, Nippy made it plain enough in the interview she did with Diane Sawyer at the end of 2002.

The interview was supposed to kick off a "comeback" for Nippy after the difficulties of the last couple of years. But all anybody would remember from it was Nippy saying, "Crack is whack." I hated that whole interview, and while I know it wasn't Diane's fault, it was obvious that Nippy wasn't ready for prime time, you know? I heard from others who were there that Diane tried her best to help Nippy out, but the result was still a train wreck.

And of course, Bobby was hovering around through the whole thing, so much that Diane finally told him to just come on in and talk to her, too. The whole thing was uncomfortable to look at, though in truth I can't blame that on Bobby or Diane or anybody else. Nippy was a grown woman, and she made her own choice to do it.

Nippy said it best herself when Diane asked her what her

biggest devil was. She said, "That would be me. . . . Nobody makes me do anything I don't want to do. It's my decision. So the biggest devil is me. I'm either my best friend or my worst enemy."

Just six months after he filed that lawsuit against Nippy, John Houston died at the age of eighty-two. The lawsuit was still pending, and he and Nippy never did get a chance to reconcile over that. Despite all that, she was still very sad, remembering all the good times and love and laughter she had shared with her father over the years, rather than the strange goings-on of his final year.

I was sad, too, but mostly for Michael, Gary, and Nippy. I never stopped loving John, but we had been divorced for so long, and so many things had happened between us, that I really didn't grieve all that much when he passed. In fact, I probably wouldn't even have gone to the funeral except that Nippy and Bae insisted. I decided to go for my children's sake.

The day before the funeral, I went to the wake with Nippy, Gary, and Michael and their families. Gary's wife, Pat, was working for Nippy at this point, and Nippy told her, "Take care of whatever they need"—meaning, she wanted to give Peggy some money toward funeral expenses and whatever else they needed. Nippy didn't have any kind of relationship with Peggy—none of us did—but she offered that assistance out of respect for her father. Lawsuit or no lawsuit, Nippy was generous to her daddy right to the very end.

But at the wake, Peggy's daughter Alana kept talking about "my daddy" this and "my daddy" that. And for Nippy,

that was just too much. That was really hard to hear, especially now with everything that had gone on. Though she didn't know Alana and didn't have anything against her, she had really never come to terms with her father's adoption of her. So even though she went to the wake, Nippy decided she wasn't going to the funeral the next day. She was hurting; she felt like she had done what she could do out of love and respect for her father, but she just couldn't do any more.

On the day of John's funeral, there was a terrible snowstorm in New Jersey. I really didn't want to go, but I'd told Michael and Gary I would, so I did. John's first wife was there, too, and she sat in the back and just cried through the whole thing. Somehow, I didn't shed a tear, and I was a little surprised at that, since John had been the love of my life. I'm sure if he and I had been on better terms when he died, I would have cried—a lot.

When he died, though, it was one of the few times that I felt more angry at him than close to him. At that point, I really hadn't been speaking to him, because of the lawsuit against Nippy. This was very unusual, because no matter what was going on in our lives, even after separation, divorce, and everything else, John and I always had stayed bonded together. He was always there for me, and I was always there for him.

I remember one time, just a couple of years before he died, when he was suffering terribly from the effects of his diabetes. He and I were both at a fund-raising event honoring Nippy, and when John came into the room he could hardly walk, even with his cane.

He was in worse shape than I'd seen in a while-in too

much pain even to be a smartass, so it had to be bad. I said, "John, what is wrong with you?" He just said, "Cissy, I can't make it to the table. My legs are hurting so bad." And you know, I'd suffered through a shattered ankle and knee replacement surgery, but at that point I was doing better than he was. So I just looked at him and said, "Well, come on, then. Lean on me, I'll get you there." John put his arm around me, and together we limped on over to the table. I don't know where his wife was, and I didn't care. Whenever John needed my help, I helped him.

That was the kind of relationship we always had, no matter what—we were there for each other. If we had been close when he passed, if he hadn't filed that lawsuit, it would not have been easy for me at all. And strangely enough, I think John knew that. He was just crazy enough, and just enough of a controlling person, to have orchestrated everything that way, to have me mad at him at the very end. Almost like a blessing in disguise.

Back in 1982, when John left our house on Dodd Street, Nippy left very soon afterward, moving to Woodbridge with Robyn Crawford. Now, more than twenty years later, something similar was happening. Because just months after John passed away, Nippy left New Jersey, where she'd spent her whole life, and moved down to Atlanta with Bobby.

Even though I hadn't been seeing Nippy all that much, I always took comfort in knowing she was just right up the road. But now she was moving so much farther away, to a place where she really could just disappear if she wanted to. I took some solace in the fact that Gary and Pat were also

moving to Atlanta to be near Nippy, but regardless, I knew I'd probably be seeing her even less now.

Nippy bought a house on Tullamore Place, in Alpharetta, Georgia. It was a big house, with five bedrooms and seven bathrooms, and there were lots of trees and room to wander around outside. There was also a gate surrounding the place, so she could have her privacy, which probably meant more to her by now than anything else a house could offer. At Tullamore, Nippy knew she could control who saw her, and when.

And that's when she really started putting up the walls. When she was in New Jersey, we used to talk on the phone a lot, but once she got to Atlanta, she stopped calling me so much. And she never seemed to have any time to visit with me, even if I could make it down there. She'd just say, "Oh, I'm so busy, Mommy!" and tell me about this reason and that reason why she couldn't see me. I did talk to Gary and Pat, and Aunt Bae was living down there with Nippy for a while, so she'd tell me things. But mostly I had no idea what my daughter's life was like after she moved to Atlanta.

It was Bobby's idea to move, but I think that, by then, Nippy didn't want to be around me or anybody else who was going to hold her accountable. I think she wanted to be free of her responsibilities and obligations, and far enough away from anyone, especially me, who would call her on her behavior. She and I never had a big falling-out or blowup, but she wanted to increase even more the distance—both physical and emotional—that had been growing between us. She knew I was worried about her, and she knew that if I believed she needed me, I was just going to show up. Be-

tween seeing her high at her house in Mendham and hearing what she said to Diane Sawyer, it was now more apparent than ever that Nippy needed help. And she didn't want that. She didn't want to let me or anybody else down, so she put herself in a situation where she could control who saw her. I think she believed she could control everything else in her life, too, but she couldn't. Nippy didn't mean for things to get out of hand down there, but they did. Very quickly.

Pat and Gary knew she was in trouble, and they tried to help in their own way. They took Nippy and Bobby to Israel not long after they moved to Atlanta, I believe as a way to help them use faith to stop drugging so much. They met with a group there called the Black Hebrew Israelites, and although I appreciated Pat's efforts, I didn't really want to know about all that. I'm a firm believer in Jesus Christ, and Nippy had been raised in the church, and I hoped she could overcome her problems that way. And anyway, whatever happened over in Israel, things were as bad as ever when Nippy and Bobby came back home.

At the end of 2003, Nippy made a 911 call. She started to say that her husband had done something, but when the dispatcher asked for her name, she hung up. The dispatcher called back, but Nippy didn't want to make any kind of report. The police traced the call, but by the time they arrived Bobby had left the house. She never told me what happened, of course, and to this day I don't know, but the police did charge him with domestic battery.

I was as worried about her as ever, and I wished she didn't want to stay with him so badly. I was loyal to John when he was my husband, but I can guarantee you if he'd ever laid a

hand on me, that would have been the end of it. But Nippy not only stayed with Bobby, she also came to court to support him when he went up on charges of domestic battery. He kept saying how they'd just had a "little spat," and acted like they were only playing around. And Nippy stood there by him, protecting him as she always did.

A lot of people wondered why she stayed with him. One reason was simple—she had married him, and he was her husband, and that was that. And I think she also wanted to prove people wrong. If everyone in the world said that she and Bobby would never last, well—she'd do everything she could to prove they didn't know what they were talking about. If Nippy was anything, she was stubborn. And she was proud.

But the other reason was, she really did love Bobby. And he knew how to make that work for him. I'll say this much, they could push each other's buttons, and I believe that there were times when he was emotionally abusive toward her, but he knew exactly how to bring her back whenever he had just acted like a jackass.

I know what I'm talking about, because I saw it. We were all in England during one of Nippy's concert tours in the late 1990s, and Bobby was acting up as he sometimes did. They had gone to a club together that night, and after "partying," or whatever they did, Bobby couldn't go to sleep—he wanted to cuss and argue all night long. He'd been at her ever since they got back to the hotel, and the shouting and carrying on had been getting louder and louder, until Nippy locked him out of their suite. At which point he began kicking on the door.

This went on for a while, and other guests at the hotel were calling down to the front desk to complain. Bae finally got up and tried to take Bobby into her room to talk to him, but he wouldn't stop. He was pissed off, and he didn't care who knew it.

Well, I had finally heard enough. I got up, got dressed, and walked down the hallway to Bae's room. Bobby still hadn't sobered up, and he began defending himself to me, telling me Nippy was arguing, too, and that she was just as bad as he was. He said he felt like everyone was always on Nippy's side, and he kept threatening to leave the tour and go home. He probably didn't mean it, but I just told him, "Okay, then. Go." Nippy had to work, and she needed her rest—I didn't care where he went, but I didn't want him around her if they were going to wind each other up like this. She had to be ready to perform.

Once I'd told him to go on and leave, he said he wanted to talk to Nippy first. And he went shuffling back down the hallway toward their suite. And you know, Nippy was already halfway to forgiving him, because she couldn't stay mad. When he started apologizing, saying, "Nip, please. I'm sorry, baby. You know I love you," her face softened, and just like that she took him right back into their suite.

Bobby knew that all he had to do was act sweet and sad and loving, and show her that hangdog face, and she would forgive him anything. He had acted like a lunatic, keeping half the hotel up with his ranting, but the minute he looked at her with those sad eyes, she melted. Nippy was like that with everybody—if you looked sad after she was mad at

224

you, she'd forgive anything. She hated conflict, no matter who was at fault, and she always just wanted to end it.

I realized later that what I saw that night in England, that quick forgiveness, is probably what happened on many, many other nights. And I suppose that's how they stayed together.

CHAPTER 16

The Intervention

fter Nippy moved to Atlanta, I might have been seeing her less—but there were still times when she would call and say, "Mommy, I need you." And I would always go to her, as she knew I would.

In September 2004, Nippy was scheduled to sing at the World Music Awards, which was being held that year in Las Vegas. Clive Davis was receiving an award, and he wanted her to perform. Clive was always proud to have been the one to bring Whitney Houston's music to the world, and despite all the mess of the past few years, he loved Nippy and knew she could still bring people to their feet.

So, Nippy agreed to come and sing for Clive. But she hadn't been working as much in the last couple of years, and this would be her first time in a while performing in front of a big audience like that. She wasn't sure how strong her voice would be, and that made her nervous. And that's why she called me.

I sat with Nippy in her dressing room before the show, and I could see she was scared. "I think I've got a cold," she told me, her voice all choked up with nerves.

"You ain't got no cold," I told her. "You're fine. All you've got to do is trust in God." Nippy always prayed before going onstage, and this time was no different. We prayed together, for strength and guidance, and when it was almost time for her to go out, I asked where she wanted me to wait for her. "Do you want me to just stay here in the dressing room?" I asked.

"No," she said. "I want you out there, in front." She wanted me to sit in the audience, up close to the stage so she could see me while she was singing. She was so nervous, I think that was a way of calming herself, knowing that she could count on seeing my face out there. Sometimes you don't know what your voice is going to do; your nerves can just cut it right out, making it hard to hit certain notes. Nippy knew I understood what she was feeling, and I think just knowing that helped to give her strength. She often drew strength from having people around her who cared about her, and she could gauge her performance by the expressions on the faces of the people she trusted. If she was at all unsure of something, she would look into the audience for a familiar face, and if the look on that face told her everything was okay, then it was.

I went out and took a seat near the stage, and then Clive came out to introduce her. "Ladies and gentlemen," he said,

"the best singer in the world today, Miss Whitney Houston." And there was my baby, backlit and walking out toward the front of the stage as the music swelled up and the audience went crazy. People were hollering and clapping and stomping, giving her so much love. But I couldn't think about all that. I was just holding my breath until she finally opened her mouth to sing.

The song was "I Believe in You and Me," and as soon as she hit that first note, I just said, "Thank you, Jesus," because I knew she was going to be all right. Nippy and I looked at each other, and I just smiled up at her, so proud. And I'll tell you something, she sang that song like it was meant to be sung. By the time she segued into "I Will Always Love You," the whole crowd was on its feet. People were waving their arms around like they were in church, just ecstatic to hear Whitney Houston doing what she did best.

My baby brought that place down. She sang beautifully, and I was so proud, I didn't even know what to do with myself. I watched and listened, savoring every moment, and by the time she finished tears were streaming down my face.

I went back to Nippy's dressing room as soon as she finished, and she was crying, too, just from the relief and emotion of it all. I went straight up to her and pulled her into a hug, and then we sat down on the couch in her dressing room, and she just put her head in my lap and sobbed, overcome. I was wearing a white suit, and she was crying so bad and getting her makeup all over it, but I couldn't have cared less. I just rocked back and forth, holding her, telling her how proud I was. I never wanted to let her go. That moment at the 2004 World Music Awards was just about the highlight of the year. Because the rest of the time, Nippy was doing something I thought was a mistake. She was making a reality show with Bobby called *Being Bobby Brown*.

Bobby hadn't been doing a whole lot since he and Nippy got married, so when a couple of producers asked him about doing a show, he jumped on it. But they didn't want just him, of course—they really wanted Nippy, because she was famous and people wanted to know what was going on with her. No matter what went down between them over the years, Nippy always wanted to please her husband, so she said yes. And so the camera people set up at their house on Tullamore and started shooting.

I really don't think there's anything Nippy wouldn't have done for Bobby. She'd spent hundreds of thousands of dollars to keep him out of jail on his DUI charge. She'd gone to court with him when he was up on the domestic battery charge. She paid his child support. She really did whatever it was he asked her to do. I couldn't understand it, except that some part of Nippy must have just wanted to let her husband be in charge. Being the head of her own company from such a young age, and being the person everybody else relied on to sing and perform and bring in money, maybe it was a relief for her to say, "Okay, now I'm just the wife."

Being Bobby Brown went on the air in 2005, but I only watched part of one episode. That was all I could stand. I couldn't see my daughter anywhere in it—I didn't even know that person on the screen. She was such a mess, so unlike the daughter I knew and loved, that I really couldn't believe what I was seeing. And you know, people will sometimes say

230

that Bobby didn't respect Nippy, and that you could see it on that show. Maybe that's true. But if you ask me, the bigger question was, why wasn't Nippy respecting herself?

So, things were obviously bad while they were making that show—but they got even worse after the shooting was done. Nippy had moved to Atlanta partly because she wanted to be able to keep to herself, and Bobby seemed to want that, too. Maybe I was wrong, but it seemed to me like the farther away Bobby could keep her family, the better he liked it. For the first few years in Atlanta, Aunt Bae had at least been there to keep an eye on things. But in 2005, possibly influenced by Bobby, Nippy let Bae go. And after Bae came back to New Jersey, that's when things really started to go to hell.

In early 2005, before *Being Bobby Brown* had even aired, Gary called me. "Ma, I think Nippy is really in trouble," he said—and Gary was not one to exaggerate. He and Pat lived close to Nippy, and they traveled with her, so they knew her situation better than anybody did. If they were worried enough to actually call me about her, then it was time for me to act. I knew Nippy wouldn't like it, but at that point I didn't care—I made plans right away to go down to Atlanta. My son had told me my daughter needed my help, so there wasn't even a question about what I would do next.

I flew down to Atlanta, and Gary and I went together to the Tullamore house. We rang the doorbell, and Bobby's sister Tina answered the door. Right away she yelled up to Nippy, warning her, "Your mama is here!" I didn't hear what Nippy said, but she didn't come down, and it became obvious that she didn't want me seeing her in whatever kind of state she was in. If Nippy was in half as bad a state as that house, then she really was in trouble. I had never in my life seen any house that looked like this one did—much less a multimilliondollar home. I just stood there in shock. It was dirty and messy, but that wasn't even it. When I walked in and started looking around, the things I saw sent a chill right through me.

Somebody had been spray-painting the walls and doors, painting big glaring eyes and strange faces. They were evil eyes, staring out like a threat. Who would do such a thing? It just seemed crazy, having these strange images painted right on the walls, all through the house. And in another room, there was a big framed photo of Nippy, Bobby, and Krissi but someone had cut Nippy's head right out of it. And then they just put the portrait right back up, as if nothing was wrong. It was beyond disturbing, seeing my daughter's face cut out like that. It was frightening.

Gary had gone upstairs to get Nippy, but she didn't want to come down. I saw her only briefly, up at the top of the stairs, and she looked like someone I didn't know. I think she must have been high, because she looked like she had the only other time I'd seen her that way, back in Mendham. She was obviously not herself, because she yelled angrily at me down the stairs, telling me to leave her alone and worse. I can't even remember most of what she said, and if I could, I wouldn't repeat it. It wasn't her, and I don't even want to remember her that way.

"Come on," I said to Gary, "let's go." There wasn't any point to staying, not with Nippy in that state. We walked

232

back to the car and got in, and as we drove away from my daughter's house, we talked about what we had to do next.

I didn't know what our options were, and I had no idea whether you could even put a person into rehab against their will. But I did know one thing: we had to try, because I was afraid Nippy might not make it to the other side of this if we didn't.

I started making all kinds of calls, trying to figure out what we could do. I spoke with a friend who's an attorney, and we started poking around, trying to sort out the laws. We talked about the situation with singer Natalie Cole, whose mother had gotten herself appointed as her daughter's conservator when Natalie was really struggling with drugs. Being appointed conservator meant her mother could make decisions on her daughter's behalf. That gave me hope maybe we could set up something similar with Nippy, at least until she could pull herself back together again.

The laws are different everywhere, so we talked to a local attorney in Atlanta, who advised us on how we could get Nippy into rehab. I just said, "Please help me—I'll do whatever it takes. I can't just leave my daughter to die." Because that's what I was afraid would happen if we didn't get Nippy out of that house.

The attorney advised me to file a petition with the court to have Nippy treated regardless of whether she consented. It had to be signed by people who had seen her within fortyeight hours, so Gary, Pat, and I all signed it. And we had to get doctors to sign it, too, affirming that Nippy was unable

to care for herself. We got all the signatures together and got the petition approved, and then we went down to the sheriff's office.

I presented the petition and asked them to help us physically get Nippy out of the house and into treatment. And that was how Gary and I ended up going back over to Tullamore Place with two sheriff's deputies. I asked specifically for female deputies, thinking that Nippy would feel less threatened that way. I knew this was going to be a struggle, and I wanted to do everything possible to make it easier on all of us.

We pulled up at the house and walked to the front door, petition in hand. This time, Bobby was home, and when the door swung open, both Nippy and Bobby were standing there in the entryway. As soon as Bobby saw the sheriffs, he started to move toward Nippy, but I just looked at him and said, "Don't you move one step, or the sheriff will take you down." He stopped dead and stood where he was, staring at me.

"Nippy," I said, "I have a court injunction here. We are going to get you the help you need, baby." I was shaking with emotion, holding the piece of paper out toward her. "Let's go. You can do this. You're either going to come with us, or we're going to make you come—one way or the other. But you *are* coming."

She just stood there looking at me. The light had gone out of her eyes, and my baby looked so, so tired. I wanted very badly to get through to her, so I kept talking. "If you need to, we can have you go on TV and announce that you're retiring, okay? Because it's not worth all this, baby. It's not

worth it." Now I was fighting back tears. "I am *not* going to lose you, Nippy!" I said, my voice rising. "I'm *not* going to stand by and watch this happen! I want my daughter back." I thought my heart would explode, I was so angry and sad and scared. And she still hadn't said anything.

"I love you, Nippy," I said, looking her straight in the eye. "And you are coming with us."

The sheriff's deputies stepped up and took her by the arms, while Bobby stood by watching. Nippy didn't struggle, didn't fight. She was angry, but I think she knew there was nothing she could do with the police there. They put her in the back of their car and set out for the hospital. Nippy had lost weight and was dehydrated, so the hospital would be the first stop before she went for rehab or anything else.

I guess I should have been relieved, or maybe even happy, but this was the worst I'd ever felt in my life. I was hurting like a dog, because Nippy was so angry with me. I knew I'd done the right thing, but I hadn't been able to reach her, and I had never felt such a gulf between my daughter and me. I knew she'd be angry with me for a good, long while. But I did what I had to do to save my baby, and that was the only thing that mattered. I had to save my baby.

Nippy stayed in the hospital for a week, and the doctors made sure she got proper nutrition and care to get her healthy again, as was required before sending her to rehab. I imagine it wasn't easy for her to be in the hospital all those days, but I never saw her in there. She was so angry, she told the nurses not to let me in as a visitor—and she wouldn't talk to me by phone, either.

She was furious with me, but I understood, because I was mad at me, too, in a way. I just couldn't believe things had come to this. I never thought I'd have to bring sheriff's deputies to my own daughter's house—it was just so far beyond any kind of reality I could have imagined. I don't know how I would have gotten through it without Gary there. As it was, I had a hard time in the weeks that followed, even though I knew I had done the right thing.

Apparently Nippy was telling everybody who came to see her that I'd had her "locked up." She was so angry, cursing me up and down, but I think she was scared, too. And she was unhappy. You know, lying there in a hospital bed, getting fed and tended to, maybe she didn't have to think about all the mess that was happening to her. But she knew she'd ultimately have to face it, and that's a scary thing.

After she was released from the hospital, she went to rehab, first in Atlanta and then at the Crossroads treatment center in Antigua. We tried to get Bobby to go, too, because she didn't have much chance of beating this problem if her husband kept doing drugs. And Bobby did go, for a while. But he didn't stay, because he didn't have to. Because of the court order, Nippy didn't have a choice. She stayed in rehab the whole four weeks.

She even had Krissi with her for part of her treatment. I think Nippy wanted her to understand what she was struggling with. She wanted to explain it to her, maybe so Krissi wouldn't wander down that same path herself when her time came. When I heard about that, I was proud of Nippy for facing up to her problem, and being honest about it. All I could

do was hope that this time it would stick, and she wouldn't fall back into that self-destructive lifestyle anymore.

Eventually, after a good long while, Nippy did stop being angry at me. She realized that I did what I did to protect her, and she later told people that I had saved her life. But you know, I'm not sure she ever really forgave me for it. I think some part of her just couldn't stand that I had seen her that way. I had forced her to reveal her worst side to me, a side she would never, ever have let me see on her own.

There were plenty of times when Nippy was able to ask me for help—she did it whenever it suited her. But using drugs was Nippy's biggest problem in the world, and for whatever reason, it was the one thing she could never ask me to help her with. If she'd had her way, I would never have seen what I saw that day in Atlanta. The fact that I had insisted on coming to get her—even to save her life—was something I'm not sure she ever got over.

HAPTER

The Comeback

Being Bobby Brown began airing in June, a couple of months after Nippy finished her treatment. I don't know how she felt about it, or whether she even watched it, because she wasn't really talking to me during that time. I do know that when the producers asked her about doing a second season, she said no. And they weren't interested in continuing without her, so that was the end of that show.

Nippy stayed mad about the intervention for a long time. All throughout the rest of 2005, she really didn't want to have anything to do with me. We had never been estranged like this, and it just about tore me up. I hated not being able to talk to my daughter, especially since the last time I'd seen her, she was in such terrible shape. I knew she was doing better, because Gary and Pat would let me know what was going on. But it wasn't the same as being able to talk to her, to hear my baby's voice.

Finally, sometime in 2006, she began talking to me a little bit. We had a phone call or two, and it seemed like she was starting to come around. I wanted her back so bad, but I didn't push her. I knew I had to let her work it out on her own time frame. I was hoping so bad that we could get back to normal, to the place where she trusted me again and would come to me if she needed me. And in April 2006, that's exactly what happened.

Nippy called to tell me that the *National Enquirer* was about to print some photos supposedly taken in the bathroom at her house. I never did see them, because I don't read that trash, but apparently the pictures showed a filthy sink with beer cans and cigarette butts and who knows what else strewn all over the place. Bobby's sister Tina apparently took the photos and sold them to the tabloid. But Nippy told me she wasn't even in Atlanta when they were supposedly taken.

I had no idea about what the pictures showed, who took them, or who was in the house at the time. The one thing I knew—and the only thing I cared about, really—was that my daughter had reached out, and she needed me. Nippy was upset, and she was asking me to come be with her for the first time since she'd been in rehab. So I got on the first flight out of Newark that I could, and I went down to Atlanta.

I spent the weekend at Gary and Pat's house, and Nippy came to spend time with me there. She looked good—better

240

and healthier than I had seen her in a long time. I ended up thinking those bathroom pictures must have been taken a while back, because Nippy really looked as if she had gotten herself together. Everything that had happened didn't change the fact that we still didn't talk about Bobby instead, we talked about Tina and why she had done such a thing. And we talked about Krissi.

By now, Krissi was thirteen, old enough to understand that all this mess was going on. I was always worried about her—not because Nippy wasn't a good and loving mother, but because I knew it had to be hard on Krissi to be in a home situation that could sometimes be unstable. Nippy would sometimes send her to stay with Gary and Pat, when things at Tullamore weren't going well. And I know she always looked out for Krissi as best she could. Always.

But you know, I don't think it's really fair to Krissi to talk about what she did or didn't go through during these times. Some people believed that Nippy was public property, because of her voice and her fame. But Krissi wasn't then, and she isn't now. She was a young girl who saw her mother go through some very tough times. All I know is, Nippy loved her daughter fiercely, and whatever Krissi went through at this time is her business to tell, if she ever chooses to do it. So I'll leave it at that.

I was just happy to finally spend time with my daughter, and so glad that she had reached out to me. It had been a long, terrible year, but we had made it through to the other side. All I could do was hope that the worst was finally behind us, and that the old Nippy was back for good. And that

summer, my hopes were raised even higher when Nippy finally made plans to separate from Bobby.

Nippy had a house in Los Angeles, and over the summer of 2006, she began spending a lot more time there. She'd bring Krissi out and stay for a month, and gradually she started moving some of the things she cared about from the Atlanta house to California. She did it slowly, over time, so nobody even noticed.

Pat and Gary would come spend time in California, too, and they started talking to her about the possibility of leaving Bobby. They knew she loved him, but they didn't talk about that. They talked about whether she and Bobby were good for each other or not, which is a very different question. And nobody looking at that situation honestly could say they were. Nippy and Bobby just pushed each other's buttons in too many different ways. They tried hard to stay together, but both of them were struggling, and had been for a long time.

And you know, just like with the drugs, this wasn't all Bobby's fault either. No matter what people said, it wasn't like Nippy was a perfect princess and then he just came along and messed everything up. She could be mean, and she could be difficult, and she didn't always face her problems like she should have. It's not fair to place the blame on Bobby for everything that happened to Nippy. And because he's the father of my granddaughter, and the man my daughter loved, I really don't want to say anything bad about him.

I will say this, though: I don't think Nippy would have ended up quite so deep in it if she hadn't been married to

Bobby. I do believe her life would have turned out differently. If she'd been with someone more responsible, it would have been easier for her to get sober and stay sober. Instead she was with someone who, like her, wanted to party. To me, he never seemed to be a help to her in the way that she needed. Parents want their children to find someone supportive, but I didn't feel that he knew how to lift her up.

But you know, as I've said, you can't choose who you fall in love with—and mothers and fathers and families surely can't choose for you. Nippy fell in love with Bobby, so she married him and did everything she could to stay with him. And because he was the man she wanted, there wasn't any other way it could have been.

In September, after she'd secretly moved a lot of her things out of the Tullamore house, Nippy officially separated from Bobby. Later, she liked to say that she told him, "I'm going out for some milk and sugar. I'll be right back"—and then she went to the airport and got on a plane. I don't know about all that, but he apparently didn't see it coming.

At first, Nippy left Krissi with Gary and Pat in Atlanta, probably to make sure she was actually strong enough to stay separated from Bobby before uprooting the child. Nippy ended up renting a house in Orange County, near Los Angeles, and she was working with some kind of drug counselor there while she tried to decide whether to divorce Bobby. She was attempting to figure out her life, and that wasn't something she could just snap her fingers and do. She needed a little time to sort things out.

Now that she was out of Atlanta, Nippy and I talked more often on the phone. And even though we still didn't talk

directly about Bobby, I made my preference known. I'd tell her, "Let it go, child. Just let it go." I knew she wanted to be done with that whole tumultuous period in her life, and I desperately wanted her to be able to make that happen. Oh, how I prayed for God to give her the strength to do it. If she had the courage and strength to make this step, I believed, she was finally going to be all right.

In October 2006, Nippy filed the paperwork to divorce Bobby. The day she told me, I was thanking God so much I'm sure nobody else could get a prayer in to Him. I was extremely relieved—and I think Nippy was, too. Nobody could say she hadn't tried her absolute hardest to keep that marriage together. But now she could finally move on, with full custody of Krissi and the rest of her life ahead of her.

In her personal life and with her family, Nippy was back. And now Clive Davis wanted to bring her career back, too. Clive had his own label now, J Records, and he came calling to ask Nippy to record with him. He asked her if she was ready, and she told him yes—and that was all it took. She signed on to do a new album with Clive, and before long, she went into the studio. The timing was perfect.

I was happy to have Clive working with Nippy again. He had always looked out for her, and he still had the magic touch in the music business. She really did seem ready to get back to doing what she loved the best—singing. And now she had a whole other layer to her music and her voice. She had been through a lot, and there was a new texture and emotion to her singing. Nippy wanted to bring that to her new album, and she wanted the songs to reflect the deeper emotions of what she'd gone through, too.

244

Clive had hired Diane Warren to write some songs for the new album, and one of them just felt perfect to Nippy. It was called "I Didn't Know My Own Strength."

Survived my darkest hour, my faith kept me alive I picked myself back up, hold my head up high I was not built to break....

Nippy said later she couldn't believe it when she heard the lyrics, that it was as if Diane Warren had looked into her soul and written her story. It was just a perfect song for where she was in her life—and for what she'd been through.

And you know, that line about "my faith kept me alive" really resonated for Nippy. Because no matter what had happened with her over the years, all the drugs and the trouble and everything else, she always kept a strong and enduring faith. Though she wasn't one to go to church too often, she believed that church was wherever you were, if you just took the time to pray. And she always did pray, even when she was at her lowest points. As she later said, there were bad times when she locked herself in her room and didn't come out for a while, but whatever else she was doing in there, she always took her Bible with her.

That may sound funny, and I'm sure some people won't believe it. But I do. I was with her many times backstage before performances, and she would always gather everybody together in a circle to pray. And she wasn't doing it for my benefit—you could tell nobody was surprised at her request, because she did it before every show from the time she first started touring. And she also listened to gospel music before performing, too, often the recordings of BeBe and CeCe Winans, Donnie McClurkin, Andraé Crouch, and of course me.

Back when Nippy was a girl and would sing in church, I'd tell her, "Bring them to their feet, baby, and then drop them to their knees." And Lord, she could do it. There is a strong spiritual connection between faith and music, and Nippy had it. Throughout her whole career, she always had a gospel song or two in her set list when she performed, and it was a joy to watch her face light up as she sang those songs of faith.

All my children grew up in the church, and no matter how much they may have strayed, that connection remained with them. Michael likes to say that I introduced him to God, but Nippy really taught him about God. As a child, he used to be scared in church, because there was a lot of shouting and crying, as there tends to be in black churches. Being scared in church made him scared of God, but Nippy calmed him down by talking to him about the Lord and different characters in the Bible. She told Michael he reminded her of David, because he was a fighter. And that gave Michael strength.

Nippy knew God, and although she was private about it, there were some moments when she showed it. One afternoon before a performance, our friend the pastor Joe Watkins was backstage. Nippy invited him to pray with everyone, and as he was praying, she just started to cry. She said, "All right, Joe, thank you," and excused herself to go into her dressing room. She was late going out onstage that day, because she had to do her eye makeup over. But the Lord had touched her that day, as He did many times. Whatever else happened, I can still take comfort in that.

246

In July 2009, just as she was starting to promote her new album, *I Look to You*, Nippy agreed to sit down with Oprah Winfrey to do a long interview. At Oprah's request, she also agreed to sing Diane Warren's "I Didn't Know My Own Strength." Everything would be filmed and then made into a two-hour special that was scheduled to air in the fall.

Clive had scheduled a "listening party" for July 21 in New York, and I went into the city for it, too. It was held in the Allen Room at Lincoln Center, and the feeling in that place was like a revival. This was Nippy's first album in seven years, and you could just feel the love and appreciation for her from everyone in that room. I think people were relieved and happy that Nippy had gotten to this place—a place where she could use the gift of her voice and get back to doing the thing she did best.

Clive played nine songs from the record, and Alicia Keys danced around when the song she wrote, "Million Dollar Bill," played. Nippy was almost forty-six now, and both her voice and demeanor had matured—but she got up and danced around, too, because the vibe in that room was so good. Clive invited Nippy to get up and say a few words, and Nippy stood in front of the room and told everyone how grateful she was that he had called her and brought her back to singing. Then she and Clive clasped hands like the old friends they were.

And Nippy said something that made everybody laugh, though it had a tinge of sadness to it, too. She said that before Clive called, she was thinking about just taking Krissi and going off to an island somewhere, to live in a hut and run a

fruit stand. People laughed, but I'm not sure Nippy was kidding. Just as when Krissi was born, I think Nippy might have liked to walk away from the craziness of the music business. She knew what was ahead now, the long months of touring and interviews, and she knew it would be a hard road. All I could do was hope she was strong enough to withstand the temptations she'd surely find along that road.

The day after the listening party, Nippy flew to Chicago to sit down with Oprah. I think she already knew this wasn't going to be just another interview. I could sense that she was ready to lay it all out there. But what I didn't realize was how much the things Nippy revealed would surprise and shock even me.

The interview aired over two nights in September, on Monday the thirteenth and Tuesday the fourteenth. I watched them at home, by myself, and there were times I just couldn't believe what I was hearing. Nippy had always tried to keep me from finding out the worst of what was happening in her life, so when she opened up about everything with Oprah, the details were as new to me as they were to strangers watching in their living rooms.

Nippy described a lot of upsetting things, but I think the worst was listening to her talk about the night Bobby spit on her. I had never heard of any such thing, and I'm sure Bobby knew what I—or Gary, or Michael—would have done if we'd found out about it while they were still married. Hearing my baby describe the way Bobby had treated her on this occasion was so infuriating, I wanted to jump through the television:

I just remember this moment. It was his birthday, and I gave him a party at a club in Atlanta, Buckhead. He drank a lot that night. He drank a lot. And for some reason, everything that I did, I tried to do to make him happy—it would turn on me....

So when we got back to the house—he's going to hate that I say this—but he spit on me. And my daughter was coming down the stairs, and she saw it. That was pretty intense. Because I didn't grow up with that, and I didn't understand why that occurred. But he had such a hate in his eyes for me.

No, she certainly did *not* grow up with that, because even when John and I were upset with each other, we treated each other with respect. And it never, ever got physical not even close. So I can imagine this kind of behavior was a shock for her. And of course she was upset that it happened right in front of Krissi—what kind of example did that set for her daughter? But as I sat there watching in disbelief, it got even worse:

I was very hurt. Very angry. And I knew somebody, somewhere, something was going to blow. I called a friend. I said, "Come get me now because it's at a turning point now," and I was almost two feet out the door at that point in time. I was ready to go....

And I asked [my friend] to come get me, and [Bobby] pushed me against the wall. . . . I was on the phone and I went back in and I took the phone and I hit him over

the head with it. He just fell out on the floor. It was just drama....

My daughter came down the stairs. She's, like, "Daddy? . . . Mom, what did you—," [her daughter asked]. I said, "I told him not to do it." I kept saying, "I told him not to do this. I told him not to do this." It was just one of those moments. It was just hateful. Ugly.

Ever since she was a little girl, Nippy would rather do almost anything but fight. But my daughter was no coward—if you pushed her too far, you'd better look out. Because she would come at you. I hated the thought that this kind of thing had happened at all, but I was glad at least that Nippy had stood up for herself when it seemed like things might get out of control.

It was so strange, watching my daughter talk with somebody on television about things like this. The interviews were very hard to watch because of terrible, upsetting moments like the spitting incident. And yet, when they were finished, the overwhelming feeling I had was one of relief. Nippy looked good, and she was really being honest about her problems and the trials she'd been through. I guess she finally wanted people to know the truth, and I could only hope that would help her get through the months to come.

In some ways, Nippy seemed to have found peace. Back in 2002, with Diane Sawyer, she had denied the extent of her drug problem. But now, seven years later, she accepted it and talked about it openly. She was trying to maintain a strong relationship with her daughter, and she was back with Clive Davis, singing again. It seemed like Nippy was

doing everything she knew how to do to get her life back together.

But you know, there was also a sadness in my daughter's eyes. I saw it during the Oprah interview, and I also heard it when we would talk on the phone. I always could tell when Nippy was sad, even if she was trying to put on a happy face for the world. I wanted so badly to help her not feel so sad, but I didn't know how. So I just told her I loved her. And I hoped and prayed that the worst was truly behind us all.

CHAPTER 18

"I Look to You"

couple of weeks before the Oprah interview aired, Nippy was scheduled to perform a few songs in Central Park, to promote her album on ABC's *Good Morning America*. Five years had passed since she'd brought the house down at the 2004 World Music Awards, singing those two songs in honor of Clive Davis. And a whole lot of things had happened since then, none of which was particularly good for her health or her voice.

But Nippy seemed ready to do it, ready to get back out into the world and sing. I came to Central Park that day to see her perform, and although a big crowd had gathered, they probably didn't know what to expect. Nippy's problems had been so public, so picked over, that by now everyone in the world knew what she'd been through. Most people probably came out just because they wanted to hear Nippy sing, but I'm sure there were more than a few who wanted to see if she could still do it.

I was a little nervous for her, just because it had been a while and *Good Morning America* was planning to broadcast her performance. But I also knew that, no matter what was going on with my daughter, she had a very deep work ethic when it came to her performances. She never wanted to let any audience down, and for twenty-five years now she'd been giving everything she had from the moment she got onstage.

All that training I had put her through when she was younger had paid off. I never did let Nippy get away with anything, because I wanted her to understand how important it was to give her best every single time. One time in the 1980s, when she was supposed to be singing backup for me, she got to the club late. It was already time to go onstage, but Nippy had only just breezed in, and she didn't have enough time to get ready.

"Mommy," she said to me, "I need some time to change clothes. Just hold on a few minutes, because I'm not ready yet."

"Well, that's too bad," I told her. "You're going to come out and sing in your old torn jeans, then." She looked at me like I had lost my mind. I don't think she could believe I'd actually make her do that, but I turned and walked right out onstage to start the show.

That was the best way I could think of to show her how important it was to be ready on time. And you know, she never forgot it—after that, she always came to her shows

ready to do her job. Over twenty-five years of performing, there was only a handful of times when Nippy wasn't able to give 100 percent to a show. No matter what was going on in her personal life, she was always an amazing performer. So I believed she'd be ready to go for that *Good Morning America* performance—but I just hoped her voice would be ready, too.

September 1 was a perfect late summer day in New York, sunny and warm, and a big crowd had gathered in Central Park. People were so excited to get a chance to see Whitney Houston perform—parents had brought their kids, people were waving signs with her picture on them, and everybody had their cell phones up, trying to take photos and record her performance. When she came out onstage, that whole crowd went crazy. They had waited for this a very long time.

I was standing off to the side, where Nippy could see me, and when she introduced the song "I Look to You," she had a surprise for me. "That's my mom!" she shouted to the audience, and she pointed right to where I was standing, a big old smile on her face. "That's my mama! I love you so much." I held my breath through the opening bars of the song, and then my baby began to sing.

Her voice was a little bit husky, and she might not have had the range she once did, but Nippy sang that song so beautifully, with so much feeling, that you could just feel the emotion surging through that place. And the lyrics couldn't have been more perfect for what she and I had been through together. If I ever wondered whether Nippy appreciated what I'd done in Atlanta, all I had to do was hear her sing the words to this song:

After all that I've been through Who on earth can I turn to? I look to you

As she sang, Nippy kept pointing in my direction, even inserting the word *mama* in the lyrics, to make it clear to everyone what she was singing about. And then, toward the end of the song, my baby's voice broke as she sang the words "You didn't leave me," and I'll tell you, that just about broke *me*. I was overwhelmed—with gratitude, love, everything you can think of. We had been through so much, but we had made it, together. Nippy finished singing that song with her arms thrown wide, looking up at the sky, an expression of sheer joy on her face. And that's exactly what I felt, too joy. My daughter was back.

In February 2010, Nippy started her world tour for *I Look to You*. This would be her first concert tour in ten years, and she was going all over creation—Korea, Japan, Australia, Germany, England. It was like the promoters were making up for lost time or something, sending her all over the globe like that. But people had been waiting a long time to see Whitney Houston in concert, and the shows sold out just about everywhere she went.

I knew this tour would be hard on Nippy's voice, and probably just plain hard on *her*. I wanted to make sure she was doing all right, so I flew to England for a few days just to check in. And while she seemed to be doing okay when I saw her, the rest of the tour didn't go so well.

256

Nippy had been working with a voice coach, but the stresses of a full concert tour are hard. Going onstage every night for two or three hours is difficult enough when you're in your twenties, but at this point Nippy was forty-six years old. And you know, nobody's voice stays as strong as it ever was over thirty years—even in the best of circumstances. And Nippy hadn't exactly been in the best of circumstances, as everyone knew.

On the advice of one of her doctors, Nippy was taking steroids to help keep her voice strong. That helped some, but one side effect of steroids is that they cause you to gain weight. And when that happened to Nippy, people didn't know what to think. She'd always been so slender, it was as if nobody knew know how to behave when she put on a few extra pounds. People can be quick to criticize, and that is doubly true of people who are watching a public figure attempt a comeback.

Unfortunately, some of the other criticism Nippy was getting was justified. Her voice just couldn't stand up to the rigors of so many performances, but because tickets had been sold and promises had been made, Nippy tried to get out there and sing anyway. For a person who had always prided herself on the quality of her performances, it had to have been agonizing for her. People complained, and some of them walked out. Some even demanded their money back. Nothing like that had ever happened to Nippy on a tour, and I can't imagine the effect it must have had on her.

Nippy also went right back to her old habit of never want-

ing me to know when something was wrong, so she never talked to me about any of this. But I can't help but think now that the frustration she felt—at not being able to sing like she wanted to, and at letting people down—must have really knocked her back a step. Because at some point, and I'm not sure when, Nippy apparently began using drugs again.

It's hard now not to wonder what might have happened if Nippy hadn't gone back out on that tour. She was doing pretty well up until she took on the pressures of all those performances over all those miles. What if she had just done as she'd threatened, and taken Krissi to an island somewhere and never performed again? Would she have been able to stay strong in the face of temptation? Would she have been able to just live a quiet life, away from all the madness of the music business?

Nobody will ever know the answer to that, but I can say one thing. Just as it wasn't Bobby Brown's fault that Nippy did drugs, it wasn't the fault of the music business that Nippy ended up struggling the way she did during and after that last tour. Yes, it can be a tough and sometimes ugly business. And yes, she had a hard time keeping up with the demands of promoting, performing, traveling, and everything else. But Nippy was a grown woman, and she had always been taught to think for herself.

Nippy made her decision, and everything that happened afterward—well, that can never be changed. And you know, God had His hand in all of this, too. Nothing happens outside of His plan, no matter how much we might not like the outcome.

Nippy's tour ended in June 2010, and after so many months on the road, she had to have been pretty spent. But whenever we'd talk on the phone, she always acted like everything was fine. She'd put on her chirpy little-girl voice, telling me about this and that, and to my ears she sounded all right. And I knew she had a few new things going on, too, so I wasn't worried about her.

She started talking about doing a new studio album, saying that she wanted to work with Will.i.am of the Black Eyed Peas. And she also started seeing a young rapper named Ray J, whose sister Brandy had starred with Nippy in the movie *Cinderella* back in the late 1990s. I didn't know a thing about Ray J, except that people seemed to be getting worked up over the fact that he was seventeen years younger than Nippy. But you know, I understood that—what do you want with an old man if you can get a younger one? I certainly couldn't blame her for that.

Throughout the rest of 2010 and into 2011, Nippy and I would talk on the phone, and every once in a while we'd see each other. She was back in Atlanta again, in the Tullamore house, and it was easier for me to get to Georgia than it was to California. But I can't say that I saw her often—certainly not as often as I'd have liked to.

Every once in a while I'd hear talk about something going on with her—she got into some kind of mess at a Prince concert, or people didn't think she sounded good when she sang at Clive Davis's pre-Grammy party. But Nippy never talked about any of that stuff with me, and I didn't press her. If there's any one thing I regret about our relationship, that's it: for whatever reason, she never could talk to me about anything that upset her, unless she was really in trouble. I wish we had found ways to communicate better with each other before things got to a crisis point.

I don't know, maybe some of that was my fault. I was touchy about certain things, and quick to tell her—or anybody—if I didn't like whatever was going on. If Nippy had been more like me, of course, that wouldn't have fazed her. She'd have just said, "Well, that's the way it is. Too bad if you don't like it." But Nippy wasn't like me, not at all. She was complicated, and she could be fragile. She always preferred to hide her bad news, rather than tell me and have to hear what I had to say about it.

Nobody likes to have their mama angry, and I would get angry at her sometimes. Maybe she was a little afraid to talk to me, afraid that I would snap at her. I wanted her to be strong, but if she couldn't be strong, I wanted her to ask for my help. Sometimes she couldn't do either one of those things. And the sad truth of it is, the more I wanted her to reach out to me, the less she probably wanted to do it. She didn't want me coming in with a bang, trying to solve her problems, so I tried to stay on the sidelines to give her some space. But the hard part about that was, I often didn't have any idea *what* was going on with her. And that's something I'll never get over and I'll never be right with.

In May 2011, I heard that Nippy was going into an outpatient rehab program. I hated that she was going back to rehab, but I was glad she was facing the problem head-on. As anyone knows who's struggled with drugs or alcohol—or loves someone who has—it's a lifelong battle. I just prayed

that when she finished the program this time, she would stay strong and just keep moving forward. It helps to have something to look forward *to*, of course, so I also hoped she could find a project to work on. And soon enough, she did.

In the fall, Nippy announced that she would be producing and appearing in a remake of the 1976 movie *Sparkle*, a project she had been wanting to do for a very long time. She had seen the original movie as a teenager, going back to the theater over and over because she loved it so much. Nippy thought the story, about the struggles and relationships of a girl group in the sixties, was inspirational.

She had gotten the rights to do the remake back in the mid-1990s, but because of one thing or another it never got done. At first she wanted the beautiful young R&B singer Aaliyah to play the lead role of Sparkle. But when Aaliyah died in a plane crash in 2001, everything got put on hold. And that's where it stayed for ten years, until a new producing team decided to take it on.

Now that the movie had new life, Nippy signed on to play Emma, the mother of the three young singers who make up the girl group. Jordin Sparks was cast as Sparkle, and shooting was scheduled for October 2011. Nippy flew to Detroit, and over the next month, she really had a ball shooting that movie. She liked Jordin Sparks, and because Krissi couldn't come out for the shoot, I think Nippy liked having someone to "mother" a little bit.

Nippy and I talked on the phone a few times, and it seemed like she was really enjoying herself. This was her first movie since *The Preacher's Wife*, and I think she was happy to finally be acting again. Michael's wife, Donna, was with her in Detroit, and whenever I'd ask her how things were going, she always said Nippy was doing great.

Toward the end of shooting, Nippy invited me to come visit her in Detroit for the weekend. I was so happy—I hadn't seen her in a while, and it's not like I would have just popped over to Detroit to see her unless she asked me to. Once she invited me, though, I didn't waste any time making arrangements. I was actually scheduled to be in Chicago just before that weekend, so it would be easy to just fly on into Detroit from there and see her.

When I finished up my business in Chicago, I packed my bags and got ready to catch a cab to the airport. And that's when Donna called me.

"Cissy," she said, "Nippy decided to fly home to Atlanta. She's tired, so she just went on ahead home."

Well, I didn't know what to say to that. I had been excited to see my daughter, so of course I was disappointed. She had invited me out there, and I'd gone ahead and bought my ticket, and now she'd just changed her mind? I guess that for some reason she just didn't want to see me. But you know, I never asked her why. I just flew on back home to New Jersey, and hoped that I'd get to see her sometime soon.

I suppose there was a little bit of pushing and pulling going on at this point, because the next time Nippy asked to see me, I told her she would have to wait. This was the Christmas visit in December 2011, when she suddenly showed up with Krissi in New York City and asked me to come spend the day with them. I had already made plans with my friend Nell up

in Sparta, so I went ahead and saw her. But on December 26, I went into Manhattan, to the New York Palace hotel, to see Nippy and Krissi, Gary, Michael, and their families.

That whole day, Nippy was as happy as I'd seen her in a long time. We all spent the day talking and laughing and cutting up, just as if we were back on Dodd Street in East Orange. It was so wonderful to be surrounded by my children and grandchildren, and when I sat down on the sofa, Nippy came over and laid her head in my lap. I stroked my baby's hair, and we just talked and talked. It was the most beautiful Christmas gift I could have had.

I was always trying to get Nippy to come see me in New Jersey, and as we talked, she promised she would come soon. "I've got to go to L.A. for the Grammys in February, but I'll come see you after that," she said.

"Why you gonna wait so long?" I asked her. "Don't worry about L.A. Come on home before that."

"No, Mommy," she said. "I've got to go for Clive's party. I'll do that, and then I'll come see you." I told her I'd hold her to it.

We spent the whole day together in that hotel, and when the sun set I finally said, "Okay, it's time for me to go." As I gathered my things together, Nippy said, "We'll walk you downstairs. Come on, Michael."

The three of us went down to the lobby, and they started to walk outside with me to get my car. Nippy was just wearing a thin sweat suit—she loved to wear sweat suits—and I said, "Child, you are going to freeze! Get back upstairs!" She just laughed and said, "I'm fine, Mom." Fortunately, the valet came quickly, and after I gave her and Michael quick hugs, I got into my car. As I pulled away, Nippy waved goodbye. And that was the last time I ever saw her.

I talked to Nippy on the phone a few times between Christmas and February. And I even talked to her while she was in Los Angeles. But I don't remember much about those conversations. All I remember is that she told me once again that she was coming to see me. She knew how badly I wanted that, so she promised to come soon.

And then, on Saturday, February 11, 2012, I got that terrible phone call from Gary. And that was the end of life as I had known it.

CHAPTER 19

Bringing My Daughter Home

R ight after I hung up with Gary, people started showing up at my apartment. My niece Diane was first, because Gary had called her to tell her to come. Then, as word got out, the apartment just started filling up with people, everybody crying and hugging and breaking down.

How could Nippy be dead? It didn't make sense. I just couldn't accept what had happened—I couldn't make my mind understand it. I believe I was in shock, because I'd be sitting in my chair in a daze, crushed under a burden of grief, and suddenly I'd hear someone screaming. And then I would realize those screams were coming from me.

I couldn't bear to think about whatever happened to Nippy in that hotel room. And even through the haze of my

grief, I thanked God I wasn't there in Los Angeles when it happened. I usually went out for Clive's Grammy party, but for whatever reason I didn't go this time. I couldn't have survived it if I had actually been right there when Nippy died. As it was, I wasn't sure I could survive it being three thousand miles away.

As more and more people came, we held hands, we cried, we prayed. People brought food, but I wasn't about to eat. People shared memories of Nippy, but I couldn't stand to listen. I just hung on to Aunt Bae like she could keep me from falling deeper into a bottomless well of sorrow. But she couldn't—nobody could. I had lost my daughter, my baby girl. After everything we had been through, she had suddenly slipped away, forever. I was sad, but I was also so angry, so hurt. The wave of emotions just engulfed me, to the point where I could hardly breathe.

I didn't know how I would make it through the next five minutes, let alone the rest of the night, or the long days and nights ahead. I didn't understand how anyone could bear up under such a burden of sadness and pain. And then, someone put on music. And I could hear the voice of Marvin Winans singing the great Andraé Crouch song "Let the Church Say Amen":

God has spoken, so let the church say—Amen!

I'm not going to say that hearing this song made everything all right, because nothing could make things all right on this night. But the message of that beautiful song—that we must give it over to God, and trust in Him to know

what He's doing—was a balm to my wounded soul. Yes, God had spoken. And even though I didn't like what He had decreed, the message was clear and unequivocal: "If you believe the Word, let the whole church say—Amen!" And so I said, *Amen*. It wasn't going to do me any good to try to fight God. I had no choice but to accept and believe that He had a plan.

With everybody milling about, and people crying and carrying on, a part of me just wanted to be left alone to grieve for my baby girl. But I know that without the love of my friends and family, I wouldn't have made it through that night, or the long, terrible nights to come. Because things didn't get any easier. No, not yet.

Those first few days blurred together in a terrible haze. At night, I would fall into fitful sleep, and then I'd wake up an hour or two later to realize my greatest nightmare was real. Sometimes I'd awaken having forgotten that Nippy was gone, and the memory would suddenly rush over me like a wave.

People were so wonderful, sending cards and messages and flowers. Many sent food—Diane Sawyer sent enough to feed a small army. I so appreciated everybody's care, because I certainly couldn't care for myself in those first days. I couldn't stop crying, let alone carry on with the business of living. I was just existing, just going through the motions.

But then something happened that, very unexpectedly, made me feel better. When my daughter's body came home to New Jersey, that was the first time I felt any real comfort since I'd learned of her death.

Nippy's body had been sent to the Los Angeles County medical examiner, so it took a couple of days before we could arrange to bring her home. Tyler Perry, who was a good friend of Nippy, graciously offered to send his private plane to do it, and a group of friends and family, including Gary and Pat, Dionne Warwick, and the funeral director, Carolyn Whigham, accompanied her body home.

I still couldn't believe this was all happening, but I went to the funeral parlor to meet my daughter's body as it arrived from the airport. Aunt Bae was with me, and thank heavens for that, because I was in as bad a shape as I'd been since Gary's phone call. I was just falling to pieces at that point, still unable to cope with the reality of what happened. And I was dreading seeing Nippy's body. I didn't know if I could handle it.

Yet strangely, the moment I saw my sweet daughter lying there in that casket, I felt at peace for the first time. She had been brought straight from the medical examiner's office, so she was wearing a nightgown, with a little cap on her head. She had such a serene look on her face, as if she were just sleeping. I reached out and touched her face, her arm, her hand. Bae reached out to her, too, but Michael just stood there sobbing and sobbing.

When he looked at his beautiful sister, lying there so peacefully, he was so overcome with grief that he could no longer accept she was gone. "Nip, stop playing!" he said, tears streaming down his face. "Get up. Get up!" He held her face in his hands and pressed his cheek against her forehead, moaning and weeping. Michael was just shattered by Nippy's death, and eventually someone had to pull him away

from the casket, because it didn't seem like he would leave her side unless she woke up.

Yet as upsetting as it was for Michael to see Nippy's body, I felt the opposite. Seeing her face so peaceful, so at rest, I finally was able to accept what had happened. Seeing my daughter, even in death, gave me strength.

That evening, we all sat around the table at my apartment and talked about what kind of funeral to have.

People had started talking about having a big service in a public place, like the Prudential Center arena in Newark, so that thousands of people could come. They felt like Nippy was a national treasure—that in a way, she belonged to the people. And the people wanted a chance to say goodbye, so maybe the best way to do that was with a big public event.

But I shot that down quick. "No," I said. "We're going to do the funeral at New Hope. I shared my daughter with the public long enough. Nippy is coming home!" I didn't want to hold a funeral for the singing star Whitney Houston. I wanted to have one for my baby girl, the daughter that I loved so much. I wanted to bring her home, where she belonged.

Over the next few days, the Irving Street agency's Curtis Farrow and Ron Lucas devoted many hours to helping me plan out all the details of the service. Curtis and Ron understood how I wanted to honor and say goodbye to Nippy. They helped me when I grew weary and carried me through the worst thing any mother ever has to do—planning how to bury her child. I don't know what I would have done without them, because they were the ones who somehow managed to pull together everything and everyone we needed for the funeral service.

On Saturday, February 18, 2012, exactly a week after Nippy died, we gathered together at New Hope Baptist Church for her funeral. That beautiful sanctuary was filled with our friends and family, people who had cared so much about Nippy beyond who she was or how she sang. These were the people who knew her and loved her, and that gave me strength. I was going to need it that day.

I went in just before the service started, so I missed whatever mess happened with Bobby Brown and his family. To this day I don't know, and I don't really want to know. The last thing on my mind that day was any kind of conflict, with him or anybody else. He is the father of my granddaughter, and I have always treated him with respect. And I certainly would have done the same that day, but he came, and then for whatever reason he left, and it all happened before I even got into the church. So I really can't say anything else about it.

When I did come into the church, I was helped to the front pew and took my seat next to Michael and Gary. And all I remember is that parts of the next four hours were moving, and sad, and a beautiful tribute to my daughter. But I was so deep in grief and mourning that a lot of it just passed me by. I was so grateful to everyone who spoke and sang and prayed, and I forced myself to get up and embrace each one and thank them for taking part. But I couldn't take everything in, and after a while it all seemed to blur together.

Until the final moment.

I had somehow managed to hold myself together through

my daughter's funeral. But after all the singers and speakers were through, and after all the prayers had been offered, there was a moment of silence in the church. And then, the sound of my baby's crystal-clear, perfect voice cut through the air:

If I should stay . . . I would only be in your way So I'll go, but I know I'll think of you every step of the way. . . .

The pallbearers lined up at her casket, and as Nippy's voice soared out over that whole church; they lifted her casket to chest level. People were standing up, crying, waving their hands, and then the pallbearers hoisted the casket to their shoulders. Everybody in the church just gasped, like they'd been hit in the stomach. And that was the moment my legs gave out from under me.

I don't know what it was about seeing that coffin raised up, and the pallbearers all facing forward to carry it out of the church, but suddenly, everything was real. Nippy was truly gone. Thank God I had two women from the funeral home beside me, to catch me, because I could not hold myself up. Each one took an arm, and I walked out of the church behind Nippy's casket, pierced through with a grief that knew no bounds.

We had a repast after the funeral, at the Newark Club downtown. I really didn't want to go—I just wanted to go home and be by myself for a while. Everybody wanted to talk to me and hug me, and I just felt very aggravated by all of it. But I knew I had to get through it, so I just took my chair at the repast, and greeted everybody who wanted to come by and say something. I'm told the meal was good and that people seemed grateful for it, but I was about a million miles away.

And as hard as all this had been, everything wasn't finished yet. We still had to bury my daughter.

On Sunday morning, a gold-colored hearse pulled away from the Whigham Funeral Home to start Nippy's final journey. I was riding in a car behind, and as we wended our way to Fairview Cemetery in Westfield, New Jersey, people were lined up along the streets, waving and crying and holding up signs for Nippy. A few of them even tried to run alongside the hearse. My darling daughter, who ever since she was little had just wanted to be liked, was in the end adored by people all over the world.

The burial was private, with only our family there, and no one else allowed into the cemetery grounds. We drove slowly up the hill to Nippy's final resting place, a grave site next to her father. The ceremony was quick, which was fortunate because I didn't know how much more I could take. When they put that coffin down into the ground, there was a finality to it that was just too much for me. It was like her funeral all over again, and I just about collapsed. Then they shoveled the dirt on top of the coffin, and just like that, my baby girl, my only daughter, was gone forever.

272

Epilogue

The day Nippy was born, as I was holding her in my arms in my hospital bed, something told me she wouldn't be with me long. It was like a voice in my head, but I didn't pay any attention to it. I figured I must just be overtired, or maybe my pain medication was playing tricks on me. I never said anything to Nippy, of course. In fact, I never even thought about it again—until that terrible February day when it turned out to be true.

I had waited so long for a daughter, and then she had to leave me so early. Nippy and I had just forty-eight years together here on this earth. A lot of people think she died before her time, but you know, I'm not sure anymore. I think God had enough of seeing her go through everything she went through while she was here, and so He decided to bring her home.

I wonder sometimes whether the Lord lets you know when He's about to come for you, because I have a strange

feeling that Nippy knew. Michael told me the same thing after she died, because in their last few conversations she was saying things like, "I've got you, Michael. Always. You know that, right?" And "Michael, you'll have to take care of yourself, and take care of Mommy." And of course, the last time Nippy ever performed in public, at a club in Los Angeles the night before she died, she raised her hands in the air and sang, "Jesus Loves Me."

Even with everything Nippy went through, I had never feared for her life. It never once occurred to me that she might die before I did. I just thought that whatever she was going through, she would always come out the other side. But God had His own plan, and I believe it was my daughter's destiny to go when she did. And even though His plan hurt me so bad, He's the boss. My pain is deep, but my faith is strong, and I believe the Master of it all simply said, "Come home, my child." That's the only thing that keeps me going—knowing He is in charge.

Let the church say—Amen.

Nippy belonged to the public from the minute those nurses in the maternity ward took her around for everyone to get a look. She was more than just an entertainer or singer. She was a person whose life and voice touched millions of people. And while I'm as proud as any mother could be about her daughter, and I'm grateful that she was able to leave her mark on the world, I would trade every last bit of it to have my baby back.

For all the things that happened to Nippy over the years, and all the rumors and stories that got told about her, I just

Remembering Whitney

want people to know what kind of person she really was. She was a giving, loving person, a human being like anyone else. She was a daughter, a mother, a sister, a friend to so many. She was quick to smile, but if you cut her, she would bleed. She could be nasty if she wanted to, but almost always, she was the sweetest, most loving person in the room.

A lot of wonderful people end up falling prey to the lure of drugs, and Nippy did, too. I never thought she would, and I never understood it. But who really knows why people do anything? They have their own insides, and their own reasons. And I think where drugs are involved, people get overtaken in ways they never expected. They may set out to do drugs, but nobody ever sets out to become a drug addict.

In the year since my daughter died, I've struggled with so many things. I'm still so angry—at Nippy, at the world, at myself. There are days when the questions just consume me. Should I have done things differently? Was I a good mother? Was I too hard on her? And the worst one of all—Could I have saved her somehow?

In my darkest moments, I wonder whether Nippy loved me. She always told me she did. But you know, she didn't call me much. She didn't come see me as much as I hoped she would. Sometimes it felt like other people told me she loved me more often than she told me herself. Those other people seem sure that she did. And I guess I believe it. But there are days and nights when those dark feelings just come, and I find myself wondering.

And then, there are other times when I almost feel she's with me. That damn doorbell, the one that rang a couple of times on the day that Nippy died, still keeps on ringing when there's no one at the door—or no one I can see, anyway. I keep asking God to let me dream about her, but I never do. But then the doorbell rings again, or a vase somehow gets moved across the room while I'm out, and I wonder if that's my baby.

I miss her so very much. I still struggle, every day, with the truth that I'll never see her again in this life. But I do believe I'll see her again one day, and that is what keeps me going. Believing that God has a plan and that we will be together is the only thing that keeps me from falling apart.

Sometimes, I'll wake up in the middle of the night crying, just sobbing for my daughter. It takes me a minute to realize where I am, and what has happened. But then I just get up out of the bed, wipe my eyes, wash my face, and lie back down to go to sleep. Because that is all I can do. I am so grateful to God for giving me the gift of forty-eight years with my daughter. And I accept that He knew when it was time to take her.

Let the church say-Amen.

"I marvel at the strength that Cissy has shown in light of some of the darkest times in her life. Cissy's ability to stand against the weight of immeasurable heartache is the emblem of the Christian faith and serves as a paradigm for all of us to exemplify."

> —Pastor Joe A. Carter The New Hope Baptist Church

Acknowledgments

Ver the years, my family and I have been blessed with love and support from many people. But I would like to thank a few in particular:

Bae—there's no way for me to say how much you meant to Nippy and how much you mean to Krissi and me. Thank you for trying so hard to take care of us all three of us.

Laurie, Shelley—I know you loved Nippy from the time she was a little girl, and that love showed in everything you did for her during her life. Thank you.

The Sweet Inspirations—without you three incredible women, my life would have been so different, and so much the poorer. Sylvia, Myrna, rest in peace. Estelle, take care of yourself, and know that the memories of us help to keep me going. We made some amazing music and had some wonderful times together; I won't ever forget that. I love you and miss you.

Toni Chambers—you have always believed Nippy and I

had a story worth telling. You encouraged me to tell it for both of us. With your help, Lisa's wonderful talents, and God's Grace, we did it. You have been with us through thick and thin, always ready with a helping hand and a kind word. I don't know how I could possibly thank you for everything you've done over so many years. You are like family to me and always will be.

Monique Arceneaux—my sweet friend, you look out for me, check in on me, and do for me no matter what. Thank you for your compassionate giving, your loving spirit, and your willingness to do whatever we needed as we wrote this book. I don't know what I would do without you.

A. Curtis Farrow and Ron Lucas—my dear friends. You've been with me in the good times and in my darkest hours. If not for you, I don't know what I would have done trying to plan my daughter's funeral. Although you didn't know Nippy, you know me and how much I love her. Thank you.

CeCe Winans—Nippy's maid of honor, Krissi's godmother, and, most of all, Nippy's friend. She loved singing with you. BeBe Winans—you and CeCe meant so much to Nippy. Pastor Marvin Winans—thank you for officiating at Nippy's wedding and her funeral. She believed in what you do. The entire Winans Family—Nippy loved all of you dearly.

Thanks also to:

Nippy's early managers, Gene Harvey, Seymour Flics, Danny Gittelman—thanks to all of you, especially Gene, who tried to feed her mind as well as grow her career. Joe Roth—you gave her a chance to establish a production company at 20th Century Fox and then again at Disney. Thank you. Debra Martin Chase, who took Brownhouse Produc-

tions and ran with it—thank you. And *Cinderella* was wonderful. I loved it.

Keith Naisbitt, our creative agent, "Saver of the Deal," and longtime friend. We love you. Steve Fisher, our book agent, our new friend, and "Shepherd of the Deal." Thank you. Everyone at APA talent agency. Nicole David, Nippy's film agent. Ben Bernstein, Nippy's first music agent. Everyone at the WME agency. And Sheldon Platt, a brilliant attorney, visionary, and longtime friend. Thank you all for being a part of Nippy's brilliant career.

Clive Davis, the Music Man and a great friend to Nippy. Roy Lott, Arista EVP during the height of Nippy's career. Gerry Griffin, who led Clive to Nippy. And everyone at Arista.

The late Lois Smith, a principal at PMK publicists. Nancy Seltzer, a wonderful publicist. Lynne Volkman, an advocate, loyal publicist, and longtime employee of Nippy, Inc.

"Big Bob" Fontenot, who took great care of Nippy and Krissi. Billy Evans and Ray Watson. David Roberts, the Englishman. And all the other security personnel who kept her safe over the years.

Tour manager Tony Bulluck. Road manager Jimmy Searle. You guys came through for her too many times to count. Instrument tech Don Juan Holder. And everyone else who toured with Nippy and always did your best for her.

Bette Sussman, Nippy's "blond-haired sister." Rickey Minor, her musical director. Paul Jackson Jr. Kirk Whalum. Bashiri Johnson. Michael Baker. To all of you, some of whom I know and some I don't—I am grateful to you for working so hard to make sure Nippy's music was right. She depended on you, and you never let her or her audience down.

Donnie Harper, my accompanist, my friend, my "little brother." Ouida Harding, for your musicianship. Thank you.

Pastor Joe A. Carter—thank you for your great support, for your friendship, and for your spiritual leadership of New Hope Baptist Church.

The New Hope Usher Board, the choirs who sang at Nippy's funeral, the deacons and deaconesses of New Hope, Donna, Tina and crew; Leila Hayes and the nurses unit, to Tina Spears and all of you who work so hard in the Pastor's office, everyone who participated in the funeral and all of you who are there every Sunday to fellowship with me—you all know what you mean to me. My church and the people who are a part of it have been the center of my life for more than sixty years. New Hope is my sanctuary. I thank you all.

Ellin Lavar, who always made sure Nippy didn't have any "hair trauma." Thank you for the beautiful photos you took of Nippy and Krissi over the years. I'm looking forward to seeing more of them when you finish your book.

Carolyn Ensminger—RIP; we all miss you. Tommy Watley—I doubt there is a better driver anywhere. Nippy didn't think there was. You know she loved having you around.

Jerome List—RIP, Jerry, I know you loved her. Cindy, who kept our books and tried to keep people accountable. Maria Padula and Kim Leon. Firoz Hasham, John Houston's driver and "body man." Nippy loved you for taking better care of her father than he took care of himself.

Forest Whitaker and the ladies of *Waiting to Exhale*— Loretta Devine, Angela Bassett, Lela Rochon—Nippy had a ball working with you, and she was looking forward to making the sequel.

Perri "Pebbles" Reid—Nippy's maid of honor, Krissi's godmother, and Nippy's dear friend.

Kim Burrell-thank you for being a friend to Nippy.

Kenneth "Babyface" Edmonds and L. A. Reid—I know Nippy loved working with you and thought of you both as friends. Thank you.

David Foster, Diane Warren, R. Kelly, Alicia Keys, and Dolly Parton—thank you for the beautiful songs you gave Nippy.

Tyler Perry—thank you for all of your kindnesses to my daughter during her life, and after her death. Thank you for the love you've shown my granddaughter and my family. And thank you for telling people that Nippy really did love God.

Bishop T. D. Jakes—your words at Nippy's funeral touched me. You were inspirational.

Kevin Costner—Kevin, you and I don't know each other, but I know Nippy thought of you as a friend. And I know she was grateful to you for helping her through those first days of *The Bodyguard*. Thank you for caring about her and taking the time to get to know her . . . and for your loving words at her funeral.

Denzel Washington—I know Nippy enjoyed being with you and Pauletta. She had fun and was able to relax with you. Thank you for giving her that.

President Nelson Mandela, Winnie Madikizela Mandela, Zindzi Mandela—you welcomed us "home" to South Africa. Thank you for helping to create one of the most memorable times in our lives.

Michael Zager-what can I say, Michael? We have been

through a lot of music together. You are my dear friend, and I thank you.

Tawanna, Fatima, and Tiffany—my "godchildren," I love you all and am so happy to have you in my life.

Reverend Joe Watkins—from the White House to the pulpit. You were always available to help us whenever we asked. Thank you for your efforts and your prayers.

Governor Chris Christie—despite the criticism you received, you honored my daughter's life by flying the flag at half-mast over the State House on the day of her funeral. I appreciate your gesture more than you know. Thank you for visiting me to present me with that flag, for speaking to us as a father and a husband, and for making my family and friends smile at that difficult time.

Mayor Cory Booker—thank you for everything you did for me and my family during the worst days of my life.

Newark Police—thank you, thank you. I will never forget the way you honored one of your own, a little girl from Newark.

Lisa Sharkey of HarperCollins—thank you for always trying to see our perspective and accommodating us above and beyond. Matt Harper—you are amazing! You gave us room to explore and grow as Lisa Dickey and I worked to find the authentic story. Thank you for everything you've done to keep this book on track. Lisa Dickey—thank you for giving yourself to this book just when we needed you. I appreciate your tireless efforts more than I can say. Everyone at Harper-Collins—all of you have been so wonderful. Thank you so much for helping us tell our story.

Vy Higgensen, Mama Foundation, Gospel for Teens-

thank you for your support and the wonderful work you do. Nellie and Herbert Thomas Jr. Thank you for all you do.

Mel Watkins.

Anna MacDiarmid and the folks at the W Hotel Hoboken—thank you for making us feel special and giving us a home during "crunch time" as we were writing this book.

Family means everything to me. I would like to honor and thank my mother and father, Delia and Nicholas Drinkard; and my sisters and brothers, William, Lee, Hank, Marie, Annie, Nicky, and Larry—who have all gone Home. I love you all, and I miss you. I know you've saved a place for me. I'll see you when I get there.

John Houston—thank you for the years, for the love, for our beautiful children. . . . We were wonderful together until we weren't . . .

Thank you to my niece, Dionne Warwick, for her support over the years and for writing the foreword to this book.

Diane Whitt and Mickey Drinkard—thank you to my nieces for always being there. You looked after me and supported me through the hardest time in my life.

I would also like to thank family members Johnnie Houston, Felicia and Gregory Moss, Barry Warrick, Gerard Drinkard, David Elliott, and Damon Elliott, as well as my grandchildren Gary Michael, Aja, Blaire, Jonathan, Raya, and Jordan.

To my sons, Gary and Michael, I love you more than I can express. You are so precious to me, as of course you were to Nippy, too. I am always here for you.

Pat Houston and Donna Houston-thank you for your

love and loyalty to Nippy, to me, and to our family; for loving my sons and for being the mothers you are to my grandchildren. I love you.

And to my granddaughter Krissi, I know you miss Mommie so much. She loved you, and Grandma loves you, too. I pray for your strength and comfort . . . and I'm here anytime you want or need me.

> Cissy Houston November 2012

Selected Cissy Houston Discography

Solo Recordings

Year	Album	
1969	Midnight Train to Georgia	
1970	Presenting Cissy Houston	
1977	Cissy Houston	
1978	Think It Over	
1979	Warning—Danger	
1980	Step Aside for a Lady	
1996	Face To Face	
1997	He Leadeth Me	
2001	Love Is Holding You	
2005	Cissy Houston Collection	
2012	Walk on By Faith	

Record Label Janus Records MajorMinor Private Stock Records Private Stock Records Columbia Records Columbia Records House of Blues A&M Records Neon Intersound Harlem Records

Collaborations

Year	Title
1957	A Joyful Noise
1975	Waterbed

Artist

The Drinkard Singers Herbie Mann, featuring Cissy Houston

Selected Cissy Houston Discography

1976 Surprises

Herbie Mann, featuring Cissy Houston

Soundtracks

Year	Film	Song
1996	A Time to Kill	"Take My Hand
		Precious Lord"
1996	The Preacher's Wife	"The Lord Is My
		Shepherd"
2007	Daddy's Little Girls	"Family First"

Backing Vocahst

Year	Album	Artist
1965	Wilson Pickett	Wilson Pickett
1967	Blowin' Your Mind!	Van Morrison
1967	Electric Ladyland	The Jimi Hendrix
		Experience
1968	Lady Soul	Aretha Franklin
1969	Dusty in Memphis	Dusty Springfield
1970	Taking Care of Business	James Cotton
1970	Doin' What We Wanna	Clarence Wheeler
1970	Moondance	Van Morrison
1970	This Girl's in Love with You	Aretha Franklin
1970	Turning Around	Dee Dee Warwick
1971	Blacknuss	Rahsaan Roland Kirk
1971	Paul Simon	Paul Simon
1971	Quiet Fire	Roberta Flack
1971	Donny Hathaway	Donny Hathaway
1971	Second Movement	Eddie Harris and Les
		McCann
1971	T.B. Sheets	Van Morrison
1971	Homeless Brother	Don McLean
1972	The Divine Miss M	Bette Midler

Selected Cissy Houston Discography

1973	Laid Back	Gregg Allman
1974	The Doctor Is In and Out	Yusuf Lateef
1974	Heart Like a Wheel	Linda Ronstadt
1974	I've Got the Music in Me	Kiki Dee
1974	Young Americans	David Bowie
1976	Boys in the Trees	Carly Simon
1976	Locked In	Wishbone Ash
1976	We're Children of Coincidence	
	and Harpo Marx	Dory Previn
1977	Garden of Love Light	Narada Michael Walden
1977	Monkey Island	The J. Geils Band
1978	Chaka	Chaka Khan
1980	Aretha	Aretha Franklin
1980	Clouds (Naughty)	Chaka Khan
1980	Naughty	Chaka Khan
1981	Freeze Frame	The J. Geils Band
1982	Forever, for Always, for Love	Luther Vandross
1982	Silk Electric	Diana Ross
1982	Diana's Duets	Diana Ross
1985	The Night I Fell in Love	Luther Vandross
1985	Whitney Houston	Whitney Houston
1987	Whitney	Whitney Houston
1990	Some People's Lives	Bette Midler
1991	Power of Love	Luther Vandross
1995	This Is Christmas	Luther Vandross
2003	Dangerously in Love	Beyoncé
2006	Elvis Lives: The 25th	
	Anniversary Concert	Elvis Presley

Musical Arrangements

Year	Track	Album
1977	"Angels"	Cissy Houston
1996	"The Lord Is My Shepherd"	The Preacher's Wife

Selected Cissy Houston Discography

Musical Compositions

Year	Title	Collaborator
1976	"Endless Waters"	David Forman
1996	"Deep River/Campground"	Donny Harper
1997	"Count Your Blessings"	
	U	

Selected Whitney Houston Discography

Solo Recordings

Year	Album	Record Label
1985	Whitney Houston	Arista
1987	Whitney	Arista
1990	I'm Your Baby Tonight	Arista
1998	My Love Is Your Love	Arista
2002	Just Whitney	Arista
2009	I Look to You	Arista

Soundtracks

Year	Film	Label
1992	The Bodyguard	Arista
1995	Waiting to Exhale	Arista
1996	The Preacher's Wife	Arista

Selected Whitney Houston Discography

Compilation Albums

	V	
Year	Album	Label
2000	Whitney: The Greatest Hits	Arista
2001	Love, Whitney	Arista
2004	Artist Collection:	
	Whitney Houston	Sony BMG Euro
		Arista
2007	The Ultimate Collection	Sony Music/Ari
2011	The Essential Whitney Houston	Sony Music/Ari

I Will Always Love You: 2012 The Best of Whitney Houston ope/ ista ista

RCA

Holiday Album

Year	Album	Label
2003	One Wish: The Holiday Album	Arista

Box Sets

Year	Album	Label
2000	Whitney: The Unreleased Mixes	Arista
2001	Love, Whitney	BMG Taiwan
2009	The Collection: Whitney Houston	Sony Legacy
2010	Triple Feature	Sony Music Special
	•	Products

Index

Aaliyah, 261 "Ain't No Way," 49 As the World Turns, 115

Babyface, 139, 183, 209 Bacharach, Burt, 40-41, 46, 204-5 Bassett, Angela, 181-82, 183 "Battle Hymn of the Republic, The," 147 Being Bobby Brown, 230-31, 239 Bernie (pianist), 54, 55 Berns, Bert, 41 Billboard, 117 Bishop's Wife, The, 184 Black Eyed Peas, 259 Blige, Mary J., 182 Bobby, 163 Bodyguard, The, 153, 157-58, 163, 165, 170, 173, 174, 181-82, 185 Bostic, Joe, 28, 33 Bowie, David, 124 Bradford, Alex, 36 Brandy, 182, 259 Braxton, Toni, 182 Brown, Bobbi Kristina "Krissi," 5, 168-70, 173, 174, 183-85, 208, 210, 232, 236, 241, 242, 243, 244, 248, 249, 258, 262, 263

Brown, Bobby, 137, 138–39, 156–57, 161–64, 165–69, 174–75, 179, 184– 85, 187–89, 190, 195, 201, 203–4, 208, 210, 217, 220, 221, 222–24, 230–31, 232, 234–35, 236, 240–44, 249, 258, 270
Brown, Estelle, 46, 54, 55
Brown, Maxine, 41
Brown, Tina, 231, 240–41
"Brown-Eyed Girl," 49
Bull Durham, 154
Burke, Solomon, 10, 37

Carter, Nell, 115 "Chain of Fools," 49 Chambers, Toni, 127, 133, 197, 198, 202 *Chess*, 194 *Cinderella*, 187, 259 *Classic Whitney*, 193–95 Coasters, 37 Cole, Natalie, 233 Cooke, Sam, 28, 38 Costner, Kevin, 153–55, 158, 159, 162 Crawford, Robyn, 101–3, 109–10, 123, 128–29, 157, 182, 198–200, 206, 207, 210, 220 Crouch, Andraé, 246, 266 Cunningham, Randall, 138

Index

Dances with Wolves, 154 David, Hal, 46 David, Nicole, 205 Davis, Clive, 112, 113-19, 139, 153-54, 159, 160, 162, 182, 197-99, 209, 227-29, 244-45, 247, 250, 253, 260, 263, 266 Davis Sisters, 27 Deirdre (singer), 54-55 Devine, Loretta, 183 Diane (Cissy's niece), 4, 265 Dixie Hummingbirds, 27 "Don't Make Me Over," 41 Dowd, Tom, 41 Drifters, 37, 40 Drinkard, Annie, 12, 20, 22, 23, 31, 39 Drinkard, Delia Mae, 12, 14-15, 17-19, 30 Drinkard, Hank, 12, 16 Drinkard, Larry, 12, 17-18, 22-23, 59 Drinkard, Lee, see Warrick, Lee Drinkard Drinkard, Marie "Reebie," 12, 17, 20, 21, 22-23, 29, 35, 77 Drinkard, Nicholas, 12-15, 16-19, 20, 21, 22-23, 25, 28, 29-30, 31, 33, 36, 38, 59, 64-65 Drinkard, Nicky, 12, 17-18, 22-23 Drinkard, Viola, 22-23 Drinkard, William, 12, 13-14, 21, 30, 64 Drinkard Singers (Drinkard Quartet), 17, 27, 28-29, 30, 31, 32-33, 35, 36-37, 38, 46, 56, 143 Ebony, 169-70, 183 Electric Ladyland, 55 Ensminger, Carol, 157 "Evergreen," 88 "Exhale (Shoop Shoop)," 183, 194-95 Farrow, Curtis, 269

Flack, Roberta, 75, 113

Foster, David, 159 Franklin, Aretha "Ree," 10, 46–47, 49, 51, 52, 70, 75, 83, 99, 111–12, 113, 182 Franklin, C. L., 46

Garland, Freddy, 32

- Garland, Gary, 4, 5, 7, 8, 9, 32, 35, 38, 44, 58, 60, 61–63, 64–65, 71, 73, 78–79, 84, 85, 87, 90, 91, 98, 100, 124, 129, 144–45, 149, 157, 165, 193, 202, 216, 218, 219, 220–22, 231, 232–34, 236, 239–41, 242, 243, 249, 263, 264, 265, 268, 270
- Garland, Pat, 216, 218, 220–22, 231, 233, 239–41, 242, 243, 268
- Get It Right, 111
- Gimme a Break!, 115, 154
- Glover, Henry, 37, 38-39
- Good Morning America, 253-55
- Gospelaires, 37
- Grant, Cary, 184
- "Greatest Love of All, The," 88, 89, 113, 121, 160, 164, 176
- Griffith, Gerry, 93, 112, 113
- Hardaway, Phyllis, 53, 57 Harvey, Gene, 117 Hathaway, Donny, 113 Hawkins, Ronnie, 39
 - Hendrix, Jimmy, 55
 - "Hold Me," 115
 - Holiday, Billie, 20
 - Houston, Alana, 191-93, 218-19
 - Houston, Blaire, 161
 - Houston, Donna, 125–26, 163, 187–88, 206, 207, 262
 - Houston, Elizabeth, 11, 74
 - Houston, Gary (Cissy's grandson), 124, 125–26
 - Houston, Gary (Cissy's son), xii, 4, 5, 9, 35, 38, 58, 60, 61, 62, 64, 65, 71, 73, 78, 84, 85, 87, 90, 91, 98, 100,

124, 129, 144, 157, 165, 193, 202, 216, 218, 219, 220, 221, 222, 231, 232, 233, 234, 236, 239, 240, 241, 242, 243, 249, 263, 264, 265, 268, 270

- Houston, John, 9, 10–11, 34–39, 41, 43, 44–45, 49, 51, 53, 54, 56, 60, 61–62, 64, 65–66, 67, 68–69, 72, 76, 78–79, 82–85, 86–87, 91, 96, 98, 99, 100, 102, 104, 109–11, 112, 123, 124, 126, 129–30, 139, 140, 143–46, 147, 149, 157–59, 161, 162, 178, 184, 190–93, 194, 198–99, 215–20, 249
- Houston, Michael, 5, 9, 38, 40, 44, 52, 58, 60, 61–63, 65–68, 70, 73, 74, 79, 84, 87, 91, 98, 99, 100, 113, 124, 125–26, 129, 144–45, 149–51, 157, 161, 163, 165–66, 172, 187, 193, 202, 206, 207, 208, 216, 218–19, 246, 248, 262, 263–64, 268–69, 270, 276

Houston, Peggy, 157–58, 191, 215, 218 Houston, Whitney Elizabeth "Nippy," 4–8, 9–10, 42, 43–45, 50, 51–52, 56, 58, 60, 61–64, 65–79, 81–83, 84, 85, 87–89, 90–92, 93–105, 109–20, 121–35, 137–51, 153–64, 165–79, 181–95, 197–211, 215–19, 220–25, 227–37, 239–51, 253–64, 265–72, 275–78

"How Will I Know," 121 "Human," 49 "Humpin' Around," 164, 166, 174 Hunt, Tommy, 49–50

"I Believe in You and Me," 229 "I Didn't Know My Own Strength," 245, 247 "I Know Him So Well," 194 I Look to You, 247, 256 "I Look to You," 255 "I Miss the Hungry Years," 35

- I'm Your Baby Tonight, 139-40, 142-43, 149, 153, 155
- "I Never Loved a Man," 49

Isley Brothers, 10

- "I Will Always Love You," 159, 164, 167, 229
- Jackson, Chuck, 41
- Jackson, Jermaine, 115, 116, 119
- Jackson, Mahalia, 28-29, 33, 36
- Jackson, Michael, 58, 63, 116, 120, 121–22, 209
- Jackson, Rebbie, 120

Jackson 5, 63

"Jesus Loves Me," 276

Jeter, Claude, 27

John Houston Entertainment, 215

- Jolly (Cissy's friend), 20-21
- Juanita (Whitney's aunt), 18

Kashif, 116 Keys, Alicia, 247 Khan, Chaka, 75, 90, 93, 113 King, Ben E., 37 Koppelman, Charles, 61

LaBelle, Patti, 182 "Lead Me, Guide Me," 130 Leiber, Jerry, 37, 40, 41, 47 "Let the Church Say Amen," 266–67 "Life's a Party," 93 "Lord Is My Shepherd, The," 187 *Love Language*, 115 "Love's in Need of Love," 176 Lucas, Ron, 269

McClurkin, Donnie, 246 McMillan, Terry, 181–82 *Make a Joyful Noise*, 33 Mandela, Nelson, 131, 175–77 Mandela, Winnie, 178–79

Index

Mandela, Zindzi, 176 Marshall, Penny, 184 Material, 111 "Memories," 111 *Merv Griffin Show, The*, 114 Michael Zager Band, 93 Midler, Bette, 143 "Million Dollar Bill," 247 Mizelle, Cindy, 90 "Moment of Truth," 124 Morrison, Van, 49 "Mr. Bojangles," 195 Murphy, Eddie, 137–38 *My Love Is Your Love*, 199

National Enquirer, 240 "Natural Woman," 49 Naughty, 90 Nell (Cissy's friend), 5, 263 New Edition, 163 Newport Jazz Festival, 33, 56 Nippy Inc., 124, 143 Niven, David, 184

Odum, Reverend, 23–24 "On Broadway," 40 *One Down*, 111 Oscar (Cissy's uncle), 19

Parton, Dolly, 159, 160 Pendergrass, Teddy, 115, 119 People, 155 "People," 176 Perry, Tyler, 268 Pickett, Wilson, 10 Platt, Sheldon, 197 "Please Stay," 40 Power of Love, The, 143 Preacher's Wife, The, 184–87, 190, 262 Presenting Cissy Houston, 61 Presley, Elvis, 33, 55–57, 61, 99, 193 Prince, 260 Rawls, Lou, 93 Ray J, 259 Reid, L. A., 139, 209 Roberts, Dave, 149 Rochon, Lela, 183

"Saving All My Love for You," 120, 164 Sawyer, Diane, 217-18, 222, 250, 267 Shemwell, Sylvia, 41, 46, 54, 55, 59 Shirelles, 41 Silver Spoons, 154 "Since You Been Gone," 49 Skinner, Kevin, 216 Smith, Myrna, 46, 54, 55, 57, 59 "Some Kind of Wonderful," 40 Some People's Lives, 143 Songs of Faith & Inspiration, 49 Sonny and Cher, 66 Soul Stirrers, 28 Sparkle, 5, 261 Sparks, Jordin, 261 Springfield, Dusty, 55 Staples, Pops, 49 Staple Singers, 38 "Star-Spangled Banner, The," 140, 147, 209 Stoller, Mike, 37, 40, 41, 47 Streisand, Barbra, 88 Swan Silvertones, 27 Sweet Inspirations, 46-48, 49, 50, 52-60, 61, 62, 70, 83-84, 86, 89

Thornton, Fonzi, 90 "Tomorrow," 94 Tyler, Bonnie, 97

Underwood, Blair, 138

Vandross, Luther, 50, 75, 89–90, 99, 111, 113, 139, 140, 143 Verdell, Jackie, 27

Index

Waiting to Exhale, 169, 181-82, 184 Ward, Clara, 29, 33, 36 Warren, Diane, 245, 247 Warrick, Lee Drinkard, 12, 22, 28-29, 31, 32, 33, 35, 36-37 Warrick, Mancel, Jr., 31 Warrick, Mancel, Sr., 31 Warrick, Reverend, 31 Warwick, Dee Dee, 31, 37, 38-40, 41, 45-46, 71 Warwick, Dionne, 10, 31, 37, 38-41, 45, 70, 99, 113, 120, 162, 268 Washington, Denzel, 184-85 Washington, Dinah, 20, 3738 Watkins, Joe, 246-47 Watley, Tommy, 157 Welcome Home Heroes, 146-48, 155, 176 Wexler, Jerry, 41, 46, 47 "Where Do Broken Hearts Go," 134 Whigham, Carolyn, 268 Whitaker, Forest, 182, 183 White, Ellen "Bae," 35-36, 57, 60, 83,

124, 145, 149-51, 157, 165, 170, 183, 192, 218, 221, 224, 231, 266, 268 White-King, Brenda, 90 Whitney, 122, 194 Whitney Houston, 116-18, 121-22 Whitney Houston Foundation for Children, 133, 141-42 "Whitney-The Concert for a New South Africa," 176 "Why Am I Treated So Bad," 49 Will.i.am, 259 Williams, Ronnie, 27, 32-33 Winans, BeBe, 246 Winans, CeCe, 206, 246 Winans, Marvin, 162, 266 Winfrey, Oprah, 247, 248, 251, 253

Yamaha Music Festival, 96–97 Young, Loretta, 184 "You're My Fire," 97

Zager, Michael, 97

About the Author

CISSY HOUSTON is a Grammy Award-winning soul and gospel singer and the mother of the late superstar Whitney Houston. She gained fame as part of the Drinkards, a family gospel group, and revolutionized the "Background Industry" as the founder and leader of the Sweet Inspirations, a well-respected vocal group who provided background vocals for such artists as Luther Vandross, Wishbone Ash, Aretha Franklin, Dusty Springfield, and Elvis Presley. She later enjoyed a successful career as a solo artist. Cissy grew up in Newark, New Jersey, where she raised her family and still lives in the area.

LISA DICKEY has been a freelance ghostwriter and book doctor since 1997. She has helped write and/or edit fourteen published nonfiction books, including six *New York Times* bestsellers. For more information, please go to www .lisadickey.com.